THE NIKON HANDBOOK SERIES:

Exposure Control and Lighting

Joseph D. Cooper and **Joseph C. Abbott**

AMPHOTO
American Photographic Book Publishing Co., Inc.
Garden City, New York

NOTE FROM THE PUBLISHER

The Nikon Handbook Series was previously published as *The Nikon Nikkormat Handbook*. The series was compiled from *The Nikon Nikkormat Handbook* and the supplements that were used to update it. As the series goes to press, it contains the latest available information on Nikon equipment.

ACKNOWLEDGEMENT

Grateful acknowledgement is hereby made to Mark Iocolano for his assistance in preparing this work for publication

Library of Congress Cataloging in Publication Data

Cooper, Joseph David, 1917–1975.
 Exposure control and lighting.

 (The Nikon handbook series)
 Includes index.
 1. Photography—Exposure. 2. Photography—Lighting. 3. Nikon camera. I. Abbott, Joseph C., joint author. II. Title. III. Series.
 TR591.C73 1979 770'.28 79-10593

ISBN: 0-8174-2162-9 (softbound)
ISBN: 0-8174-2490-3 (hardbound)

Manufactured in the United States of America

Contents

Introduction

This volume of the Nikon Handbook Series concerns itself with using cameras, lenses, artificial lighting, and films so as to extract maximum creative potential. Chapter 1, "Image Control," discusses problems of perspective, creative control of perspective with various Nikkor lenses, psychological aspects of image perception, and sharpness of depth. Chapter 2, "Exposure Control," deals with light characteristics, subject exposure characteristics, light measurement, films and filters. The final chapter is an extensive discussion of artificial- and existing-light sources, including flashbulbs and electronic flash as well as continuous sources. Descriptions of Nikon flash equipment are also included in this chapter.

This compact, seven-volume edition of the Nikon Series constitutes a significant revision of the original two-volume loose-leaf edition by the late Joseph D. Cooper. The present work is not a condensation; all of the material of the original Nikon-Nikkormat Handbook, including loose-leaf supplements volumes one and two, is presented here. Additional material on the latest Nikon equipment has been collected especially for this edition. The original text, containing references to material and techniques, has been thoroughly revised to reflect current developments.

Insofar as possible, material has been organized so as to separate descriptions of equipment from explanations of usage. In the book describing cameras, for example, Chapter 2 is the basic reference source on individual cameras and their features. The handling of cameras is treated in the following chapter.

As a systems reference guide, the Nikon Series is also designed to serve photographers (and photographic dealers) in discovering new applications and information about equipment they do not have but may want to procure. It includes historical information: the evolution of the entire Nikon camera line, beginning with the rangefinder models; characteristics of discontinued lenses for the Nikon reflex cameras; and operating information on important discontinued accessories.

In addition to being a technical reference source, the Nikon Handbook Series has been designed as a general guide to photography with the 35mm single-lens reflex camera and its lenses, accessories, films, and other materials. For example, the chapters on exposure, artificial lighting, closeups, motorized photography, underwater photography, special effects, and other subjects are fairly complete coverages of principles and methods going far beyond the use of Nikon equipment alone.

CHAPTER 1

Image Control

In this chapter we discuss general principles for the creative manipulation of the photographic image. This is *image control* which, in its simplest sense, is the ordering of the elements within the pictorial rectangle to achieve an intended effect. This is ordinarily referred to as *composition,* one of the main topics covered in this chapter; however, the concept of image control is more inclusive.

In its most familiar sense, composition is treated as the arrangement of elements of tonal mass within the flat plane formed by a single frame. Our treatment here goes further to cover those factors that convey the impression of depth on a flat screen or piece of paper. In part, the sense of depth is controlled by the choice and use of lens, by spacing to show relative size and separation, and by aerial perspective in outdoor scenes. These and other factors are discussed within this chapter in the following sequence: (1) the principles of perspective control; (2) the creative use of lenses in perspective control; (3) the psychological aspects of image perception; (4) sharpness in depth; and (5) the principles of composition.

What the photographer perceives at the time the picture is taken is quite different from the image that is recorded on the film. It is this difference that makes photography an art as well as a science. Mastery of image control enables one to previsualize the final results at the time the picture is to be taken.

THE PRINCIPLES OF PERSPECTIVE CONTROL

The geometric perspective accomplished with a camera-lens system is always correct. That is, the way parallel lines converge and the way objects at different distances from the lens are imaged at different sizes are mathematically exact.

The viewer of a photograph may sometimes find the perspective unusual and consider it distorted, but such judgments are subjective and have nothing to do with correctness. In fact, the concept of incorrect perspective does not belong in photography at all. It is an idea that relates principally to inaccuracies found in drawings.

Much of our daily survival has to do with our ability to successfully judge

depth, which includes such simple actions as drinking a glass of water or crossing the street. When we look at a photograph, we also tend to seek out depth indicators that suggest not only the relative sizes and distances among objects but the distance of the viewer from the scene. Geometric perspective is one type of depth indicator that can be controlled by the photographer. Other clues to depth and size relationships are light and shadows, aerial perspective, and overlay.

Geometric Perspective

In general, largeness is associated with nearness while smallness is associated with distance. The nearer the object, the larger its rendition; the farther away it is, the smaller it appears. This is one aspect of the principle of diminution, which is the basis of geometric perspective. Another obvious effect is the convergence of parallel lines, which is most evident in photographs of roads or railroad tracks that stretch off into the distance and in pictures of tall buildings taken with the camera tilted.

Size Relationships. If we examine a photograph of a number of similar objects that extend obliquely away from the camera, such as a row of telephone poles, we can see that the nearest pole is exactly twice as large as a pole twice the distance from the camera. If the nearest pole is fairly close, so that it fills the full frame, the initial diminution will be quite apparent. The rapid fall-off in size is known as steep perspective and is associated with close camera-to-subject distances. As the distance between camera and subject increases, the fall-off in size is far less noticeable, so much so that in a photograph of telephone poles extending off toward the horizon, the last poles appear to be nearly the same size. This effect, known as flat or "pancaked" perspective is commonly associated with telephoto lenses.

Convergence. Parallel lines that extend away from the camera appear to converge; that is, the distance between them appears to diminish. The most obvious example of this is railroad tracks extending off into the distance. When the camera is held so that it is parallel to the lines of the subject, no convergence is seen, as when we photograph the front of a building and hold the camera so that the face of the building appears as a perfect rectangle in the viewing screen, or when we photograph railroad tracks from the air. On the other hand, if the side of the building also appears in the picture, the side will appear to converge. The greatest convergence is exhibited by those subjects that are close to the camera and extend away at *nearly* right angles to the film plane. Camera tilt and height are the photographer's principal means of controlling convergence, although camera-subject distance is also important.

In practice, if you want to achieve maximum separation between objects or the effect of great extension in space, you will want to work as close as possible to your subject. By working closely, you can make one figure stand out from others in a crowd, a common technique among journalists who favor wide-angle lenses. Similarly, you can make an automobile or building appear longer. On the other hand, you can make figures some distance apart appear about the same height by stepping back and using a long lens to magnify image sizes.

Tilt and Height

Camera tilt—the angle from which the lens views the subject—and the height of the camera above the ground—are two of the photographer's most useful methods of perspective control. Tilt, also called *camera angle* or *angle of view*, refers to the way in which you point the camera, relative to the subject. The greater the

tilt, the greater the upward or downward convergence and apparent distortion of shape, especially when working close to a subject with a wide-angle lens. For example, if you shoot downward at a small child, the child's head will appear disproportionately large compared to the lower part of his torso and his feet. If you tilt the camera upward to catch the top of a building or use the upper, uncluttered portion of a wall as a background when shooting indoors, the parallel lines formed by the architecture will appear to converge.

Extreme tilts can be used effectively to exaggerate perspective effects, such as shooting downward from a tall building. When the effect is unpleasant, it is sometimes called "tilt distortion" or "wide-angle" distortion. Such effects can be eliminated by keeping the camera parallel with the subject, which may necessitate moving back to get all of the subject within the frame (as when shooting buildings), changing the height of the camera, or using the PC-Nikkor lenses.

As a matter of convenience, we usually think of the camera as being held at eye level and parallel with the ground. Scenes taken with the camera held in this position usually exhibit "normal" perspective; that is, the resulting print or transparency closely resembles what an ordinary viewer at the scene might see. Subjects above or below eye level must be photographed by either tilting the camera or changing the height of the camera. If we want to eliminate all tilt distortion, we choose the latter method and find a camera height appropriate to the subject. To photograph a child, the photographer can kneel down until he is at the child's level. Architectural structures can sometimes be photographed from the window of a nearby building. For very low camera heights, however, a right-angle or waist-level finder is a great help, especially when the camera is mounted on a tripod and the photogra-

pher wants to take the time to carefully consider his composition.

Unusual angles of view can often help turn a dull photograph into an interesting one. Tilt can also help solve background problems. Indoors, for example, walls often are cluttered with pictures and other decorations up to about six feet from the floor, but the wall space near the ceiling is frequently empty. By tilting the camera and adjusting camera height, the photographer can use the clear upper wall as a simple background for a portrait.

The technique of changing height and angle of view can be used to place a subject in a pleasing relationship to a background. Objects in the foreground can be positioned relative to subjects in the middle ground so that they form leading lines, or trees or archways can be used to frame a subject. Occasionally suitable objects such as sculpture, shells, fruit, and so on can be located in the foreground, by shifting camera position, for contrast or comparison with the principal subject. Moreover, by choosing the appropriate lens, the photographer also can control the scale of foreground-subject-background relationships and camera-to-subject distance.

Clues to Depth

Overlay. A photograph may contain numerous indicators of depth relationships not associated with geometric perspective. One of the most obvious of these is *overlay,* which refers to the way objects appear to overlap. Overlays are generally not a problem unless they create confusion through overlapping of distracting or incongruous objects or through tone mergers that make it difficult for the viewer to interpret a photograph. Unless confusion is intended, these should be avoided by either changing the camera position or the lighting.

Light and shadow. The quality and direction of light has a significant effect on depth relationships. On one end of the scale we have diffuse, shadowless lighting that makes subjects appear flat. On the other end there is strong, contrasty side lighting that produces deep shadows, brings out surface texture, and emphasizes even the most subtle differences in depth.

The following are some general rules concerning the effect of typical lighting situations on pictorial depth:

1. Diffuse shadowless lighting, such as that produced by certain types of artificial lighting or that found on a heavily overcast day, yields low-contrast pictures with minimum separation between various parts of a scene. Diffuse but recognizable directional lighting, such as that found outdoors on hazy but bright days, produces soft, rounded shadows that are especially suitable for portrait photography and for color photography in general.

2. Contrasty lighting that produces sharp, well-defined shadows creates maximum separation between various parts of the subject, provided the direction of the lighting is appropriate. Clear, sunny days provide this type of lighting. This is generally a poor lighting situation for portraiture, since the harsh shadows tend to break up the rendition of facial contours, but it can be excellent for bringing out qualities such as texture and line.

3. The direction of the light should be considered in relation to the various parts of the subject. Direct frontal lighting eliminates shadows and provides almost no indication of depth. Side lighting is commonly used to bring out texture, because even minor variations in the surface of a subject can cast shadows when the light is at the appropriate angle. A low, raking side light can even pick out the surface texture of paper and other substances normally rendered without depth. Like side lighting, top lighting casts distinct shadows, and although not commonly used, subjects such as abstract sculpture can receive interesting treatments in this type of light. It is unsuitable for portraiture since it tends to deepen the eye sockets and distort other facial features.

4. Backlighting provides maximum separation between the subject and background. The effect of having the main source of lighting directly behind the subject is dramatic but also makes it difficult to achieve an exposure that combines satisfactory highlight and shadow detail.

5. A dark foreground in front of a well lit subject adds depth by separating the viewer from the subject.

6. A dark background emphasizes the depth behind the main subject being photographed but decreases the apparent separation between the viewer and the subject.

Aerial perspective. When we look at a distant subject or scene, the colors appear to become progressively fainter and tend to grey out. Moreover, depending on the amount of moisture in the air, colors appear progressively bluer. In landscape photography this effect is often desirable, for it suggests distance. However, when working with telephoto lenses it may be a problem because of the magnification of particulates in the air.

THE CREATIVE USE OF LENSES
IN PERSPECTIVE CONTROL

The selective use of lenses and the correct position of the camera relative to the subject allows the photographer to achieve desirable background and foreground effects and to control both the rendition of size and the feeling of space among objects.

The primary function of focal length in perspective control is to permit the photographer to change the working distance between himself and his subject while maintaining a satisfactory image size. Changing working distance creates a change in the apparent size of objects relative to each other. When we maintain a camera position and simply interchange lenses, the effect is to change the scale of rendition on the film in direct proportion to the focal length, but there is no change in perspective. Let's say we switch from a 50mm lens to a 100mm lens. This cuts down the field of view and doubles the size of all objects in the pictorial frame; however, there is no change in the size of objects relative to each other and therefore no change in perspective. *To control perspective, the photographer must change his camera position and select the lens that gives him an acceptable image size at the chosen working distance.*

Depth Control Through Distance

Picture taking at close working distances may be done with lenses that range from wide-angle to normal and slightly longer. When you decrease the camera-to-subject distance the following effects become more pronounced:

1. There is an apparent distortion in the closest regions of your subject due to rapid diminution beyond.

2. The effect of spatial separation between objects in the foreground and middle ground is increased.

3. Foreground objects are emphasized because of their larger size in relation to objects in the middle ground and background.

The effect of extremely close working distances on the photographer is twofold: First, being in such close proximity with a subject demands that he have some affinity for his target, regardless of its normal size. This is not as much of a problem when photographing inanimate objects as it is with living beings. When photographing persons at close range with wide-angle lenses, rapport with the subject, or lack of it, becomes quite evident in the results, since the photographer's presence is strongly felt by the subject. Second, the steep perspective effects observed in the viewfinder often appear unique because the reflex system allows the photographer to see the entire subject in depth, at a glance, in a way he could not possibly see using his own eye-mind system. The impact of novelty in these situations sometimes overrides good pictorial judgment. Thus, close working distances demand close attention to pictorial considerations if disappointing results are to be avoided.

The Pictorial Field

For purposes of analysis, an image can be divided into three principal zones—foreground, middle ground, and background. These three zones comprise a field in depth, within which the principal and secondary subjects appear. By selecting the appropriate lens and working distance, the photographer can control the placement of his subject within this field.

Consider two photographs of a person standing in a doorway, both showing the person the same height on the transparency or negative, but one taken with

a wide-angle lens, the other with a tele-photo lens. Because the image of the person is the same size, the sharpness in depth will be the same. The placement of the subject within the total field, however, will be radically different. In the wide-angle shot, parts of the inner frame around the door will be visible, and so the immediate environment of the subject will appear to have considerable depth. On the other hand, objects in the middle ground and background will appear fairly small and far away. The telephoto shot may show little or none of the inner frame of the doorway, and objects in the middle ground will be rendered large, as will background objects. Thus the pictorial field will appear much more limited in depth; the separation between foreground, middle ground, and background will be much less evident. If a third shot were made with a normal lens, the pictorial field would appear much as it did to the observer at the scene, and the subject within the field would appear normal size in relation to objects in front and behind it.

Regardless of the lens used, color has a pronounced effect on our perception of the field. Warm colors such as red, orange, and yellow tend to move forward; cool colors such as blue, green, and violet tend to recede. When both field and subject consist of warm colors, the appearance of depth is reduced, and there is a feeling of closeness to the viewer. When both subject and field are cool colors, the sense of spatial separation is also reduced, but the subject appears more remote. A large, warm field, such as that created by a red backdrop behind a subject sitting for a portrait, can overwhelm the subject. A cool background will tend to separate the subject from the field and focus attention on the person.

In black-and-white photography, lightness and darkness affect the apparent depth of field in relation to the subject. If the subject is placed in the middle ground, a large, dark foreground will add distance between viewer and subject. A dark background surrounding an object will have a similar effect. A light foreground surrounded by a dark field will make the subject appear closer to the viewer.

When the subject-field relationship is ambiguous, the relative size of the subject compared to the field alters the illusion of depth both within the pictorial frame and in terms of the distance between subject and viewer. For example, in a close-up shot of a small shell on a piece of dark velvet that forms the entire field surrounding the shell, the larger the shell is rendered, the closer it will appear. The presence of depth or scale indicators would locate the subject within the field, placing it in foreground, middle ground, or background, thus helping to determine the apparent distance between subject and viewer.

The choice of a lens to control foreground, background, and placement of the principal subject in relation to these is discussed below.

Backgrounds

In strict linear perspective, the background is that part of a picture that appears most distant from the viewer. In pictorial terms, it is generally thought of as that area against which the subject is seen, although in some photographs, such as those of distant mountains, the subject itself may be part of the background.

The background is often the most difficult pictorial zone for the photographer to control successfully. This is especially true in candid photography and photojournalism where sometimes the photographer must work as best as he can in a given situation.

A dark area of a room can be used as background for an illuminated subject. Outdoors, the sky makes a good background for portrait photography. A subject in bright sunlight can be contrasted

against an area in dense shade, such as a group of trees, which will record simply as a black area with little or no detail.

A distracting background can often be handled by selective focusing techniques. A brick wall makes a good background only when it is thrown well out of focus. Sunlight filtering through tree leaves creates an interesting pattern of lights and darks when sufficiently blurred. However, there must be sufficient distance between subject and background for this technique to be effective.

Size and distance relationships can be altered by choosing the appropriate lens and working distance. When you work with lenses that range from normal through wide-angle, you can choose a lens according to the size and amount of background you want to include, then alter the camera-to-subject distance to achieve the desired image size. With lenses in this range, especially the wide-angle lenses, moderate variations in working distance have little effect on the rendition of more distant backgrounds.

In news photography, backgrounds are often used to comment on the subject. A painter might be photographed in front of one of his works; a housewife in her kitchen; a weathered tenement juxtaposed against a modern skyscraper; a child in a slum pictured against the rubble of a vacant lot; and so on.

Foregrounds

The following general principles can be stated as guides for handling foregrounds in various situations.

1. To minimize the foreground, use a long working distance and a telephoto lens. Choose a camera position that allows you to exclude objects close to the lens.

2. To emphasize foregrounds, use a wide-angle lens and include objects or depth indicators within the frame.

3. Objects in the foreground can help anchor a composition; if suitably arranged, they can also help to integrate foreground and background.

4. Trees, archways, and the like appearing in the foreground can be used to frame a subject and add pictorial interest.

5. When a principal or secondary subject appears in the foreground, be aware of the amount of permissible shape distortion, choose your working distance accordingly, and then find a lens that gives you a desirable subject-to-background size relationship.

6. To unify foreground and background, include leading lines, such as gracefully curving paths or arrangements of objects within the foreground.

7. Slightly out-of-focus foregrounds are usually disturbing. It is sometimes possible, however, to throw a foreground element so far out of focus that it becomes a barely noticeable shadow pattern. For example, when you photograph animals in a zoo, a fence or the bars of a cage can be eliminated by working close to these barriers at full apertures.

8. When the background is complex, contrast it with a simple foreground (and vice versa).

PSYCHOLOGICAL ASPECTS
OF IMAGE PERCEPTION

It is important to understand the difference between the way a camera system produces an image and the way the human being perceives the same image, because such understanding relates directly to problems in lens selection, composition, and other factors in effective image control.

Seeing With Eye and Mind

Compared with the relatively simple action of light on film, the image recording and perceiving system of a human being is incredibly complex, involving millions of nerve interconnections, memory, continuous adaptation to variations in brightness and color, prior experience, the context within which the image is perceived, and even the expectations of the perceiver. Before the sensations produced by light in the eye are finally recognized and interpreted by the mind an enormous amount of information processing occurs both in the eye and the brain. The exact nature of this processing is not fully understood; for our purposes it is enough to recognize a few of the major aspects of the eye-mind system of perception.

As we scan a scene, our freely roving eyes can take in an area of about 130 degrees. If we cease to scan and fix our eyes on a single point, our critical perception is limited to an area covered by a 20-degree angle of view, similar to that of a lens in the 100mm to 135mm range. Even with the eye fixed, seeing still takes place over an area covered by an angle of about 50 degrees. Beyond the area of critical perception, however, only movement and large objects are perceived. Lenses in the 45mm to 58mm range have comparable fields of view.

Normally, our eyes constantly move unconsciously from one point to the next as we scan a scene, continually refocusing to adjust for variations in color, depth, and variations in brightness. The result is a collage of individual images, each of which provides some information about the scene in front of us. It is this collage of images that is interpreted by the mind as a continuous picture of the scene. In the process, variations in the color and intensity of light are compensated automatically. The camera-and-film system cannot do this; it depends solely on the cumulative effects of light on film. Differences in brightness are recorded as different image densities; movement as blur, unless arrested by appropriate shutter speed; and focus is restricted to a fixed depth of field. If we look at a familiar face in bright sunlight, we usually do not see the harsh shadows cast by the sun. We accommodate them. The camera and film do not accommodate; they record the contrast and the result can be a picture with harsh, ugly shadows. The photographer must learn to see such effects and make the appropriate compensations, such as using a reflector or flash to cast more light into the dark areas.

Most of what we call "seeing" is done with the mind. During the course of day-to-day seeing, how we expect things to look is often more important to us than how things actually appear. For example, one may *know* a favorite girl is quite pretty and *see* her as such under lighting conditions that in fact make her appear unattractive.

Another element of psychological perception is *size constancy*. When we see two persons at different distances from the eye, we tend to see them as though they were both of normal height. The camera would record the more distant person as smaller. A similar effect occurs with objects. Through experience we

know that a more distant object is supposed to be larger; by relating it to other known objects in the environment, we come to a determination about its size. In a similar way, we come to determinations about distance by comparing size differences between known objects as seen at various distances. Scale indicators help prevent ambiguity about depth relationships. Their inclusion in a photograph allows the viewer to go through the usual process of interpretation, thus enhancing the illusion of reality.

Shape constancy refers to the way we see familiar shapes as undistorted, regardless of our position or angle of view. When we look down at a normal child, we do not see an enormous head perched upon a body that rapidly recedes to disproportionately tiny feet. We know what the child ought to look like; the visual perception does not accommodate distortion through diminution. If we photograph the child from this position, the camera will record just what was mentioned above, yielding an image that appears distorted. When we look at a friend from a distance of five to eight feet or so and see a handsomely proportioned face, the fact that at two feet his nose actually looks enormous in comparison to his ears is not seen. But the camera sees it. Shape constancy shows up in other ways, such as when you look at a saucer obliquely and see it as round, even though when photographed it would appear as an ellipse. Recorded *shape fidelity* may be achieved by increasing the distance between lens and subject while using a lens in the intermediate long range for image magnification—85mm through 135mm.

Color Perception

The perception of color is a subjective reaction of the eye-mind complex to the stimulus of various wavelengths of radiant energy. Here, as in other areas of visual perception, we tend to see mainly what we think we see.

The mind-eye perception of the color of grass may depend on what the viewer thinks grass ought to look like. Grass illuminated by the slanting golden sunlight of a late summer afternoon appears to have a greenish-golden hue to careful observers; a less experienced observer may simply think "grass" and see green. Furthermore, some films are capable of recording this greenish-golden hue faithfully—or reasonably so—and others are not. Obviously, a photographer who sees the grass simply as green will want a film that renders it as such if he wants "true" color rendition. Another photographer might prefer a film that will record the colors he saw. Neither is right or wrong.

Similarity of experience is an important factor in coming to agreements about accurate color renditions, and it can be very important in professional photography where one is obliged to produce results that will please a client. For example, in making a color portrait of a person, you can lighten or darken the individual's complexion simply by changing the exposure. Normally, a standard exposure will produce an image that is pleasing to most persons, but by no means to all. Some persons habitually see themselves as lighter or darker than the image provided by a standard exposure. Hence, bracketing exposures in color photography is more than insurance against under- and overexposure; it is a practical means of compensating for the highly subjective nature of color perception.

These observations are variations on the phenomenon of *color constancy;* that is, we tend to perceive colors as being the same, regardless of the quality of illumination. A complex network of nerves, linked to the rods and cones in the eye, allows us to make color conversions subconsciously without the aid of conversion or light balancing filters. Un-

13

less we deliberately short circuit this automatic process, we will tend to see familiar colored objects as having a constant color, especially lighter objects, under daylight, fluorescent, or tungsten illumination, notwithstanding measurable differences in outcomes.

Other attributes of color perception have subtle implications for composition. The lenses you use are color corrected so that various wavelengths of light are all brought to a focus in the same plane, but this does not pertain to the eye. The eye rapidly shifts focus to compensate for different colors; what the individual normally perceives as being a continuous perception is actually a collage of multiple perceptions. Colors such as red and blue can not be viewed simultaneously; the eye must refocus to accommodate each color. Hence, brilliant red and blue areas adjacent to one another appear to vibrate along their mutual edges. This vibration is due to the rapid refocusing of the eye as the viewer tries to perceive the line formed by the conjunction of red and blue.

The color saturation of an object is partly determined by the sharpness of the boundaries of the object. Sharply focused parts of an image often appear more highly saturated in color; colors in an out-of-focus image are often perceived as softer, less saturated, and more luminous. Therefore, control over sharpness in depth affords some control over the impression of color seen by the viewer of a print or transparency.

Intended Use

Although some subjects are so interesting that they are worth photographing simply for themselves, the successful photographer usually must have some idea of what he intends to do with his pictures once he has them.

As a photographer begins to develop his abilities, he strives for technical perfection, but this is only an intermediate step, a means to an end. We need to know why and to whom we are communicating. The reasons for taking pictures range all the way from record-keeping through reportage to pictorialism and the intent to produce an aesthetic response in the viewer. The kind and amount of technique required varies with the intent. For record pictures, the minimum standards are usually sharpness and clarity of important details. On the other hand, to achieve pictorial impact, the photographer must be able to see photographically in terms of the individual reactions of selective viewers or the mixed reactions of a heterogeneous body of viewers.

Many photographers are discouraged when pictures for which they have a special fondness are received indifferently by others. It is well to remember then that a visually sophisticated picture is best appreciated by someone with an equal level of visual awareness. This awareness is developed by taking pictures and studying and talking about pictures. Books and periodicals, camera clubs, training programs such as the Nikon School, and interactions with fellow photographers are important media of learning.

Slide show presentations, camera club discussions and competitions and, for the professional, acceptance by clients, are all part of the learning process. A photograph is made to be viewed; it is not complete until it has been presented to its intended audience.

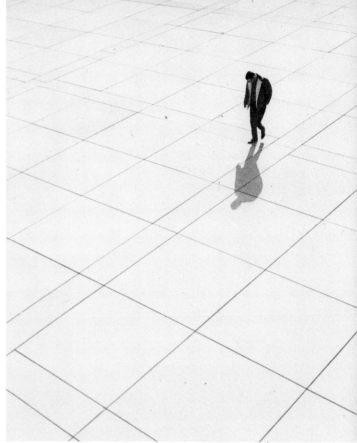

Perception of depth is influenced mainly by convergence causing parallel lines to come together in the distance and objects to diminish in size. Light and shade contribute also to perception of depth. Convergence here is moderated somewhat by high viewpoint. Place finger over shadow and note how 3-dimensional effect is lost. Hoferichter waited one hour for just the right person to come along in the right place. 28mm lens, Kodak Plus-X.

N. R. Hoferichter

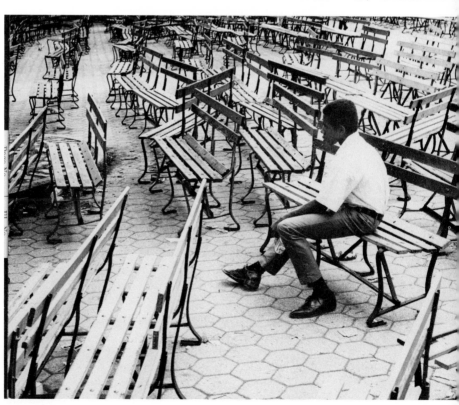

Convergence of irregularly positioned park benches terminates in jumbled confusion, thereby adding to the intended effect. The crowd had left, and this one man had remained; early morning, New York, 28mm lens, Ilford FP4.

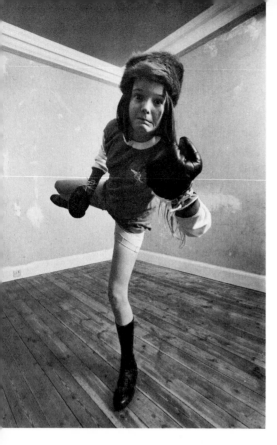

Graham Finlayson

Distortion due to closeness of lens to subjects. Extreme wide-angle 20mm f/3.5 lens combines wide-scene coverage with ability to work close to subject. Comparison shot below right, also with 20mm, shows limbs all at same distance from lens. In picture below left, 28mm lens presents less distortion due to slight change in working distance, but note that bottom limbs of both figures show size distortion. Ilford FP4, one main flash bounced off large reflector panel to right with secondary flash bounced off ceiling to left to fill shadows. f/8.

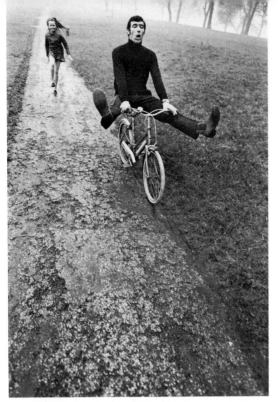

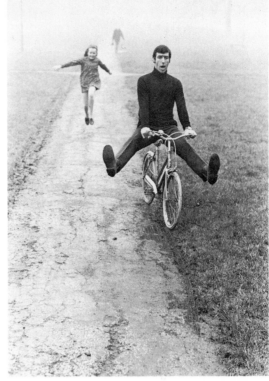

Graham Finlayson

Perspective effects achieved with same subject and lenses of different focal length. Top left, 20mm imputes a "rushing" perspective due to extreme rate of convergence of path. Adjacent picture shows much milder perspective with 35mm lens. Below left, 50mm yields natural perspective and diminished emphasis on foreground. Bottom right, with 85mm lens, takes this stage a bit further throwing main emphasis on the two figures.

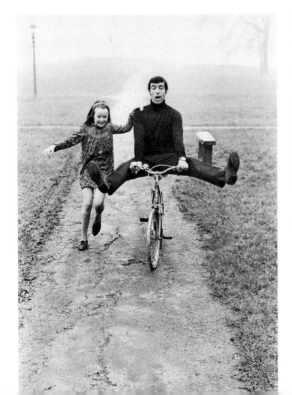

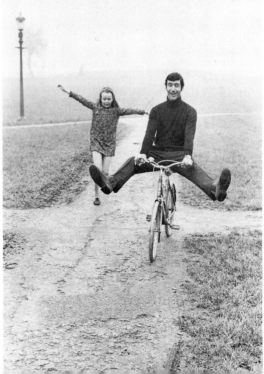

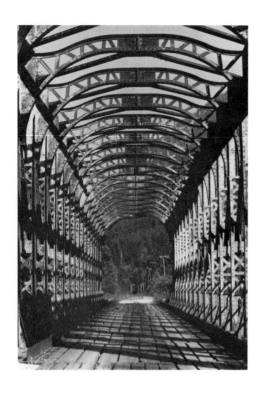

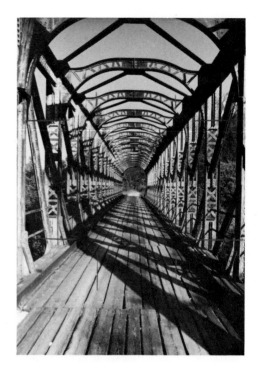

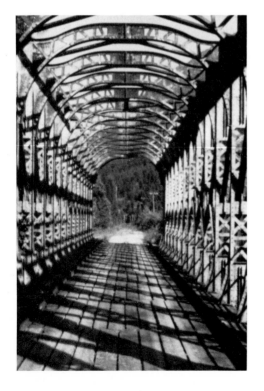

Joseph D. Cooper

Wide-angle lenses used close cause a stretching out of foreground objects, but effects diminish with distance of objects from lens. Upper left, 80–200mm zoom lens; note perspective effects when working at distance from subject—parallel steel girders and shadows on floorboards retain ordinary perspective effects except that moderate telephoto magnification brings out background compression. Upper right, 24mm lens at beginning of bridge for same front width coverage; note distortion effects of front shadows and steel girders. Picture below magnifies central area of upper right to show that perspective rendition tends to become comparable with increased distance of subject regardless of lens used.

Joseph D. Cooper

Effect of light on perception of depth. At left, camera axis was nearly in line with sun's direction, creating almost shadowless flat effect. Comparison photo, with camera position moved to left, pulls masonry block away from wall and renders 3-dimensional effect. 105mm lens, Kodak Tri-X Pan.

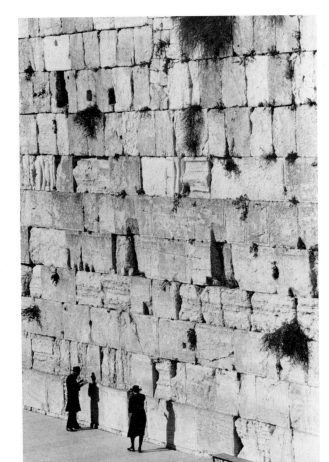

Anne B. Reinstein

The Wailing Wall in Jerusalem. Brilliant sun at angle to camera axis causes deep shadows to be cast rendering depth to wall structure. Nikkormat FT, 135mm f/3.5 lens, 1/125 sec., Kodak Tri-X Pan.

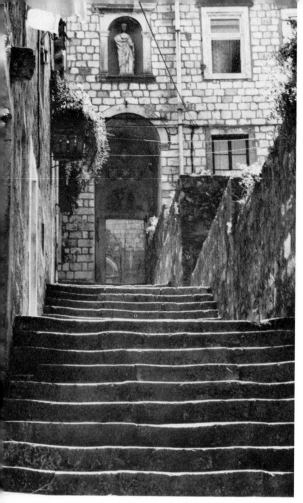

Joseph D. Cooper

Depth and 3-dimensional character of steps rendered by overhead sun, slightly forward of lens. At extreme left of steps, note that depth is lost in areas not touched by sunlight. 80–200 Zoom at 80mm brought out slightest compression leading into background. Low shooting position chosen to achieve narrow highlights on tops of steps. Dubrovnik, Yugoslavia. Ilford FP4.

Alfred Gregory

If you cover the boy sitting on the steps, the perception of depth disappears entirely. The angle of the sun, casting no shadows on the steps, causes them to appear to be a solid wall rising above the woman. Cuzco, Peru. 105mm lens, f/11, 1/125 sec. Kodak Plus-X Pan.

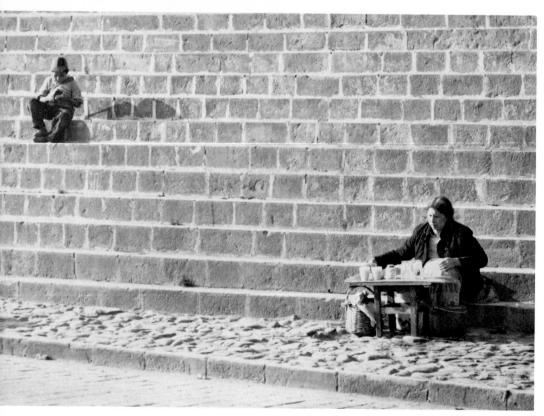

John Minihan

London, obviously. Foreground figure pulled out for emphasis through use of 28mm lens at close range. f/5.6, 1/125 sec.

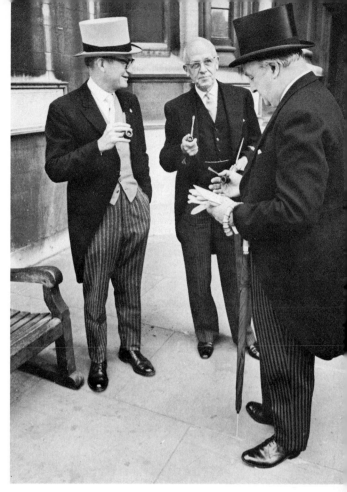

Peter Millan

Depth is indicated by dark foreground object. Deep water reflections caused by low sun; water texture rendered by sun in front of camera. Dawn. 55mm lens.

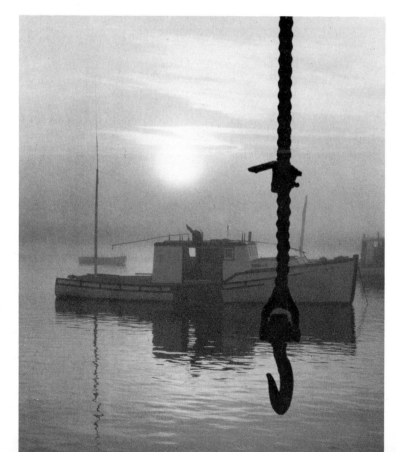

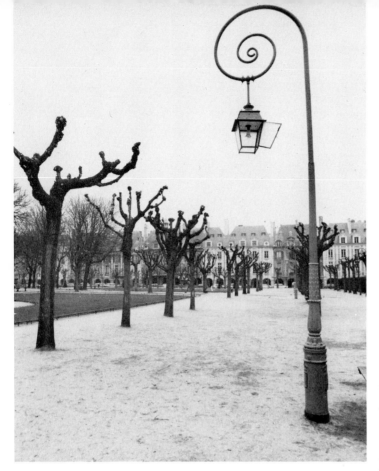

Joseph D. Cooper

Top, 24mm lens with camera positioned so that lamppost (Place des Vosges, Paris) would fill image frame vertically. Bottom, 105mm lens at greater distance from lamppost so that again it would just about fill the image frame. The differences: 24mm lens puts emphasis on foreground while 105mm used at greater distance appears to compress distance between lamppost and background. Physical outline of lamppost in bottom picture appears correctly rendered as compared to lampposts further beyond, but one made with 24mm lens shows elongation at top and bottom. Wide-angle picture taken close in enables you to see underneath the lamp while with 105mm lens lamp is viewed almost head on. Wide-angle picture encompasses more detail in background in diminished scale. Telephoto picture pulls in limited part of background, greater magnification. Rate of convergence is "fast" with wide-angle lens; with telephoto it is "slowed" down. Central group of trees in front of building has same size and perspective characteristics in both pictures.

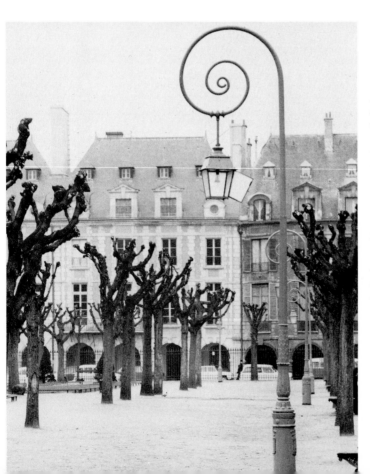

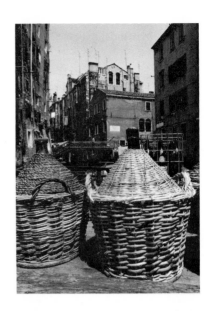

Joseph D. Cooper

Wide-angle lenses—particularly 20, 24, and 28mm—can be used to hold backgrounds fairly constant in size while altering size of foreground objects through slight changes in distance from camera. In this group, made with 24mm lens, assume the leading building in background is 300 feet away. Then, assume that closest wine cask in top picture is about 4 feet away from lens. If you move 2 feet closer, the wine cask is doubled in size with diminished coverage in foreground; background building would be increased 2/300ths or so little as hardly to be noticed. Details in closer building at left constituting middle ground vary a little more noticeably in size. Reproduced from Kodachrome originals.

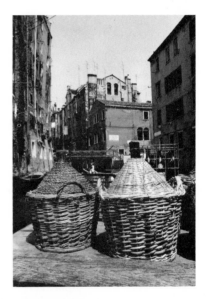

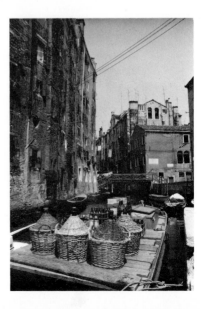

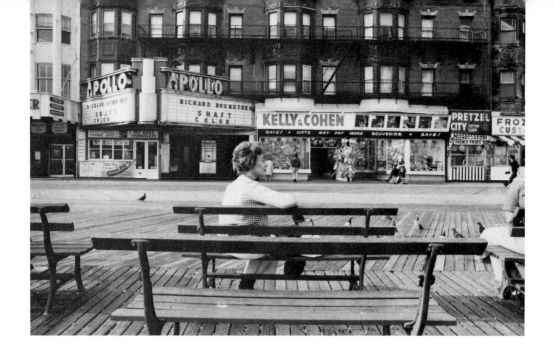

Joseph D. Cooper

Front bench and seated subject recorded approximately same size by changing shooting distances with lenses of different focal lengths. Top, camera positioned behind second bench using 24mm lens. Note sweep and scale of image details in background and foreground separation from boardwalk and shops. Bottom, 80mm focal length of 80–200mm Zoom-Nikkor; foreground, middle ground, and background merge into one. Camera positioned somewhere behind eighth bench. Convergence and separation of first two benches nearest shops are limited. Background magnified and more selective in coverage.

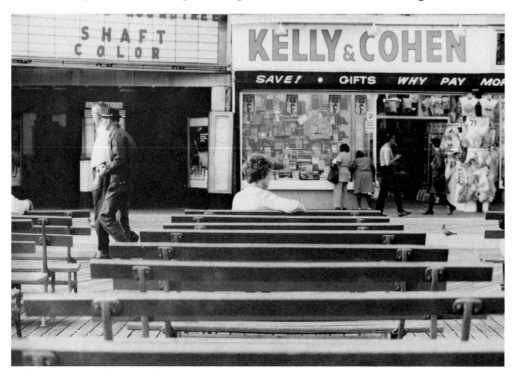

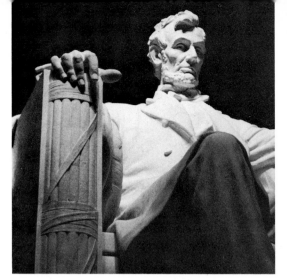 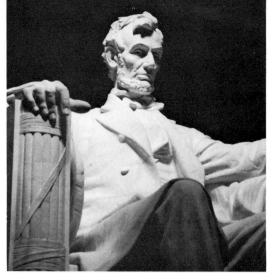

Joseph D. Cooper

For architectural subjects, tall monuments, and other high-positioned subjects, convergence effects are obtained when working close and having to tilt camera upward. One solution is to back away, using lens of longer focal length to eliminate or minimize angle of tilt. Another solution is to use PC-Nikkor. Note upward convergence with shorter focal lengths while more normal view was achieved by backing away and using longer lenses. Lincoln Memorial pair included 24mm and 105mm lenses. To overcome tilt effects in photographing patriarch at Dubrovnik, 80–200mm Zoom-Nikkor was used at distance and focal length that would fill frame while rendering sides of sepulchre nearly parallel. Note differences in head rendition.

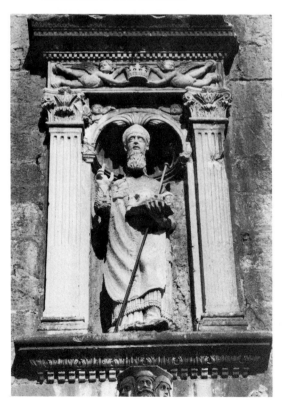 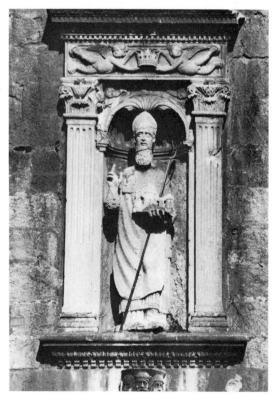

Joseph D. Cooper

To record top of tower with minimum of tilt and convergence, 80–200mm Zoom-Nikkor used at maximum focal length at distance that would fill frame.

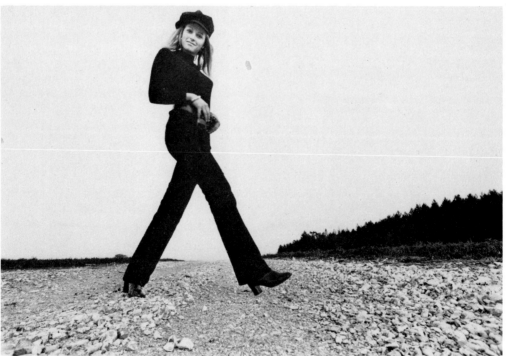

Graham Finlayson

Combination of extreme wide-angle 20mm lens and low shooting angle near ground without camera tilt yields maximum "wide-open spaces" effect. Ilford FP4. Model is Pia Walker, once Miss Norway, subsequently a dedicated teacher.

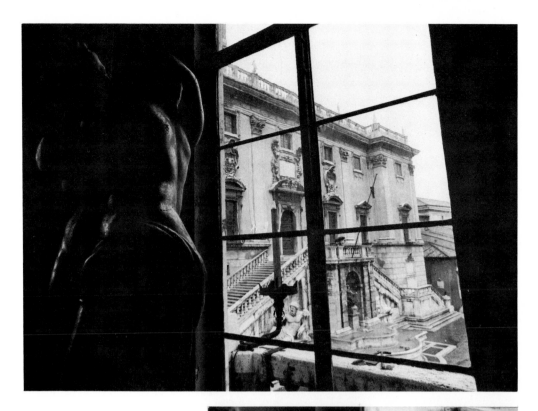

Francisco Hidalgo

View from window of Capitoline Museum. Picture above made with 20mm lens at f/5.6, 1/30 sec. shows extraordinary depth of field from interior figures to outdoor structures. In picture at right, 43–86mm Zoom-Nikkor was used at or near 86mm end, also at f/5.6, 1/30 sec.; here, depth of field is limited due to longer focal length employed, so selective focusing is used to place sharpness zone outdoors. Distortion of outdoor details in side picture is due to irregular refractions of window panes magnified by longer focal length.

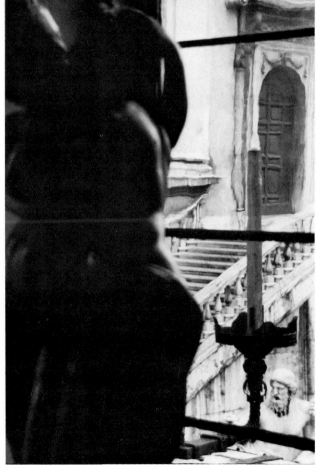

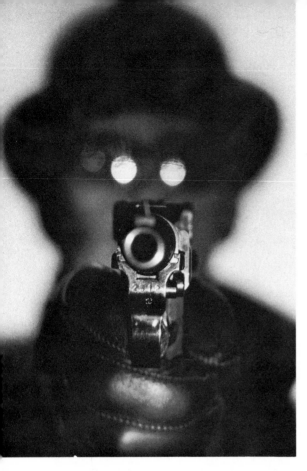

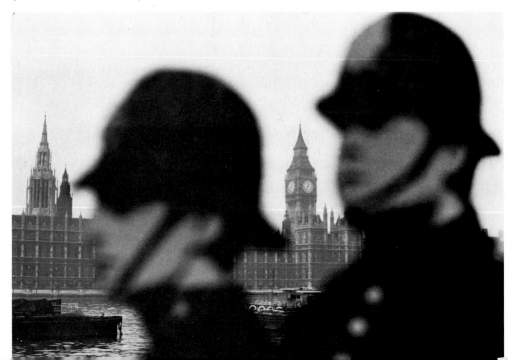

Bill Goldstein

Wire in glass door of telephone booth sharply focused while figure outside rendered more fuzzy than normal due to interference by glass. Nikkormat FTN, 50mm $f/2$ lens, Kodak Plus-X Pan.

Creative use of out-of-focus reflections from eyeglasses. Limited sharpness zone due to use of telephoto lens, 105mm $f/2.5$, at close range and full aperture. 1/30 sec., Kodak Plus-X Pan.

Francisco Hidalgo

Creative use of out-of-focus foreground figures to frame Big Ben in background. 43–86mm $f/3.5$ Zoom-Nikkor wide open, 1/125 sec. Kodak Plus-X Pan.

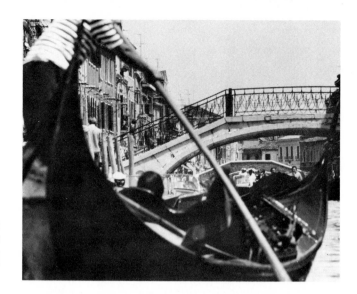

Curvature of gondola extended into figure of gondolier serves as natural framing device. Venice. Standard 50mm f/1.4 lens.

Joseph D. Cooper

Fence serves as framing aid through which to break up separate scene components. 50mm lens.

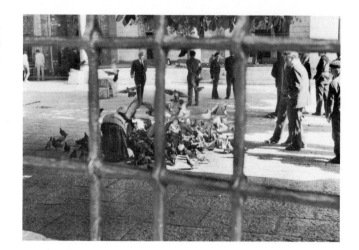

Raghu Rai

Summertime in Delhi. The foreground objects frame and lend perspective to the background. 28mm f/3.5 lens, 1/250 sec. f/11, Kodak Tri-X Pan.

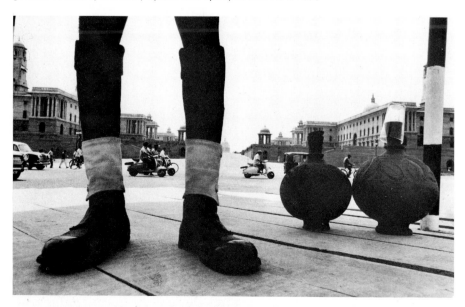

29

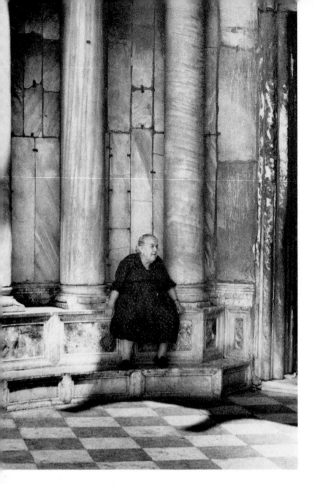

Joseph D. Cooper

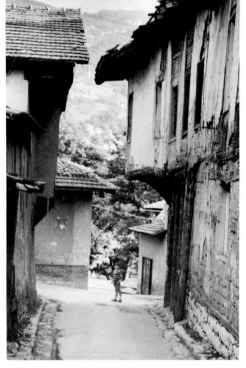

Framing ties together or puts outer limits on scene in which a small object of interest might seem lost. In many cases, though, small objects are effectively set off in contrast with a coherent mass. Two upper pictures, 80–200mm Zoom-Nikkor used for precise composition as well as shooting convenience. Bottom picture breaks ordinary rules of composition with center horizon line but tree and dominant foreground shadow are primary. 105mm ƒ/11, 1/125 sec., reproduced from Kodachrome-X. Bottom right courtesy of Nikon School.

John D. Slack

Joseph D. Cooper

View from hotel window at Grand Canal, Venice. Upper picture focused on outdoor scene with 80mm focal length of 80–200mm Zoom-Nikkor; part of scalloped window frames subject, but window remains out-of-focus— perhaps desirably. Second picture of same scene made closer to window with 24mm lens f/8–f/11. In this case, blurred window-opening outlines would have been distracting.

Graham Finlayson

Otherwise barren scene given depth and form by framing from abandoned building. From book, *Just a Few Lines*, about derelict rail-roads. 35mm f/2 lens, f/8 at 1/30–1/60 sec., Ilford FP4.

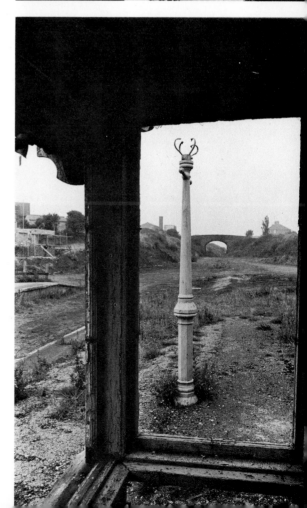

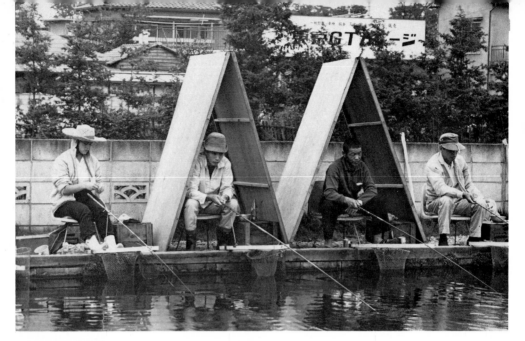

Suzanne G. Hill

Fishing in Tokyo. Symmetry is one approach to composition, but may not always be interesting. When single element breaks pattern—the lone woman—it may add human interest factor. 135mm lens.

John Minihan

Law and Holy Order. Rhythmic or repetitive factor provided by sisters of the cloth while the incongruity factor is introduced by the London bobby who represents a different type of temporal order. The picture was preconceived and posed. 28mm lens, at f/5.6, 1/250 sec.

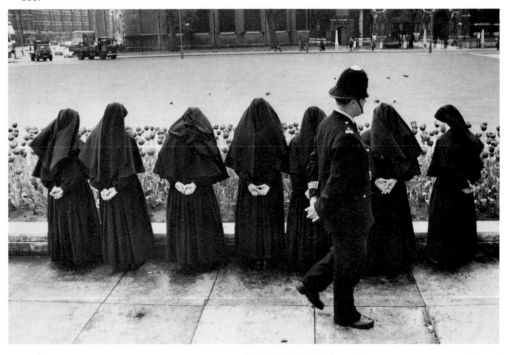

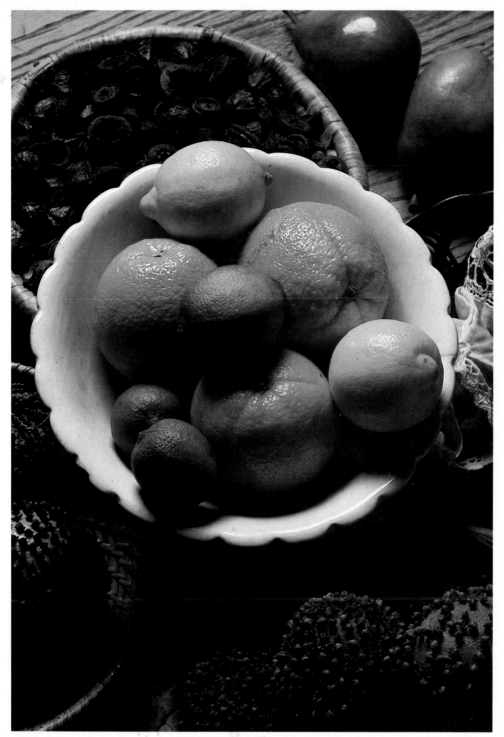

Tom Tracy

A broad brightness range, such as the contrast between the dark nutshells in the background, the bright yellow of the lemons, and the white bowl, presents problems of exposure and color saturation. The photographer chose to expose here for the highlight areas, thereby losing some detail in the shadows.

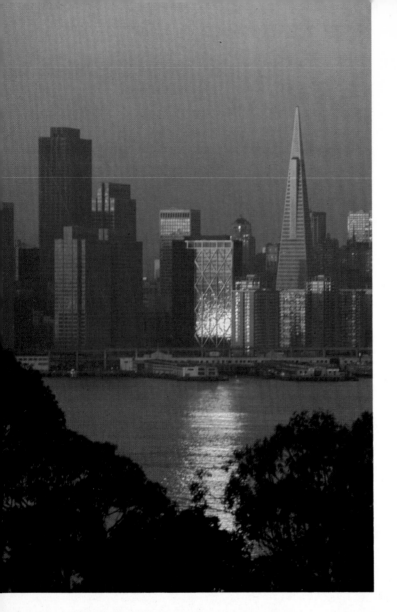

Tom Tracy

Natural lighting at different times of day can provide vastly different effects. (Left) The reflection of a sunset on the glass facade of one of the buildings on San Francisco's skyline provides a bright center of interest in the blueing dusk. (Below left) Sunrise over the Grand Canyon provides a raking, light that brings out the natural textures of the rock formations. (Below right) A time exposure produced this beautifully detailed photograph of the brightly lighted buildings of Parliament, taken by late twilight.

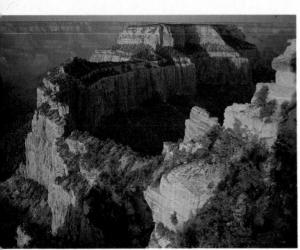

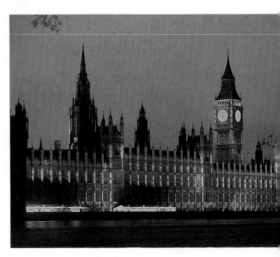

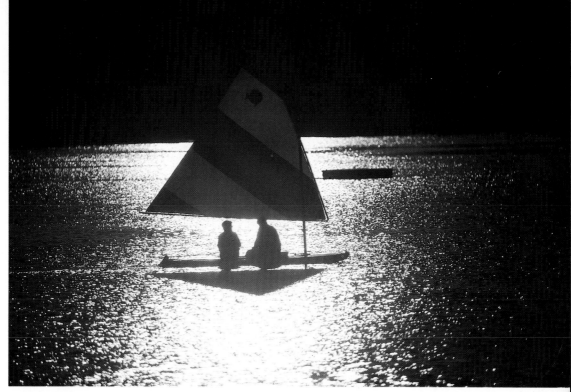

Michael Melford

(Above) Backlighting always presents exposure problems. If the subject lends itself to a silhouette effect, as this sailboat does, the result can be unusual and quite dramatic. (Below) It is possible to take excellent pictures by available light if all light sources in the area are properly utilized. While the highlights on the little girl's hair were produced by an overhead light fixture, the overall softness of the lighting is an effect frequently obtained by window light.

Tom Tracy

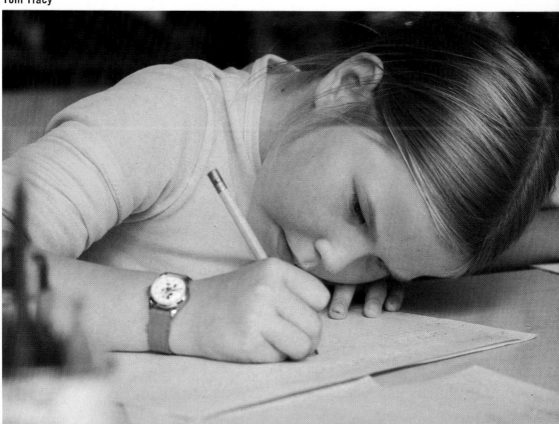

Michael Melford

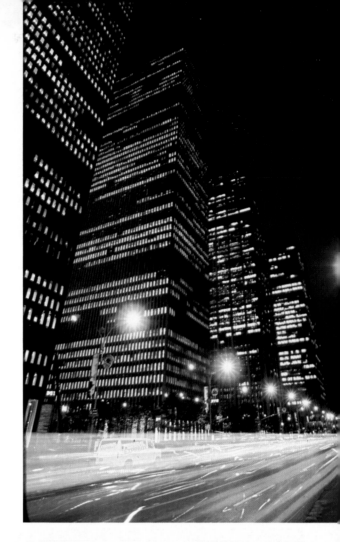

Long time exposures at night are frequently characterized by streaks of colored lights representing moving traffic and large star-like spots of light from streetlamps. Such photographs require tripod-mounted cameras to avoid the effect of movement in stationary objects like buildings. (Below) Strong sidelighting illuminated the striations in the enormous ship's propeller blade in the foreground, while other detail is lost in shadow. Note how the lighting was arranged to place the workman's red hardhat within the area of greatest brightness, adding a colorful center of interest to an otherwise monochrome composition.

Tom Tracy

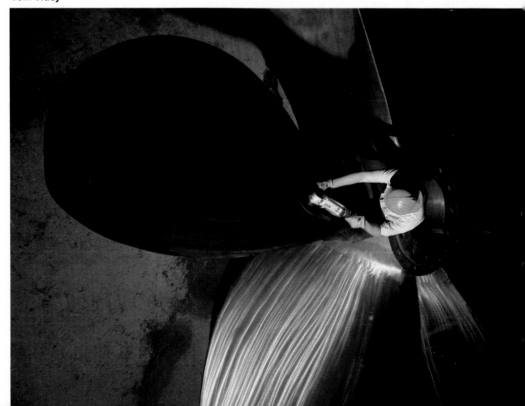

Roelf Backus & Harry Andriessen

Among the infinite rules of composition, one is that centers of interest should be positioned off-center, but not very much so. Above, suggestion of something beyond path balances with couple to right of picture. 135mm lens at *f*/5.6, 1/15 sec. on tripod. Compare with inset picture, subject centered but leading nowhere. 24mm lens at *f*/5.6, 1/15 sec. on tripod.

John D. Slack

Model Pam Ascanio has uncluttered background in picture at left. Comparison at right, originally color, has distracting, brightly-colored figures in background. Normal daylight exposure *f*/8–*f*/11, 1/250 sec. Nikon School.

<div align="right">**John D. Slack**</div>

These two pictures, originally in color, demonstrated that slight underexposure yields better color saturation with some loss of detail. Comparison shows better unity when members of a group face each other or toward center of common interest. 105mm lens at f/11, 1/250 sec. Nikon School.

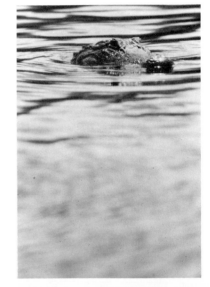

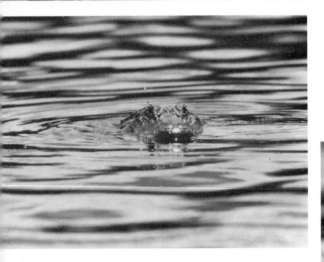

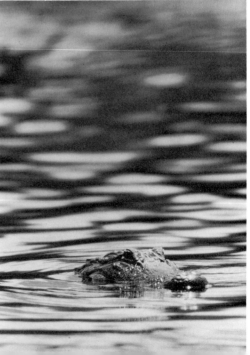

Centering the subject is wrong. Choice is between upper and lower thirds. Lower-third position is best, for the eye has somewhere to go into receding water texture beyond. 600mm lens, f/8, 1/500 sec., originally Kodachrome-X. Nikon School.

34

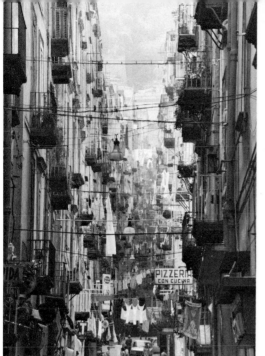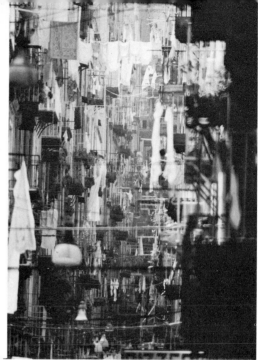

Joseph D. Cooper

Outdoor laundries and aerial perspective above Naples street. View at left made with 200mm lens shows much of foreground clearly delineated, but background is gray and misty, taking on unsharp character having nothing to do with sharpness of lens. Loss of sharpness in the distance becomes more evident, at right, with 500mm f/8 Reflex-Nikkor.

Raghu Rai

Two examples of details contrasted with or supported by mass. The notion of a single center of interest is displaced, at left, by the parallelism between top and bottom. Left, 85mm f/11 1/250 sec.; right, Nikkormat FT 55mm Micro-Nikkor f/8 1/125 sec.

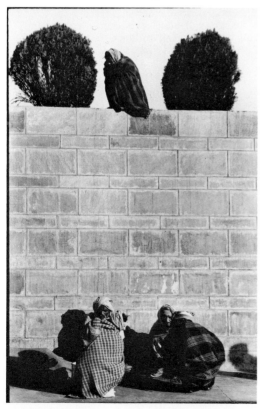

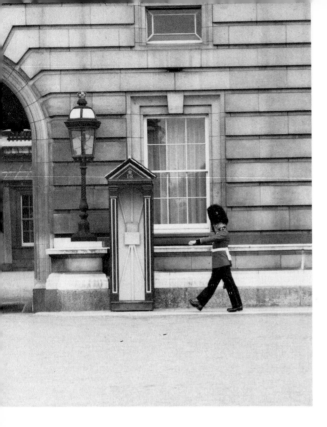

Joseph C. Abbott

Exercise in geometrics at Buckingham Palace, London. Nikkormat FTN, 135mm f/2.8 lens.

Francisco Hidalgo

The Brooklyn Bridge, New York, against a background of Manhattan skyscrapers. Intersecting lines for dynamic effect. Depth indicated through aerial perspective which refers to perception of more distant objects through greater veiling by dust, mist, and other particulate matter. 200mm f/4 lens, f/8, 1/125 sec. Plus-X Pan.

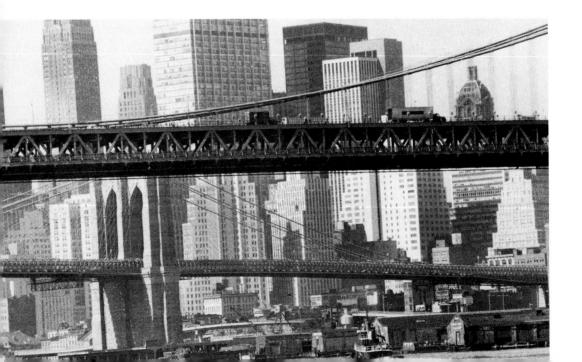

SHARPNESS IN DEPTH

When the photographer selects a shooting aperture, he makes an important decision concerning depth of field. Here depth will be dealt with in terms of sharpness as a matter of control.

The standard for depth-of-field tables that appear in this book is an 8″ × 10″ print seen at a minimum distance of 10 inches, which is about as close as we can get to a subject and still scan it comfortably. If we were to make a very large blow-up of a print that appeared sharp under normal viewing conditions, and view a portion of it from a distance of 10 inches, apparent sharpness would be lost. For equivalent depth, the blow-up would have to be seen at a greater viewing distance. Mathematical formulas that specify viewing conditions for any given depth of field can be used, but since these conditions are seldom met in actuality, the photographer need not concern himself with them.

Theoretically, a lens focuses on one plane only. Anything in front of or behind that plane is somewhat blurred, depending on the focal length of the lens and the distance to which the lens is focused. Within limits, the resolving power of the eye is such that it can not detect this blur. Apparent sharpness in depth exists solely because of this limitation. As soon as the eye can see the blur, the image appears out of focus.

This does not take into account another property of the eye called *vernier acuity,* which is the ability of the eye to match up lines. It has pertinence for low contrast subjects and those that do not offer clearly defined edges. The effect is increased by flat, diffuse lighting and partially remedied by the use of contrasting light. Some subjects are inherently unsharp. Furry animals fall in this category. This explains why many photographers find it difficult to get satisfactory shots of their pets. In addition to the use of controlled lighting, a simple, uncluttered background may provide either brightness or color contrast.

Increasing Depth

Frequently we hear it said that the wider the angle of view of a lens, the greater the depth of field. There is some truth to this, but it is by no means the whole story. Any change that *reduces* image size will increase depth of field. During picture taking, this can be accomplished by maintaining camera-to-subject distance and using a wider-angle lens or by stepping back and putting more distance between camera and subject. You can also use a smaller f/stop to increase depth (with correspondingly slower shutter speed to maintain equivalent exposure). When you shoot color slides, which are normally viewed in sequence at the same degree of enlargement, these are the only controls available.

With prints, both absolute sharpness and apparent depth of field will depend on size of print and viewing distance—all else being equal. Most prints are viewed in hand at a distance of 10-15 inches regardless of the print size or original camera-to-subject distance, both of which should be considered in deciding the best viewing distance. A small print will exhibit more overall sharpness and greater depth than a larger print from the same original. The greater sharpness is due to narrowing, scaling down, or diminution of image details, contours, and lines. Hence, a poorly focused picture should always be shown smaller. Depth of field increases for the same reason.

Now let us take a situation in which a subject or scene is photographed at the same distance with both a wide-angle lens and a longer lens. When prints of

the same size are made, the one made with the wide-angle lens will show smaller and sharper details than the other. If, however, the wide-angle print is enlarged so that details are of the same size as those recorded with the longer lens, depth of field will still be greater in the print made with the wide-angle lens. Some overall sharpness of image details may be lost, however, with any substantial enlargement.

If we select a lens of shorter focal length and then try to maintain image size by moving the camera closer to the object, there is no increase in depth of field for that object because there is no change in the image ratio (also known as the ratio of reproduction). There will, however, be an increase in depth for middle ground and background objects beyond.

Working in the other direction, negatives made for producing large-size display prints, which may be viewed at closer than recommended distances, require that perceptions of sharpness, influenced by greater depth of field, lighting contrast, and tonal contrast, be taken into account when the picture is taken. For big picture outcomes, one technique is to use at least one f/stop smaller than that indicated as adequate on the depth-of-field scale. Depending on lighting conditions, this may require using a faster film to maintain a sufficiently high shutter speed.

When you focus on middle ground, depth of field extends farther beyond the distance focused on than in front—about one-third in front, two-thirds beyond. To get two subjects within the range of sharpness, focus between the two at a point about one-third of the way from the nearer subject. This method is sometimes useful when there is not sufficient time to ensure that the distance to each subject is included within the depth-of-field brackets on the lens. A quick check can be made using the depth-of-field preview button. This rule does not apply at very close focusing distances.

Selective Focus

A photographer who exercises effective image control will often manipulate his depth of field so that some portions of the field are sharp and others blurred. This technique is called *differential* or *selective focusing* and involves selecting an f/stop and shutter-speed combination with deliberate manipulation of the plane of sharpest focus. The simplest technique is to focus on the subject and use a small aperture for extended depth or a very large aperture to throw some of the field out of focus.

In general, an out-of-focus background is more pleasing than a blurred background, which tends to be distracting. In portraiture, a wide aperture is often used to throw distracting background details out of focus and provide a contrast in sharpness, which tends to place attention on the subject. When working very close to the subject, or when magnifying images with long lenses, depth of field becomes razor thin. Special care must then be taken to place accurately the plane of sharpest focus. In close-up and macro work, a plane of sharpness should be selected that corresponds to either the most important or the most visually interesting detail.

A variation of this technique is to keep the subject within the zone of sharpness but not to focus on the subject principally. To do this, find the distance at which the subject is in sharp focus and then turn the focusing ring, moving the plane of sharpest focus toward or away from the camera, while keeping the distance to the subject within the depth range indicated by aperture brackets on the lens. A rough approximation can also be made using the depth-of-field preview button.

COMPOSITION

The subject of composition has fascinated thoughtful and aware people throughout the ages. The result has been the promulgation of countless theories, some designed to explain after the fact why certain works of art are pleasing, others designed to help artists and photographers to order and organize the various elements of their work as a matter of pre-visualization. The term *composition* means the technique or process of organizing the various elements of the image on the picture plane. In previous sections composition has been discussed in terms of depth, the treatment of the zones of recession (foreground, middle ground, and background), and the interrelationships among elements of the subject within these zones. Here we are concerned with the geometric ordering of line, shape, tone, color, and mass within the pictorial frame.

The principles discussed below are meant to serve only as guidelines that may or may not be useful, depending on the photographer's motivation and experience. There are no fixed rules that, if violated, will doom a picture to failure. On the other hand, some pictures are unquestionably more successful than others, and, although good organization is no substitute for interesting subject matter, a photograph that is a hodgepodge of disparate elements is usually not worth taking. In fact, the only excuse for not composing a picture is when a shot must be taken "on the wing," as sometimes happens in photojournalism when there is barely time to point the camera in the general direction of the subject before pressing the shutter.

Simplification

One common means of composing a picture is to reduce the number of elements within the frame to as few as possible in order to impose unity on the subject. The following techniques are useful in simplifying a subject:

1. Fill the frame with the subject by working close or using a long lens.

2. Crop tightly to eliminate distracting elements surrounding the object. This can be accomplished during picture taking by selecting the appropriate lens, camera position, and framing of subject in the viewfinder. A zoom lens is especially suitable because it allows the photographer to crop without changing his position. If you use negative film, cropping can also be done when the picture is printed.

3. Use simple backgrounds and control their tone, when possible, through lighting to achieve desirable contrast with the subject.

4. Focus selectively so that unwanted elements are blurred into simple masses of tone or color.

5. Find or arrange scenes, when shooting color, that exhibit a limited range of colors. A few simple masses of color are generally more effective than a rainbow of hues, which can be confusing.

6. Avoid tone mergers by choosing a camera positon that places the object within a contrasting field.

Dynamics of the Pictorial Frame

The boundary or limits of the frame in 35mm photography is a rectangle of 24×36mm. The rectangle itself is a fairly dynamic shape that can be used either vertically, for an increased sense of action, or horizontally, for an increased sense of repose.

Most of the images we see around us, from billboards to cinema and television, are structured within a horizontal format. This often influences photographers to compose within a horizontal frame.

However, the highly maneuverable 35mm camera allows you to compose vertically as well. It allows you to impose limits at the time the picture is taken that will influence the pictorial impact of the finished photograph. In fact, for most pictures, the limits of the frame are the limits of the final picture. Cropping after the picture is taken requires an extra step in the darkroom, editorial office, or slide-making process that only should be taken when necessary.

One way of handling composition is to consider the elements of the picture as they relate to the pictorial frame. The following factors should be taken into account:

1. The closer a complete shape is to the edge of the picture, the more the visual tension between the edge and the shape. The mind-eye seeks both an interest center and boundaries of the picture.

2. Incomplete shapes, cut off by the edges of the picture, lead the eye out of the frame and create unresolved questions. Occasionally, incomplete shapes at the edges add interest, but more commonly they create a visual confusion that should be avoided.

3. Clearly defined complete shapes near the edge of the picture act as anchor points, stopping and—depending on the configuration—directing the scanning motions of the eye.

4. Horizontal shapes suggest repose; vertical shapes, activity. Landscapes are often suitable for horizontal framing. Action sports shots frequently come off better when framed vertically.

5. The apparent direction of motion should normally lead into rather than out of the frame. The strongest movement is suggested along an oblique line that runs from one of the upper corner segments of the picture downward toward the opposite corner.

6. When a subject is obviously looking in a particular direction, the eye will tend to follow the subject's glance in an unconscious effort to determine "what's so interesting?" Allow for this reaction by putting something, either an object or space, between subject and frame. In portraiture, allow more space in the direction in which the subject is looking.

7. Avoid dead space, that is, space that has no pictorial function, by filling the frame with the subject. All of the techniques described under simplification are applicable here.

The frame is often used as a means of structuring the space within it into segments, which provide areas in which to place primary and secondary subjects. One practical process is to divide the frame horizontally and vertically into thirds and place major and secondary subjects at the inner intersections of the lines formed. Thus, all subjects are placed off center. This can be accomplished easily during picture taking.

The technique of thirds is a modification of the more exact method of dynamic composition. In this technique, diagonals are drawn from corner to corner of the rectangular frame. Then lines perpendicular to the diagonals are drawn, placed so that they bisect the corners. The four points at which perpendicular meets diagonal are considered good points at which to place the subject.

A related technique is to place a subject so that it divides a line, such as the horizon, into pleasing proportions. The "golden mean," considered harmonious since classical times, divides the line into proportions of about 1:1.62.

Precise mathematical placement of objects within the picture is generally inapplicable to modern 35mm photographic technique; however, the photographer who does his own darkroom work may occasionally find negatives that can be cropped in a way that places the various elements of the scene in exact relationships. Today, most pho-

tographers disregard such theories and concentrate on finding interesting and pleasing subject-field relationships.

Dynamic Integration of Pictorial Elements

Simplification is the first step in the development of a photographer's ability to compose. The next and most important step is acquiring the ability to integrate the various elements in the picture so that they form a unified and meaningful structure. To this end, the photographer can make use of such factors as contrast, leading lines, balance, color, and image tone to unify an image through the interplay of elements that direct attention, control the scanning movement of the eye, point toward centers of interest, and help produce various degrees of feeling in terms of activity and repose.

Leading lines are elements that direct the viewer's attention toward principal points of interest. A gracefully curving path or road or railroad tracks extending from the edge of the frame to an oncoming train may provide such a line. The furrows of a plowed field converging toward a single vanishing point also can be used. Lines are created also by patterns of masses or spots. If the indicators are strong enough, the viewer tends to fill in and feel the presence of lines, even where none are actually present. Such lines unify foreground and background, make two-dimensional patterns, and direct attention.

A similar effect occurs when a number of elements form points that, when connected, suggest a simple geometric shape such as a triangle, square, rectangle, curve, or circle. Such arrangements of elements make unified patterns that are strengthened when the picture is considered as a two-dimensional design on a flat surface and weakened when it is considered as a three-dimensional representation of reality. The resulting con-

figurations have been given various attributes by those who write on the subject. The triangle, for example, is often considered as feminine and stable when viewed with its base parallel to the horizon and unstable when seen with its apex balanced on a point. The square is thought to be stable, the vertical rectangle, active and masculine. This type of analysis is usually the result of social conditioning and is sometimes helpful to the photographer who is aware of the social and ethnic backgrounds of his intended audience and knows that his viewers will respond toward these configurations in the aforementioned ways.

Shapes are natural pathways that the eye may follow while scanning a picture. Regardless of subjective attributes such as sex and activity, they create an impression of unity. Points or masses that appear to form lines or shapes can be created by choosing an appropriate point of view and are an important means of emphasizing subjects and integrating a subject with its surrounding field.

Balance relates to kinesthetic perceptions. As we visually evaluate the world around us, we unconsciously make determinations about the weight of various objects. Without this ability, our method of lifting a glass to our lips would be quite different, as would our way of determining the amount of force needed to move any object at rest. When we view a photograph, we apply that same sense of weight to the elements within the pictorial frame, despite the fact that their actual weight is only that of a thin deposit of dye or silver on paper or light on a screen. Balance is a subjective phenomenon, an illusion that is evaluated by the mind as a reality.

A large, dark mass is perceived as having greater weight than a light mass; a mass closer to the bottom of the frame has less potential downward movement and is considered to have more inertia, thus making it heavier; a spot can balance a large contrasting area of tone or

color. If we imagine a fulcrum placed at the bottom edge of a photograph, balance is achieved when both sides of the photograph appear to have the same weight according to our subjective evaluation. Such balance creates a sense of unity, regardless of subject matter. An off-balance photograph is not necessarily bad, but it does lack the structural unity imposed by balance. Other factors may succeed in compensating for this lack, but they are difficult to achieve.

Color Composition

The principal difference between composing in black-and-white and in color is that, in black-and-white, pictorial elements are recognizable only because of variations in brightness or contrast. In color work, brightness contrast is only one of many types of contrast; others are hue, luminosity, warmth or coolness, and the degree of degradation or admixture with other colors.

The following is a short summary of some of the general principles of color composition that are most applicable to the practice of color photography.

1. Concentrate on large, simple masses of color that exhibit a limited range of hues. Do not try to include every color in the rainbow within the picture. Simplicity and harmony are the keys to good color composition.

2. Consider size relationships of various masses of color in terms of pictorial impact. Yellow and violet, for example, go well together, but yellow is very active, and it takes almost three times as much violet, in terms of area, to create a harmonious relationship between the two.

3. Crop to eliminate unwanted colors.

4. Use cool colors for background emphasis. These range from green through violet and appear to recede in space. The coolest color is a pure blue.

5. Use warm colors for foreground emphasis. These range from yellow through red. They appear to move forward in space.

6. Use small spots of highly saturated color for emphasis. Such a spot, if presented against a very light background, such as the daylight sky, will seem deeper or more saturated. The same spot of color seen against a dark, contrasting background can stand out brilliantly.

7. Use differently colored backgrounds to alter total impact. Subject colors diminish or increase in both apparent hue and luminosity, depending on the nature of surrounding colors. Black, white, or gray as a surrounding tone will alter the brightness of the color.

8. Consider color adjacency effects, accommodated by the mind-eye, but not by the film. When a neutral or impure color exists next to a pure color the impure color will be altered toward the pure color's complementary. Thus the gray dress of a girl photographed against a red background takes on a greenish cast. Be aware of colors reflected onto objects by things in the environment, which may or may not be included in the pictorial frame. Flash lighting bounced from a colored wall will create a color cast. In open shade, a blue sky can create a blue cast. Nearby buildings, sand, foliage, and other natural reflectors can affect the color of an object.

9. Use out-of-focus colors to draw attention to sharply defined color areas. Out-of-focus colors appear more luminous and lighter than the colors of objects in sharp focus. Panning with the action creates a blend of luminous background colors that can be quite effective, especially if the subject itself has a dark or highly saturated color.

10. Use filters and special films to control overall effects. Color compensating filters control overall color casts; light balancing filters change the spectral balance of the light source. For unusual effects, try a false-color system, such as that provided by infrared color films.

CHAPTER 2

Exposure Control

The essence of good exposure technique is to know when and how to depart from what the built-in exposure meter of the camera (or of an independent exposure meter) tells you is the correct exposure for a given situation. For the average run of pictures, the meter-governed exposure will yield satisfactory results. Exposure-metering systems are preprogrammed to read and interpret reflected light from a subject or scene in terms of scientifically recognized standards of light reflectance. When exposure readings are made of a series of panels or boards painted successively as white, light gray, medium gray, dark gray, and black under identical lighting conditions, each required exposure would be different yet each, when developed, would be rendered in the same middle-gray tone. This is due to the fact that the meter cannot tell the difference between a white or light gray surface under low illumination and a dark gray or black surface bathed in bright light. For the one, the meter says, "less exposure, please," while for the other it says, "more exposure, please."

In this example, if you want to represent a scene as a clean white—snow is a real world case in point—you would override the meter either by using a wider f/stop or a longer shutter speed or a combination of the two. On the other hand, if you want a dark scene to be rendered dark on film, you will have to cut back on the indicated exposure. I recall a picture I made at dusk of a harbor with the houses perched on the surrounding hills. I used the exposure indicated by my meter for this photograph. The result was a nicely exposed daytime scene; the only clue to the fact that it was taken in the early evening was the lights in the houses.

This is why the essence of good exposure is in learning how to override the meter or the automatic controls of a camera. There is much more to it than that: one needs to know how to manipulate camera controls, how to interpret the properties of light, how to use exposure meters to achieve desired effects, and how different kinds of films will respond to exposure.

Contrast ranges will be treated in the section on light characteristics, although it also impinges on film characteristics. Depending on the particular circumstances, the photographer may wish to make selective readings—the usual method—or he might want to override the indications of the meter.

This chapter will expand upon these topics. It will provide guidance on the use of the center-weighted meters of Nikon and Nikkormat cameras as well as independent exposure meters used for special purposes or when Nikon cameras are used without meter-coupled finders. The topic of "available (or existing) light" photography will be covered in the succeeding chapter on artificial lighting under the heading of Low-Light Level Techniques, inasmuch as the techniques are particularly relevant to artificial illumination. Of course, low light levels also are encountered without artificial illumination and these instances will be treated here as part of the discussion of light characteristics.

EXPOSURE TECHNIQUE IN BRIEF

The material discussed in this section will give an overall view of the subject, but will serve also as an introduction to other sections. The topical sequence is: (1) a summary of the characteristics of well-exposed film positives and negatives; (2) a summary of the basic elements of exposure to show their interrelatedness; (3) lens and shutter controls with particular attention to their reciprocal manipulation; (4) limits of reciprocity—conventionally referred to as reciprocity failure; and (5) a brief restatement of the essence of exposure strategy.

What Constitutes
Good Exposure?

The cardinal rule of good exposure is that the film should have discernible detail in both highlight and shadow areas. This is not always possible to attain when there is a wide range of subject brightness within the scene; if so, some compromises must be achieved. In a color transparency, the most important bright areas—such as skin texture in a portrait—should present well-defined details. If a bright or highlight area is overexposed it will have a characteristic washed-out appearance accompanied by a loss of good color saturation. On the other hand, shadow details should not be blocked out or lost from being recorded on the film. Inasmuch as some-thing must be sacrificed if the brighter areas of a photograph are to be rendered well, it is usually the shadow detail. This can be solved either by directing or reflecting light into shadow areas or by excluding them from the picture as much as possible. In an extremely overexposed color transparency, only the shadow details may be well rendered, when there is a wide range of contrast, but otherwise there will be a loss of color saturation throughout, a complete absence of highlight detail and even a loss of some of the more luminous shadow details that contribute to making an attractive transparency.

What constitutes good exposure is relative to pictorial expectations. If shadow details—as in making a picture of people in a shaded picnic area—are most important, the more brightly exposed areas can be sacrificed; the brighter areas will either be burned out or will be devoid of good color saturation, but the darker areas and the shadow details will come through quite pleasingly.

A moderately underexposed transparency is characterized by deep color saturation in the brighter areas and excellent rendition of details, but darker pictorial components are lacking in luminosity and detail. The overall effect can be either good or depressing in tone and mood depending upon spatial proportions of the middle and dark tones. If the well-saturated color areas

are pleasing in effect and occupy a relatively large proportion of picture area, the overall effect may be either satisfactory or highly successful. If the underexposed darker areas predominate, however, the overall effect will be unpleasant.

A badly underexposed transparency may make a good showing only in small or tiny highlight areas and bright reflection points, but the greater part of the picture will approach almost total blackness. Badly underexposed transparencies are beyond salvage, but moderately underexposed transparencies can sometimes be saved through slide-duplicating techniques or by making black-and-white negatives as intermediates for black-and-white prints.

Negative film exposures, black-and-white or color, offer more latitude in contrast ranges, but otherwise they have the same exposure attributes, except in reverse. An overexposed negative is dark throughout; the brightest areas will block up and will tend to be impenetrable while the darkest subject areas, including shadow details, will be thinnest but most capable of presenting recognizable shadow detail in a print.

An underexposed negative will show little or no visible detail. The extremely underexposed negative will show isolated details of highlights or brightness areas surrounded by emptiness or ghost-like images.

The black-and-white negative has the widest range of contrast acceptance. Ideally, it should show details in the thinnest part while the denser areas, placed on top of a sheet of newsprint, should allow the print to be read through those darker portions. The density range of a well-exposed black-and-white negative should permit making good prints on an enlarging paper of normal contrast (grade 2).

The ideal color negative is more easily viewed than described. A sample of an ideal color negative, showing good tonal range or density scale as well as good overall density, is included in the *Kodak Color Data Guide*, Kodak Publication R-19. A color print is included to match the sample negatives. This publication is excellent for both professionals and advanced amateurs and includes data relevant to exposure, developing film, and printing color pictures.

Elements of Exposure Control

In some measure, the elements of exposure control have already been introduced briefly. They will be expanded upon below. Here they will be mentioned as an interrelated grouping of elements, any of which may be altered or given dominance in order to achieve intended effects. In order to be able to achieve pictorial control through exposure, it is essential that the attributes or characteristics of each of the elements be well understood.

Lighting is the most essential of the elements. With rare exceptions, we are dealing with reflected lighting, for hardly ever does the photographer take pictures of direct sources of lighting—the sun, flash lamps, or flood lamps. The first key factor is brightness, which has its own range depending upon whether there is atmospheric interference of clouds, dust, moisture, or other particulate matter. Then there is lighting direction that, if it is not frontal, lends both depth and contrast to pictorial subjects. The color qualities of light will vary with the time of day, atmospheric filtration, and reflection from the surfaces of the pictorial target. Contrast characteristics of light are partly influenced by reflectance properties and lighting-source ratios, particularly when there is more than one source, as in artificial lighting.

The subject is a secondary contributory element in that it both filters and reflects the light and modifies it—as perceived on film—by its dimensional con-

figuration, its color, and its reflection rate. Dimensional configuration is given depth through the loss of reflectance away from the most prominent (closest) points facing the light sources.

The lens and shutter, from the standpoint of exposure only, govern the amount of light entering the camera. The lens aperture governs volume of light, while the shutter speed governs duration of exposure of the film to the light.

Films have varied light sensitivity, contrast characteristics, and color sensitivity. Light sensitivity is ordinarily expressed in terms of a film speed represented by the letters ASA or DIN, ranging from least sensitive (slow) to most sensitive (fast) for full lighting conditions, action, and so forth. (Lens and shutter settings are governed by prevailing light levels and pictorial intentions.) Color sensitivity relates to whether a film is "balanced" for daylight or artificial light, although the same film, appropriately filtered, may be used to take pictures with either type of light source.

Films have varying contrast and grain properties; the slower films tend to be more contrasty while the faster films are usually less contrasty.

Filters serve a variety of purposes. With black-and-white films, they are most conventionally used to alter sky rendition, but they are also used to alter the monochromatic rendition of color. Color film filters divide into two main categories—conversion filters that permit the use of tungsten-balanced (artificial light) films with daylight and vice versa, and light-balancing filters that bring the light reflectance properties from original sources of lighting into balance with the particular light sensitivity of color films. Roughly put, they range from warming filters to cooling filters.

Film processing or developing procedures can be used to intensify recorded images exposed under low light levels.

They can also be used to increase or decrease pictorial contrast and also to create unusual effects as departures from conventional photography.

Pictorial aims or intentions govern whether and how one departs from normal exposure readings or how one makes selective exposure readings. One might wish to have a low-key effect, calling for somewhat less exposure, while a high-key effect would call for an increase in exposure. A desired effect might call for rearrangement of subject matter, use of supplementary light sources including reflectors, choosing a different vantage point for shooting, or shooting at a different time of day.

Lens and Shutter Controls

Lens apertures and f/stops are the same things—optical designations of the relative volumes of light entering the camera through the lens as governed by the dimension of the diameter of the lens diaphragm. The maximum f/stop is inscribed on the front of the lens as a ratio in the form of 1:1.4 or 1:2, and so on. This expresses the ratio between the diameter of the aperture or lens opening and the focal length of the lens. The diameter of the lens opening is not important in itself but only in relation to focal length. Hence, with lenses of different focal lengths, the identical f/stop is an assurance of the transmission of identical volumes of light. The f/stops are engraved on the lens barrel in a standard progression to indicate a successive doubling or halving of light depending on the direction of the f/stops from small to large or vice versa. The standard progression on the 50mm f/1.4 lens is 1.4, 2, 2.8, 4, 5.6, 8, 11, and 16. Some lenses go beyond to f/22 and f/32. A few provide apertures as small as f/64. Note that the larger the absolute number, the smaller is the f/stop. This is more readily understandable when one reverts to the ratio, which is another way

of expressing a fraction. Hence, instead of $f/2$ or $f/4$, one ordinarily would have 1:2 and 1:4, translatable into $\frac{1}{2}$ and $\frac{1}{4}$, with the greater denominator always representing a smaller fraction. The beginning lens aperture is not always one from the standard progression of f/stops, as seen on the 55mm $f/1.2$ lens, the 28mm $f/3.5$ lens, and the 80–200mm $f/4.5$ zoom lens, among others. When the widest opening is one of these intermediate stops, the next f/stop marking on the aperture-setting ring is usually a standard number.

The relationship between any two f/stops in terms of volume of light passed through the lens is determined by the method of squares. Thus, 1.4 squared yields 1.96 while 2 squared yields 4. Again, 2 squared equals 4 while 4 squared equals 16. In the first adjacent pair, the fraction $1/1.96$ is approximately twice as great as the fraction $1/4$, which suggests the passage of twice as much light. In the second pair, in which an intermediate f/stop is by-passed, the fractions become $1/4$ and $1/16$ with the obvious conclusion that four times as much light is transmitted through the first lens aperture as compared to the second. Of course, one does not have to actually use the method of squares; a one-stop difference means that the larger aperture admits twice the light or that the smaller aperture admits one-half the light of the other, while a two-stop difference means $4\times$ or $1/4\times$, a three-stop difference means $8\times$ or $1/8\times$, four stops represent $16\times$ or $1/16\times$, while five stops leads to $32\times$ or $1/32\times$, and so on.

Many lenses have intermediate click-stops to show intermediate f/stops in the range of 1.2, 1.7, 2.5, 3.4, 4.9, 6.9, 9.8, 13.5, 19.6, and 27. Intermediate f/stops and shutter speeds are important in fine-tuning exposure settings, particularly with later camera models that permit continuously variable shutter speeds.

The reciprocal relationship between aperture and shutter speed has to do with the joint aims of achieving a particular pictorial effect while assuring that good exposure will be achieved. In regulating the volume of light reaching the film, the lens aperture also influences depth of field: at any given distance, the smaller the lens aperture, the deeper is the zone of sharpness extending from some point in front of the plane of critical focus to some point behind it. (The significance of this general rule diminishes to a point of insignificance in extreme photomacrography.)

The shutter-speed progression is calibrated in progressive halvings or doublings of time duration in order to establish a reciprocal relationship with the lens apertures. Each shutter-speed number engraved around the edge of the shutter-speed dial is the denominator of a fraction whose numerator is always Arabic numeral 1. Thus, 1 means $1/1$, 2 means $1/2$, and so on in progression with 60 meaning $1/60$, 250 meaning $1/250$, on up to $1/2000$, depending upon which camera model you have, each fraction representing that part of a second. The full range of numbers is 1, 2, 4, 8, 15, 30, 60, 125, 250, 500, and 1000 sec. with additional slow shutter speeds represented in full seconds and a superfast shutter speed of $1/2000$ sec. on particular models. With the shutter-speed dial set at "B," the shutter is held open as long as the shutter-release button is held down, this usually accomplished with a cable release attached to the camera on a solid support.

The self-timer mechanism of the Nikon F2- and F2A-series cameras can also be used for obtaining extra-slow shutter speeds of 2 to 10 seconds. To do this, cock the shutter, set the shutter-speed dial to "B," turn the T-L finger-guard to the "T" position, adjust the self-timer to the desired shutter-speed setting, and press the shutter-release button. The shutter will remain open for the preset duration.

47

Since the shutter speed controls the duration during which a given volume of light reaches the film, its additional function, beyond that of being a kind of light valve, is either to freeze or depict action as a pictorial aim as well as to overcome camera shake when movement or blur is decidedly not wanted.

Hence, in making a manual selection of a lens aperture to which a shutter speed is to be matched, the photographer is ordinarily opting for a pictorial effect relative to depth of field. If he should opt for a specific shutter speed he has another aim, as just described, which calls for some variable adjustment of f/stop to assure that adequate light reaches the film. In practice, the most common occasions for reciprocal use of aperture and shutter speed are when the photographer discovers that at a given aperture the shutter speed is too slow for a safely hand-held exposure, particularly under low light levels. The photographer might think, "If I lean on this chair can I trip one off at 1/15 sec. or would it be safer for me to open the lens a little and shoot at 1/30 sec.? Maybe I can do it on the chair support or, if I hold the camera steady at 1/30 sec., I can avoid movement. Just for safety's sake, since I'm doing a portrait candid-style, what really counts is that I get the leading eye in sharp focus, so maybe I can open up another couple of stops and go to 1/125 sec."

Even with the automatic camera models, the photographer must make the same kinds of decisions. Looking through the viewfinder, he finds that he does not have a sufficiently fast shutter speed with the f/stop he has indexed into the automatic exposure system by setting the lens aperture on the lens. (This is called the aperture-priority system.) On the other hand, he might decide that he wants a longer shutter speed in order deliberately to depict motion, usually with the camera on a tripod so that he can keep the background in sharp register. He might also decide that he has too much depth of field, which means he will have to widen the lens aperture while the camera responds automatically with a faster shutter speed. These are only a few examples of the kinds of decisions made to optimize aperture and shutter settings.

When the shutter is given priority, an adjustment of the lens aperture must follow. This is done automatically by the EE Aperture Control Attachment Mechanisms DS-1, DS-2, and DS-12. These units for the Nikon F2S, F2Sb, and F2AS cameras automatically respond to changes in the lighting conditions by rotating the lens-aperture ring.

Notwithstanding what has just been said about automatic adjustment of controls under either the lens-aperture-priority or shutter-priority systems, the photographer may still want to override the automatically indicated exposure to achieve different exposure conditions relative to his pictorial aims. By switching from automatic to manual, he can adjust either the shutter-speed dial or the lens aperture to allow more or less light to enter in order to achieve other pictorial effects. In so doing, the photographer makes use of his knowledge of the reciprocal relationship between aperture and shutter speed, even if intermediate shutter speeds and apertures are indicated by the automatic exposure readings. He simply turns the aperture ring the equivalent of one or two f/stops to a similar intermediate position. Or he can make a one-half stop adjustment in like manner. He can do the same with the shutter-speed setting on a camera model that has continuously variable shutter speeds.

The Limits of Reciprocity

What has been said about the reciprocal shifting of lens apertures and shutter

speeds, while achieving the same exposure effects, holds true under most conditions but may fail to hold true for either short duration or long duration of exposure. The term for this is *reciprocity failure*. A more specific operational term used here is *the limits of reciprocity.* This is applicable mainly to exposures of 1/1000 sec. or less and 1/10 sec. or more.

When exposures are of very short duration—1/1000 sec. or less—you may observe lower than normal contrast. This is characteristic of high-intensity illumination, such as that provided by electronic flash units whose peak bursts of light may be 1/1000 sec. or much less. The quenching mechanism of automatic flash units may yield exposure durations that are as short as 1/50,000 sec. On the other hand, with slow exposures of 1/10 sec. or more, underexposure may be encountered, depending upon the film being used. These effects are applicable to black-and-white film and to color film, but are more pronounced with color film.

The theory of the reciprocity effect, which depends on mathematically correlated lens apertures and shutter speeds, as described above, is that one ought to achieve the same results with one unit of light falling on a film for 100 seconds as when 100 units of light fall on the same film for 1 second. After all, the same amount of light reaches the film surface. The extremely short exposure is referred to as a high-intensity effect; its failure relates to the fact that the exposure is of too short a duration to build up a latent image that is capable of being brought out by developing procedures. At the other extreme, the very long exposure, referred to as a low-intensity effect, yields a diminishing intensification of the latent image formation with an increased exposure. Films made for different purposes have different reciprocity characteristics. As this phenomenon is most often encountered with color films, some manufacturers have designed films for optimum performance under conditions of long exposure. The effective sensitivity of a photographic emulsion varies with the illumination level and exposure time. When an emulsion is designed, a point is determined that yields the greatest response to light at a particular level of illumination. On either side of this level of light intensity, the response to reduced or increased exposure time decreases until a situation is reached where extra exposure is needed to obtain normal density.

Tables of reciprocity characteristics and their compensations are available from the respective film manufacturers. At an exposure time of 1/1000 sec., for example, Kodak recommends only an increase in development time of 5 percent with Tri-X Pan; no other adjustments are called for with this film or with Panatomic-X or Plus-X Pan. The exposure duration of 1/2000 sec., available on the Nikon F2- and F2A-series cameras, will not affect results with Kodak films noticeably, but this may not be necessarily true of films offered by other manufacturers. At the longer exposure times, adjustments may be needed in both exposure duration and development time.

In view of the longer exposure durations made available by recent camera models, it is important that the photographer know the reciprocity characteristics of the films he uses beforehand, together with compensations needed, so that he can make use of them under particular circumstances by altering exposure durations, *f*/stops, and filtration, as appropriate. A practical problem, however, is that when camera loads have varied subject-lighting characteristics, *f*/stops and filtration can be modified for individual exposures, but development procedures cannot be altered unless appropriate for the entire film length.

LIGHT CHARACTERISTICS

Light must be considered both as direct source light and as reflected light. In rare cases, the original source—sun or artificial light—may be photographed, but it is usually the light reflected from the subject that is measured and recorded on film. In this section, we will take up the attributes or properties of daylight expressed in terms of picture-taking effect. These include brightness qualities, directional qualities, and color-content qualities. While they are discussed separately, they actually are interrelated. Thus, bright sunlight inevitably is associated with harsh shadows in portraiture, particularly with side and three-quarter lighting. When, however, the sun is hazy bright, pictures taken with the lighting at the same angles have open shadows that are excellent in portraiture for they help add depth.

The serious photographer studies each picture-taking opportunity seeking to isolate and recombine the separate properties of brightness, direction, and color content in order to conceptualize the effect to be attained on film—especially color film. In doing so, the photographer must also relate these properties to subject matter characteristics as described in a succeeding section of this chapter. Since all of these ingredients are never uniformly held constant, the resultant exposures translated into transparencies or negatives are always unique, even if minutely different. Assuming that the photographer could actually hold constant all of the light and subject properties, he would still be up against variations in film emulsions from batch to batch and variations in developing chemistry, all of which interrelate and affect results. Some photographers go back to the same landscape scene innumerable times in order to catch different nuances of color governed by such ingredients as brightness, direction, time of day, atmospheric properties, and season of year, among others.

Brightness Qualities

Five main types of daylight are identified here, each of them constituting a single f/stop variation from the next category in series. These are super-bright or brilliant, bright, hazy-bright, overcast, and dull.

Brilliant or super-bright is similar to bright unadulterated sunlight, except that brilliant lighting is associated with beach scenes, seascapes, and light sand as reflectors, and an absence of dust, haze, or other environmental contaminants. Such brilliant light is becoming increasingly scarce throughout the world, especially in heavily populated and industrialized areas. Inasmuch as the winds carry atmospheric pollutants across the face of the earth, most geographic areas are affected. The brilliant category is, therefore, relatively scarce. It offers an increment of one f/stop in light value.

On a very clear day, when there is a minimum of particulate matter in the lower atmosphere, the ordinary bright sun casts clearly delineated, but rather harsh, shadows. In the early era of picture taking with relatively slow film through relatively small apertures, the bright sun was preferred inasmuch as it permitted making instantaneous exposures of adequate density. Under modern conditions, bright sunlight is ideal for a great variety of pictorial subjects, but mainly when the sun is behind the camera so as to minimize casting deep shadows. The bright sun is a very poor light source for portraiture. When it is high, it casts deep shadows in the eye sockets, under the nose, and under the chin. It precludes taking pictures of people wearing hats with brims, for the deep shadows practically obliterate facial detail. On the other hand, provided the sun is at an angle that does not cause the subject to blink, a bright sun can enhance textural attributes, such as when you want to bring out the creases in the

skin of an older person, the weather-beaten skin of a subject who has lived and worked in the outdoors, or an unshaven face. The sun is at its brightest usually about 9:30 A.M. to 3:30 P.M. Sharply delineated shadows have a downward cast and, unless it is high noon, the shadows are at an angle to one side or the other depending upon the position of the sun, the subject, and the photographer. Landscapes are best taken in the morning or afternoon because at high noon the bright sun does not cast the side shadows needed to show separation of objects from each other. The pictorial properties of bright sun from the side, the rear, or at a low angle are discussed under the heading of Directional Qualities.

The next step down, as a matter of lighting intensity, is hazy-bright sunlight. It is caused by a thin overcast consisting either of clouds or the haze generated by a combination of humidity and industrial wastes or vapors. Shadows are open due to the diffusion and softening of the light rays by the particulate matter in the sky. Hence, pictures are not characterized by sharp contrasts. This is the ideal source of lighting for outdoor portraiture and for other close- or medium-distance objects. In portraits, there is a delicate deepening of shadow tones as they trail off around the side of curved objects. The three-quarter-angle picture by diffused natural light is rendered very well in color, whereas if the sun were bright there would be a trailing off into harsh shadows around the side of the face away from the sun. Full-face portraits are also possible, since the sun is at least partially obscured and subjects are not forced to squint. Subtle details of texture in a variety of forms are more easily brought out, for there is no burning out or overexposing of catchlights or highlights. Quaint market scenes and narrow streets are more easily managed when the sun is not directly overhead

(and even with the sun in that position), for the contrasts between shadow and brightly lighted areas are markedly reduced.

Overcast is the next step down in light intensity. Some brightness comes through —enough to give slight shape and depth to objects and scenes—but a moderately heavy cloud cover or blanket of haze imposes a grayness on the overall scene with the slightest suggestion of shadows.

Cloudy, dull lighting constitutes the next step down in lighting equivalence. Such pictures tend to lose pictorial depth because there are no shadows to set objects apart from each other. This lighting conveys a feeling of monotony and hence is best suited for mood pictures that capture deep or somber effects as well as pictures in which you wish subjects to be absorbed passively into their backgrounds. In color photography, a warming filter is a must unless you deliberately want to maximize the cloudy-dull effect.

These five main outdoor light groupings can be used as the basis for subjective exposure determination as described in the subsequent section on light measurement. Hence, in addition to understanding the light characteristics for pictorial reasons, you have a reserve means for exposure determination if anything should happen to your meter or if you are not using one.

Subjective measures for rainy days and for open shade are less easy to categorize because of the variety of factors that may be encountered. The rainy day usually has all of the attributes of cloudy-dull lighting although sometimes the sun may be shining while it is raining.

Open-shade lighting combines dull, flat lighting and downward reflection from a bright blue sky. The latter conveys a vibrant quality uniquely characteristic of this type of lighting. In the first place, the open shade is created by an object in the path of the sun—a build-

ing, a tall hedgerow, tall trees, or single clouds with clear skies otherwise. The shaded area is ordinarily not dense (or irretrievably so) because of the downward thrust of reflected light from the sky. It is a brighter source of reflected lighting, if the sky is clear blue. This accounts for the blueness of snow in a brightly lit picture. A light warming filter should be used in such circumstances. When you have a combination of shadows caused by the bright sun at an angle and the shadows are filled by reflections from the sky through a thin overcast, you have a softness of light reaching subjects in the open shade to give them form and depth. Open-shade lighting offers attractive picture-taking possibilities in portraiture because of the absence of harsh shadow contours. Hair is likely to be highlighted from above because of the downward direction of the sky's light. At different times of the day, there will be shifts in the angle of the highlighting.

Reflectors and fill-in flash can be used to open up harsh shadow areas for outdoor portraits and closeups of flowers and other objects. When taking pictures against the sun, one or more reflectors in front of the subject can be used to bounce light back onto the subject. Such reflectors, especially when used in portraiture, should have bright, diffuse surfacing. Reflectors are described in the next part, "Artificial Lighting." They are invaluable in reducing the range of tonal contrasts, particularly with color. The bright wall of a building can also be used to bounce light back onto shadow areas of the face.

The delineation of shadow contours will vary under the different conditions of lighting just described. Thus, under bright sun, which is a point source, shadows have sharp edge configurations. As the light source broadens, the shadow edges become softer. The transition is most marked from bright to hazy-bright to overcast.

Directional Qualities

For portraiture and many other subjects, an ideal lighting angle corresponds to the classical Rembrandt style. This would be a broad-source overhead lighting that creates a downward thrust from the forehead to the lower opposite rear of the head which, of course, would be in shadow. This lighting in daylight would be provided by sunlight diffused by a light overcast, with the sun in the morning or afternoon at an angle with the subject and ground.

Overhead lighting is characterized by bright reflections in the hair that tend to get "burned up" on film because of the necessity of exposing for the face and clothing. Shadows form inside the eye-socket and under other facial features. This shadow-patterning is characteristic of all three-dimensional objects illuminated from above. The range of contrasts between shadows and toplit highlights is greatest under brilliant or bright sunlight and least at the other extreme of cloudy-dull daylight. Correspondingly, details in shadow areas are more clearly rendered as the brilliance of the lighting source diminishes to the point where shadows cease to exist, as in cloudy or dull lighting.

Sidelighting means to illuminate a subject on one side with the sun at an angle to the subject position and ground. The lower the position of the sun in the sky, the more pronounced are the qualities of this type of lighting; one-half of the face is fully illuminated while the other half is in shadow. The contrast range between the two sides of the face corresponds to the range of brightness qualities of the lighting source. A good example of sidelighting is a portrait done indoors using light coming in through a window.

The light entering a window creates the same effect as the light falling on an outdoor subject. If the direct rays of the

sunlight enter the window and fall on a subject, the side of the subject facing the window will be brilliantly defined and the darker side of the face will create an interesting contrast. It is what enters the window that counts rather than the prevailing conditions of daylight outside. Thus, if the sun is shining brightly, but the window is positioned so that it does not directly receive the rays of the sun, the quality of light will be comparable to that of open shade without the presence of downward sky reflections. These factors are relevant to the color properties, in particular, of exposures made with color films.

In general, if you take a picture close to a window or porch opening you will have strong, directional lighting, which will cast deep shadows. If the picture-taking direction of the camera is roughly parallel to that of the window faced by a subject looking outward, the front of the face will be well-illuminated, but there will be a darkening of features leading to the rear of the subject while the room itself will recede into darkness. With the camera still in the same position (optical axis approximately parallel to the window) and with the subject facing the camera, one side of the face will be well-illuminated while the other half will be in deep shadow. The effect is as though the face were bisected. One solution is for the photographer to turn his back to the window and point the camera toward the subject who would be facing the window directly. Thereby, both sides of the subject's face become uniformly illuminated against a dark background. Another solution, when only one side of the face is illuminated, is for a reflecting surface to be held up or to be positioned so that it bounces some of the window light back onto the shadow area of the face. The subject can be positioned next to an adjacent wall that could function as a reflecting surface. An ideal time for util-

izing light in this way is mid-morning or mid-afternoon when strong light enters the room and is bounced around to illuminate details of interior objects and surfaces.

Many dramatic pictures are made by positioning the camera facing toward the sun in defiance of all conventional wisdom. If the direct rays of the sun strike the lens, they will cause flare and sometimes interesting depictions of the shape of lens elements and the diaphragm opening intermixed with the pictorial subject. For most purposes, these effects may be regarded as interferences that ruin a picture, but occasionally interesting effects are achieved that can be used to create special outdoor moods. Mainly, we are concerned here with the creative use of *contre jour* lighting—the classical Continental term for daylight facing toward the front of the camera. Either the camera or subject or both must be positioned so as to obscure the light source. When the sun is low, this is easily accomplished, but the higher the position of the sun, the lower must be the position of the camera relative to the ground, pointing forward. The feeling of depth is enhanced by the pattern of shadows leading toward the viewer. Contrast ranges between highlights and shadows will be governed by the brilliance of the light source, as earlier discussed. If you expose for the side of the subject facing the camera, the backlit surfaces will be overexposed, showing no highlight detail. In a portrait, typically, the head and shoulder contours will be brilliantly defined when the exposure is made for the face. A dramatic example is when fluffy hair is penetrated by the sun and photographs as though it were aflame. The face in shadow with the sun behind the head can be lightened to the degree desired either by using reflectors, which would bounce light toward the subject, or by using fill-in flash. When reflectors are used, the effect, being con-

Suzanne G. Hill
Man with donkey, 200mm, f/6.3, 1/125 sec.

Size, direction, and dramatic impact of shadows often depend on camera viewpoint. In both shots high viewpoint emphasizes shadow effect.

Bull-baiting scene, 50mm, f/4, 1/500, Plus-X.

Francisco Hidalgo

Joseph D. Cooper

Under brilliant sun, shadows lose detail if highlights are preserved. High viewpoint maximizes shadow length and creates pattern. 24mm lens.

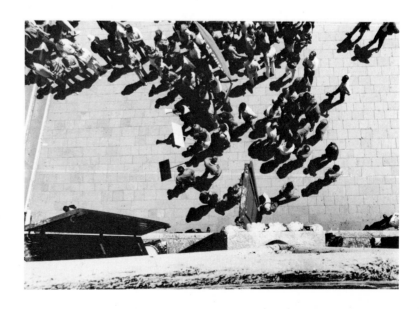

Joseph D. Cooper

The houses in shadow have no depth indicators. Those partially illuminated have three-dimensional effect.

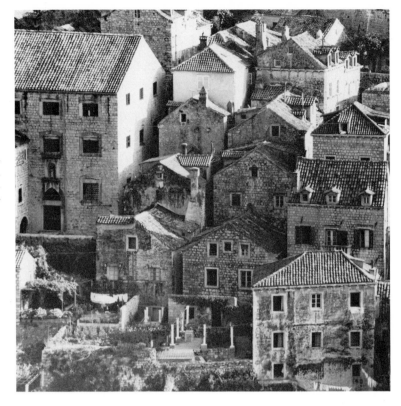

Francisco Hidalgo

Some houses and objects stand out more than others where they cast shadows caused by oblique lighting, but some are placed so that they receive sunlight frontally and cast no shadows, thereby offering no depth indicators. Clock tower in background, for example, does not stand apart from land beyond except through perception that it is supposed to stand apart. Cuenca, Spain. 50mm f/1.4 lens, f/8, 1/250 sec., Plus-X.

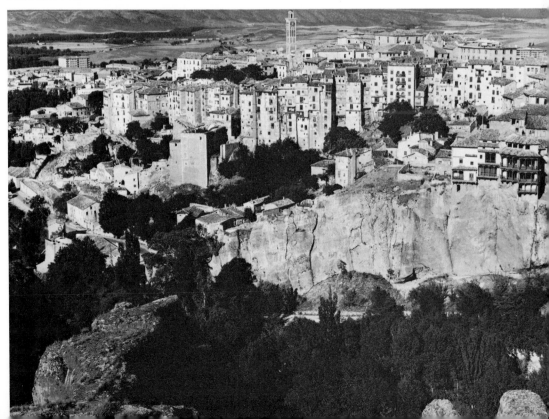

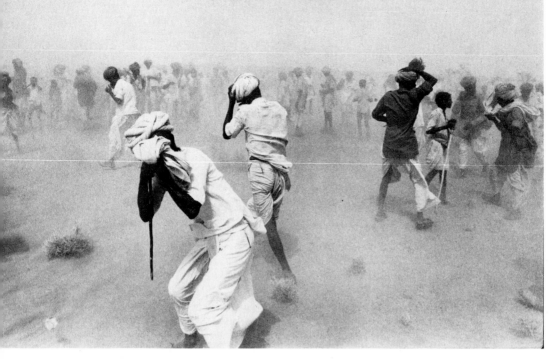

Raghu Rai

Sand Storm in Rajasthan. Effect is comparable to deep fog or aerial perspective. Foreground figures delineated by sun stand out most clearly, but accumulation of matter in depth obscures distant images. 28mm f/3.5 lens.

Struan Robertson

Almost no light left when herd of sheep came by in early evening raising great cloud of dust. 55mm f/1.2 lens at full aperture, 1/30 sec., thus using full reserve power of lens, hand-holdable shutter speeds, and fast film.

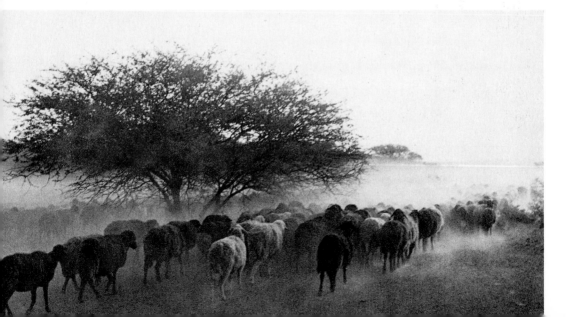

Bill Goldstein

The footprint in the sand shows how directional lighting brings out surface depth and texture. Nikkormat FTN, 50mm f/2.

Ken Biggs

Backlit pictures—light coming toward camera—yield dramatic effects. Stock favorite is sunset made with long lens for magnification especially if foreground object is silhouetted; 105mm lens nearly wide open to avoid hexagonal shape of sun.

David Doubilet

Bottom picture by light of full moon made on a Bahama beach where dogs often form into packs and run loose. 200mm f/4 lens with yellow filter.

tinuous, can be observed on the camera viewing screen. Contrast ranges can be altered by measuring details selectively. When using flash as a supplemental fill-in source, you have to balance flash exposure factors against a combination of f/stop and shutter speed that best renders the daylight part of the exposure. You have greater latitude for accomplishing this with flashbulbs, which permit selection of a wide range of shutter speeds, as opposed to electronic flash, which requires that you use a relatively slow shutter speed in order to allow the flash to synchronize properly. Since the output of the flash is constant, the amount of fill is governed by distance of the flash from the subject, by filtering the flash with a handkerchief, or with neutral-density filters.

When taking pictures against the sun, it is important that you never look at it directly through the viewfinder. If you do, except as to the low sun near the horizon in sunsets and sunrises, you'll risk incurring severe burn injuries to the eye. Low frontal lighting is achieved with the sun rising early in the day or beginning to set in the afternoon. Characteristically, with bright sunlight the effect is that of a spotlight aimed from the rear of a theater toward a subject on stage. Frontal views of people are difficult to record well because the direct sunlight makes a person blink. Front surfaces are usually devoid of shadows when the camera is closely aligned with the sun pointing toward the subject. Hence, they usually are devoid of dimensional qualities. For rendering image depth, the photographer should stand somewhat at an angle toward the subject while carefully watching shadow configurations. From a portraiture standpoint, the best lighting is hazy-bright with the subject's eyes (if not entire face) turned away from the sun. Striking landscapes, sides of old barns, and other structures can be made

with this type of light. As explained in the section "Color Qualities," such lighting is of low color temperature and tends toward orange and red except with heavily overcast skies.

Bottom reflectance is encountered mainly with the particular ground properties of water, beach sand, snow, and wet streets combined with bright lighting. The color and textural properties of the ground surface govern both the brilliance and texture of reflections upward. Portrait subjects show a characteristic filling in of shadow areas from below. The typical blue-cast snow is caused by the reflection of the blue light from the sky reaching the snow from every possible angle, in addition to sunlight from a single point in the sky. Because of the abundance of light in bottom-reflected scenes, there is some tendency for the exposure meter to be deceived into calling for less light; the photographer has to compensate by admitting one or two f/stops of additional illumination, depending on the subject.

Color Qualities

Daylight slide (or reversal) films are designed to yield most natural or most faithful color rendition, particularly of facial tones, when the sun is at its highest at midday or noon standard times. A white subject photographed early in the morning would have reddish tint, which would thin out until the middle hours of the day when it would be rendered as a reasonably faithful white. Then, as the afternoon deepens, the same white subject once more takes on a warm orange-to-red coloration that is most pronounced at sunset. Technically these variations in color properties are expressed as color temperatures in degrees Kelvin corresponding to the centigrade scale and named in honor of Lord William Thompson Kelvin of Great Britain. Day-

light color films are balanced for color temperatures of 5400–6000 K. The practical thing to remember about color temperature with daylight films is that the color qualities of daylight are governed first by time of day, second, by reflections from the sky, particularly if clear and blue, and third, by atmospheric or environmental filtration. The latter pertains to the presence of moisture, dust, and other particulate matter. Moisture tends to increase the blue factor in daylight because it picks up and disseminates ultraviolet radiation. Other color attributes of particulate matter will correspondingly influence the color temperature of daylight.

Daylight and artificial-light sources cannot ordinarily be mixed when using color films, but this is no problem with black-and-white films that will accommodate any mixture of lighting sources. Electronic flash and blue-coated flashbulbs can be mixed with daylight sources as they are fairly closely matched in color output. The use of color-temperature meters, pertinent both to natural and artificial lighting, is covered in the section on light measurement in this chapter.

SUBJECT EXPOSURE CHARACTERISTICS

In a sense, the following material belongs under the heading of light characteristics. It is treated separately only because we are dealing here with reflected-light properties. Ultimately, no matter how one deploys lighting or how one measures it, the light reaching the film is that which is reflected from the subject unless, under unusual circumstances, one is directly photographing the light source. Contrast qualities are also part of this discussion since they relate to the ability of film to record a range of reflected-light intensities. This pertains both to individual objects and to total scene patterns.

Reflectance Qualities

Reflection of light from the subject must be adequate in order to make the correct exposure and achieve the desired pictorial effect. This is a matter of light intensity. Then there is the matter of how the surface filters and changes light in the process of absorbing and reflecting it. The original light inevitably is altered by the color properties of the subject as well as its textural properties that are reflected back to the camera and the film.

Smooth, shiny surfaces reflect "hot spots," particularly since they are rarely, if ever, absolutely flat. (This happens to be a key problem when copying flat originals illuminated by artificial lighting.) Irregular or textured surfaces may reflect tiny specular highlights; in so doing, they dilute color saturation. On the other hand, they make better reflector surfaces for redirection of light toward the subject.

Different colors will reflect different amounts or percentages of light. A dull or matte black surface will reflect nothing, while a diffusing white surface will reflect about 80 percent of either daylight or tungsten. Colors reflect varying amounts of light on a subtractive basis: that is, they absorb part of the illumination spectrum and reflect the balance. Dull black absorbs all and reflects nothing. Shiny or polished surfaces reflect more light than do soft or matte surfaces. The accompanying charts show the reflectance ratios of different colored papers. There are differences between

daylight and tungsten reflectance: colors of shorter wavelengths (violet, blue, and green) are brighter in daylight, while the longer-wavelength colors (yellow, orange, and red) are brighter in tungsten light, although yellow and orange have the brightest reflectance among all colors in either type of light. The variable reflectance of colors has implications for exposure measurements and contrast rendition.

COEFFICIENTS OF REFLECTANCE FROM COLORED SURFACES

Colored Surfaces	Daylight	Tungsten
White Diffusing	0.80	0.80
Red Purple	0.16	0.23
Deep Red	0.14	0.22
Red	0.21	0.31
Orange	0.38	0.48
Yellow	0.60	0.65
Yellow Green	0.46	0.42
Saturated Green	0.32	0.24
Blue	0.23	0.17
Violet Purple	0.14	0.12

Source: M. Luckiesh, *Light and Shade.* (New York: D. Van Nostrand Co.)

Subject configuration relative to a single source of lighting and the position of the camera governs the patterns of light reflection or its absence, which is what we call shadow. When daylight is the source, its angle to a flat surface relative to camera position should make no difference in intensity of illumination reflected from any point on that flat surface. The situation is different with artificial lighting in that the inverse square law is applicable, which is evidenced in a geometric rate of fall-off in light intensity varying with distance from source. When any type of light travels in depth away from a leading prominent surface closest to the light source, patterns of shading or deep shadows will be observed depending upon physical configuration. These diminutions in light reflectance from the subject give it pictorial depth and thus make possible the imposition of three-dimensional effects on two-dimensional surfaces.

Contrast Qualities

Contrast in the picture, which is what ultimately counts, is usually expressed as a ratio of highlight-to-shadow densities. It can also be expressed in non-shadowed terms of light-to-dark tonal ratios. Pictorial contrast is governed by the interplay of many factors including the following:

1. Dimensional characteristics of lighting sources ranging from point sources to broad surface sources that govern shadow patterning.

2. Light direction in relation to subject and camera and the implications of these for the range from highlight to shadow.

3. The ratio of lighting intensities falling on the subject (and measured at the subject's position whether by the reflected- or incidental-light measurement technique) when there is more than one source.

4. The extent of fill illumination in shadow areas, whether from ambient light, reflectors, or supplementary light sources.

5. Contrast characteristics of the film.

6. Filtration at the lighting source or the lens, especially in black-and-white photography, which causes changes in the color attributes and tonal relationships of different colors within a given image area.

7. Manipulation of contrast through film development, especially concerning black-and-white films, but in some measure with regard to color films.

8. Manipulation of contrast during printing on paper through paper-grade selection, exposure, and development.

60

9. Viewing conditions, considering such factors as brilliance and color characteristics of light used to illuminate prints or slides and projection or transillumination of slides.

10. Preflashing of film to reduce contrast—a technique used primarily in copying and slide duplication.

The most important of these contrast-influencing factors are items 1 through 5.

The different types of films vary in their ability to accommodate contrast ranges. These can usually be expressed in f/stop ratios. Thus, color slide films (reversal or transparency films) yield best results with a ratio of subject reflectance not exceeding 4:1 or two f/stops. With color negative film, offering some printing flexibility, the lighting or contrast ratio can be 8:1 or a maximum of three f/stops. With black-and-white film the contrast ratio can be as much as 256:1, more or less, or eight f/stops.

Since films vary in their own contrast characteristics, these ranges of acceptability must be adjusted to your experience with the films you customarily use, developed under rather constant conditions. As a rule of thumb, the slower films tend to be more contrasty while the faster films tend to reproduce average scenes with less contrasty results. Hence, slower films are best with average-to-flat subjects, while faster films are best with average-to-contrasty subjects. This is true for both color and black-and-white film, although there is much more latitude for contrast correction of the latter in darkroom manipulation of prints.

As a practical matter, films cannot accommodate all of the contrast ranges to be found in real life, while papers cannot accommodate the full range of contrasts that can be recorded on film.

In the days when advanced and professional photographers worked mainly with individual sheets of film, they had maximum latitude for manipulation of contrast through selection of films, alteration or selection of lighting conditions relative to those films, and manipulation of the films and printing papers in the darkroom. Assuming that the 35mm photographer has some control over his circumstances, mainly by standardizing exposure conditions for a given subject to be recorded throughout an entire length of film, which itself is matched to subject and lighting, he can have some latitude for contrast control. Such latitude diminishes, however, when different kinds of subjects illuminated under a variety of conditions are all to be exposed on the same length of film and subject to identical development.

Under these conditions, low contrast subjects can be improved by using one of the medium or slower films that tend to render subjects in medium-to-high contrast. Brilliant or bright sunlight, having point-source characteristics, will maximize highlights and shadows, particularly if at an angle to the subject and camera.

On the other hand, high contrast subjects can be softened by using one of the faster films that have low contrast and are exposed under diffuse daylight conditions with the lighting source either behind the camera or supplemented by reflectors or other fill-in illumination.

Black-and-white films can be manipulated by both exposure alterations and changes in developing procedures. With low contrast subjects, this is almost essential when there is a contrast range of 8:1 (three f/stops) or less. One technique is to underexpose and overdevelop using a soft-working developer that does not create a chemical fog. With high contrast subjects, the reverse procedure is to overexpose and underdevelop.

LIGHT MEASUREMENT

Three different methods for measuring light conditions and converting these into exposure determinations are treated here. The first is the subjective estimate. The second is the reflected-light reading, whether through the camera or through an independent meter. The third is the incident-light reading. In addition, guidelines for exposure adjustments that are necessary because of lighting conditions that depart from the average are discussed.

Reflected-Light Readings

Most exposure readings are taken with the built-in exposure element of the finder/meter that is an integral component of Nikkormat cameras and of the interchangeable finder/meters of the Nikon series cameras. Photographers may also elect to use independent exposure meters under a variety of conditions, both spot meters and general purpose wide-acceptance-angle meters. In common, these meters measure the intensity of light reflected from the subject.

The reflection standard. All meters are programmed to read the intensity level of the subject area as though light were being reflected from an 18 percent gray reflectance card—a standard substitute for middle tone values. Any average subject should be correctly exposed in accordance with the meter reading, if it is used appropriately. Cameras with automatic exposure controls will give correct exposures for such subjects. Most average subjects, accounting for the greatest proportion of pictures taken under ordinary good lighting conditions outdoors, will be correctly exposed when using either the built-in meter of the camera or an independent exposure meter. It is when exposure conditions deviate from the average that you may need to override either type of meter,

based upon your knowledge of light conditions and your pictorial intention. No meter, built-in or independent, will make such adjustments for you. One of the things that sets the competent, creative photographer apart from others is his ability to interpret scenes and to make appropriate exposure adjustments or corrections.

Finder/meters. The finder/meters for all Nikon series cameras and all Nikkormat cameras are of the center-weighted type. Although they measure the intensity of light in the entire 24 × 36mm picture field, they favor the central portion corresponding to the 12mm-diameter circle on the focusing screen. This central portion accounts for 60 percent of the exposure readings but only about 13 percent of the image area. Hence, the built-in meter functions somewhat as a wide spot meter. The principal advantage of this metering system is that it permits measuring the main subjects, particularly in portraiture, where they are centrally located. Then, if surrounding areas tend toward darker or lighter intensity, it does not really matter, for the exposure will be correct for the central area. If that central area is typical of the entire image area, the exposure will also be correct. On the other hand, if there are exceptional conditions of light intensity within the central area, you will have to override the meter reading. This may occur when there is any departure from the average in terms of light intensity or contrast range. An example of departure from average contrast range might be a dark object against a light ground or a light object against a dark ground.

The center-weighted meters can be used to take selective exposure readings of objects that would not, from the standpoint of composition, fall within the central area. In such a case, the read-

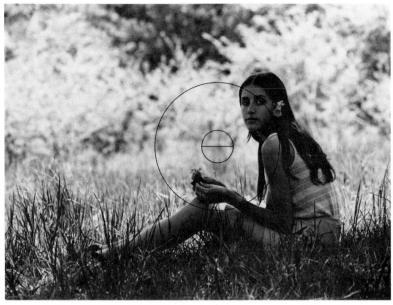

f8 250

Although the meter generates a center-weighted reading, the central part of the focusing screen should always be aimed at the main subject in order to obtain a proper reading. Otherwise, unimportant bright or dark areas may adversely influence the exposure reading. In the upper picture, the reading was taken with the central part of the focusing screen targeted on a bright area. The result was underexposure. In the lower picture, the reading was taken with the central focusing area targeted on the young woman. After the reading was taken, composition was selected by the photographer to yield the result shown below.

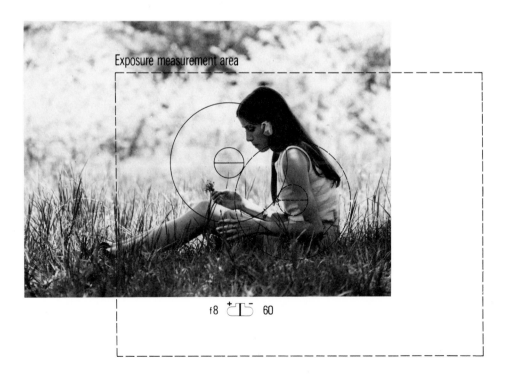

Exposure measurement area

f8 60

ing would be taken of that central image area, but then, after the exposure settings had been determined, the picture would be composed for the desired pictorial effect. Also, the significant high and low intensity areas within the total picture field can be selectively measured as a means of determining the contrast range or ratio. Necessary exposure adjustments under these circumstances will be discussed later.

Stop-down readings. The built-in finder/meters are designed to be used ordinarily for full lens-aperture exposure measurement. Full-aperture metering can be done only with Nikkor Auto lenses with automatic diaphragm action. Because of the brightness of the finder image, the photo cells are little influenced by the incident light entering through the finder eyepiece. With nonmeter-coupled lenses and when the meter linkage of Nikkor Auto lenses is interrupted by close-up extension devices, full-aperture metering cannot be done. Stop-down measurements then must be made by depressing the preset button and observing the exposure indication within the viewfinder. When exposure is automatic, a correct reading will be communicated. In either case, under dim light conditions, a brief adjustment period should be allowed to permit sufficient time for the photo cells to adjust to the dim light conditions. If experience indicates that stop-down readings do not yield correct exposures with particular lens and close-up attachment arrangements, compensatory adjustments will have to be made. An eyecup is recommended for stop-down readings because the incident light entering the viewfinder from the rear is relatively more influential due to the diminished intensity of the light entering through the lens.

Independent meters: general and spot. A general-purpose exposure meter usually covers an angle approximately similar to that of a normal lens, although some may have slightly wider angles of coverage. Such a meter would yield adequate results when taking picture readings from the shooting position, provided the light and dark areas balance each other off and are not too extreme in their contrast ranges. Correct exposure readings will not be attained if the picture situation contains significant departures from a smooth progression of high to low contrast. Readings will have to be adjusted if the lighting in a scene deviates significantly from average, or if light or dark areas of principal interest are overwhelmed by backgrounds of opposite brightness. Examples are small dark objects against bright ground and small light objects against dark ground. Typically, these examples may be portraits. Again, the difficulties stem from the fact that a meter is programmed for averages, but it is not possible to average a portrait with a competing background intensity and achieve good results.

Some independent meters have narrow angles of acceptance. They are more selective, enabling you to take measurements of the principal areas of the scene without having to get close to the subject, an advantage particularly when you cannot get close. Even within these narrower angles of acceptance, you might still encounter differences in scene contrasts that call for creative exposure adjustments.

Spot meters, independently available, usually measure a central circular area constituting a 1-degree angle of acceptance displayed within a wider nonmetering area of image coverage. The purpose of the latter is to make it easier to track and find principal subjects to be measured. With so narrow an angle of coverage, the meter enables you to take measurements of very small portions of the overall scene, either to find the exposure setting for that part of the picture field or to enable you to take selective

readings of high and low light intensity areas as a basis for independent determination of exposure settings for desired effects.

The selectivity of a spot meter makes it particularly useful in telephotography with Nikon series cameras that have finders without built-in meters. The spot meter is additionally useful in close-up photography, where there is a wide range of contrast, and in measuring the contrast in backlighting. Up to a point, represented by the 135mm lenses, the spot meter is superior in that it covers a more limited area of the pictorial field due to the workings of the center-weighted reading. With the longer lenses, the center-weighted reading functions as its own spot meter. Consider that with the 500mm lens, one-eighth of the horizontal angle of view of 4 degrees is converted to ½-degree angle of acceptance, less than that afforded by any spot meter.

Success with the spot meter lies in knowing what areas to average for a correct exposure or what highlight and shadow densities to measure in order to determine contrast ranges as a basis for exposure determination.

The alternative to selective spot readings, when using general-purpose reflection meters, is to get close to the subject and take readings of specific areas in line with the camera-to-subject axis.

Substitute subjects. When a principal subject is inaccessible for a reliable reading with either the built-in camera meter or an independent one, you can use substitute subjects. Standard substitutes are an 18 percent gray reflection card (such as sold by Kodak) or a 90 percent white reflection card (the reverse side of the gray card or plate). The gray card is placed in the path of view from camera to subject so that it will receive the same kind of light as the actual subject. This will yield a correct average exposure. This method is also suitable for reproducing diagrams

and documents where the preponderance of white would ordinarily yield underexposure. Deviations from standard are treated in accordance with the guidelines for adjusted readings given below. Care must be taken so that a shadow is not cast either by the camera or by an independent exposure meter. As the 18 percent reflection rate of the standard card was originally derived from measurement of indoor subjects, there may be times where it will be inapplicable to outdoor daylight conditions to the extent of yielding one f/stop less exposure than indicated by an exposure meter. Through repeated trials, the photographer will obtain his own compensatory factor. When photographing solid objects that are illuminated at an angle, the reflection card should be held at a corresponding angle in order to properly represent intermediate light-reflection values or intensities. When photographing against the light, the reflection card should be placed in complete shadow thereby indicating a greater-than-necessary exposure for which the photographer must make adjustments according to the pictorial effect intended.

An alternate substitution method for use with dark or low-light-level subjects is the utilization of a white surface with a 90 percent reflection rate. This is the white side of the Kodak Neutral Test Card or an art paper with a reflection rate close to 90 percent. The white surface is used in the same manner as the 18 percent reflection card, except that it has the effect of raising exposure-meter sensitivity by 5 times. Accordingly, the aperture must be opened up 2⅓ stops or, alternatively, an ASA rating must be used that is one-fifth that which ordinarily would be used. For purposes of magnifying the reading, the former might be preferred.

The palm of a light-skinned hand also can serve as a simple and convenient substitution. The hand must be held

Chris Smith

Experienced photographers like to avoid high noon and bright suns because they produce unmanageable contrasts of highlights and shadows. They like to work on the feather edges of the light. This is an example of the latter taken at dusk with a 28mm lens f/8, 1/250 sec. Kodak Tri-X.

Graham Finlayson

The window as light source offers many possibilities for modeling the subject. With one side of face toward window, other side is near-silhouetted. 50mm lens used close to overemphasize bony structure of face and famous broken nose of British explorer-traveler-writer Wilfred Thesiger, a man of immense strength, dignity and character who could only be photographed with utter simplicity. Courtesy *Daily Telegraph Magazine*.

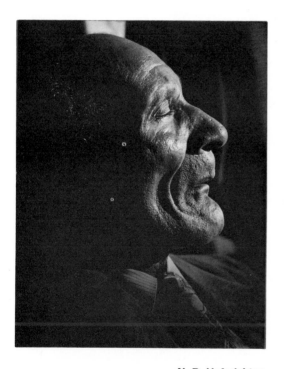

N. R. Hoferichter

Facing subject toward window brings out skin texture if photographed as above, but zone of darkness is toward rear. Wider view of scene at right retains directional quality of light but selectively depicts character of living quarters. Hoferichter has portrait displayed 20″ × 24″ near grainless. Both with 85mm lens f/5.6, handheld 1/60 sec., Ilford HP4.

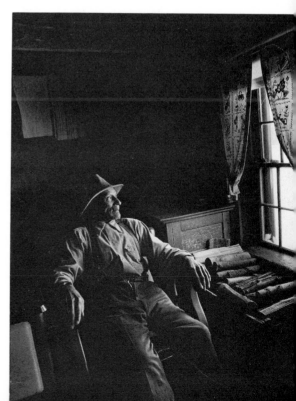

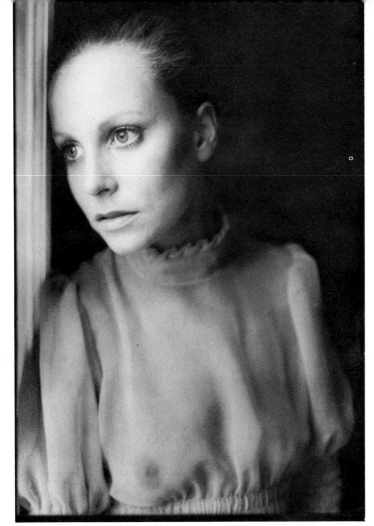

Graham Finlayson

Three window-lighting effects with model Felicity Devonshire with and without hairpiece taken in virtually same place on same afternoon within same hour. At left, camera positioned to capture near-frontal lighting of face. 50mm lens. Below left, white reflector used to fill in side of face away from window. 50mm lens. Below right, subject slightly removed from window to achieve silhouette effect under existing light conditions without props. 20mm lens. All Ilford FP4, two layers of nylon stocking on enlarger lens.

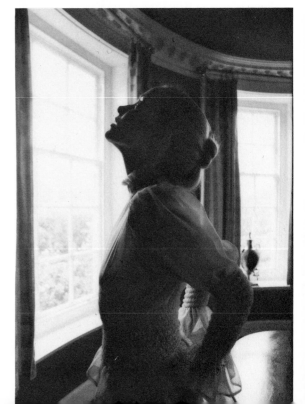

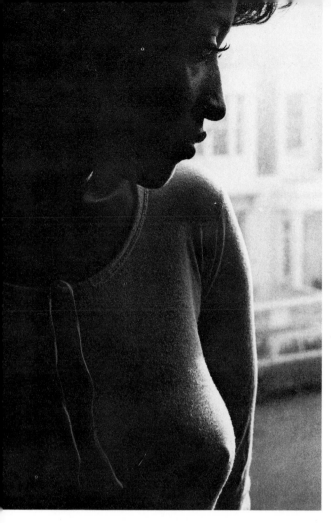

Ian Bradshaw

Window lighting contours
the face with enough spill-
ing over to organize frontal
features and to give form to
breast. 105mm f/2.5 lens.

ph D. Cooper

ian musician photographed by window light with
gh ambient light from other sources to fill
ows. Background is bricked wall out of focus.
n f/1.4 lens wide open.

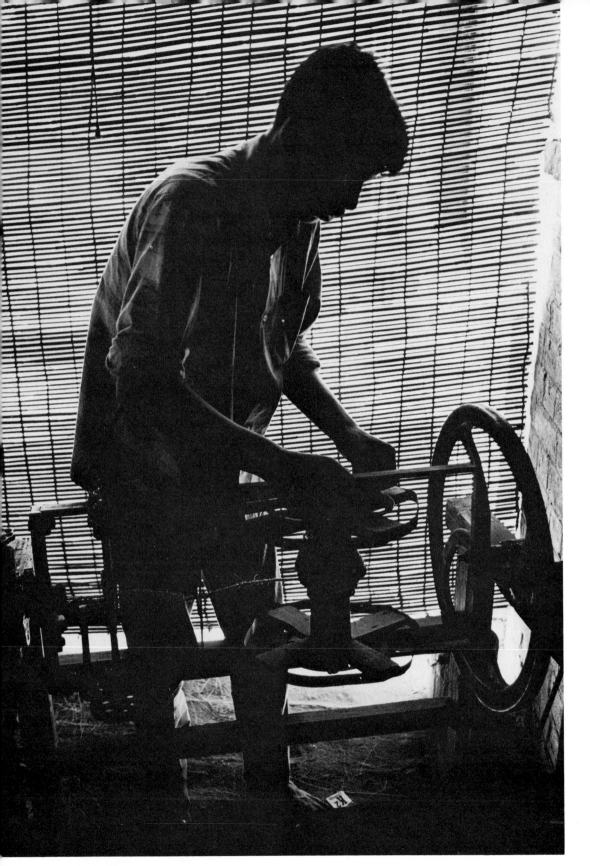

Ian Bradshaw

Blind boy making rope in India. Reed shade makes patterned backdrop against which to partially silhouette the scene for dramatic impact. 24mm lens used to take in entire scene in crowded quarters.

at a distance of about 10–20cm; a longer distance would add the effect of surrounding areas, while a shorter distance would introduce shadow interference from the meter or body. The reflection rate of the palm of the hand is about 30 percent as compared to the standard gray card or plate, which is 18 percent. Accordingly, the amount of exposure indicated by the meter with the normal ASA setting must be increased by 1.6 times or, alternatively, the ASA setting must be reduced by that factor. As a practical matter, you have a choice of opening the aperture by an additional three-quarters stop, with films that have limited latitude for exposure deviations, or, with the faster wide-latitude black-and-white film, the measured palm exposure can be used directly. If the palm exposure reading is a substitute for a portrait reading of similar facial tone, regardless of lightness or darkness of skin, the hand reading can be used as is.

Reading brightness ranges. Exposure reading through the lens would constitute an average reading only if it is typical of the entire scene. If you wish to take account of all or most of the brightness range within the scene—apart from facing the reading on the central subject wherever it might be located—the procedure would be to take separate readings of the most important highlight and shadow areas and to set the exposure at an intermediate value that favors the side of the brightness range that is most important. Depending on the scale of image areas to be read selectively, the possibilities are to use the central 12mm circle or an independent spot meter to read brightness values selectively. In most cases, the use of the built-in exposure meter should be sufficient, although it might require taking some close-up readings. This strategy is most important when the contrast of the subject is fairly great compared to the film latitude.

In some cases, brightness range is ignored in favor of emphasizing either highlight or shadow areas. The strategy is one of selective sacrifice, particularly when color slide or reversal films are used. The measurement is taken not of the brightest highlight but of the most important highlight area. In fact, in order to preserve some of the intermediate and darker tones, elements of extreme brightness are either sacrificed or excluded from the image area by careful positioning of the camera. In any event, shadow areas will be sacrificed to a degree in relation to the intensity of the light source and the extensiveness of the brightness range.

On the other side of the brightness range, when the shadow areas are favored, highlight areas are usually sacrificed completely. Where the shadow areas predominate, this may not matter; the highlight areas, however, should not constitute distracting burned-out patches of image area.

Basic exposure corrections. Since exposure readings taken with meters of all kinds are based on a concept of average governed by experience with indoor use of a gray card, scenes that depart substantially from that average must be given more or less light than the indicated exposure values. When the scene or major subject is brighter than average, the meter will indicate less exposure in order to yield an appropriate middle-tone effect. Hence, exposure strategy is to overcome automatic negative compensation by opening the lens aperture or by using a slower shutter speed. Conversely, with pictorial targets that are darker than average, the meter will signal more exposure value in order to achieve a middle-tone effect. This time, reverse compensation will provide less exposure. The amount or extent of exposure adjustment is determined subjectively based upon assessment of the scene in terms of the comparative $f/$stop

71

values of different types of light. The need for making adjustments is more critical with color slide film than with black-and-white films, except for those in the slowest categories.

In the case of substitute reflection card readings, however, a different approach is applicable since the reading has been made from a substitute subject of a middle tone under varying light conditions without regard to the reflectance properties of the actual subject to be photographed. The strategy of exposure compensation is the opposite of that applicable when meter readings are made of actual subjects. In the case of color tints, a subject with bright colors would call for one-half stop less exposure than indicated by the gray card reading, whereas a dark color would call for one-half stop more exposure than indicated. In the special case of a gray card being placed in a complete shadow, more exposure may be indicated than is necessary. Accordingly, the indicated exposure should be decreased in relation to the density and other attributes of the shadow area.

When brightness distribution is unduly influenced by sky, water, or snow occupying more than one-third of the total picture area, other pictorial detail will be substantially underexposed. Readings can be taken selectively so that exposure values will be set accordingly when the picture is recomposed. The very bright areas, will, however, then be grossly overexposed. An alternate approach is to change shooting position to limit the portion of pictorial area occupied by very bright objects or elements. In many instances, contrast can be controlled by exposing for adequate shadow detail and underdeveloping the film.

With lenses of different focal lengths, exposures may vary due to distances in the brightness content of the image areas covered. Thus, with a standard or wide-angle lens, there may be a range of tonal values presented within the central image-scanning area. A longer lens with a narrower acceptance angle might isolate a predominately dark or bright area, thereby signaling a change in exposure values. Moreover, longer lenses may accentuate the dilution of contrast in the far distance. Although the center-weighted meter will give proper exposure readings, subject to compensation for departures from average, the pictorial effect may nevertheless be different in a series of exposures with different focal-length lenses.

Incident-Light Readings

Incident light is that light which illuminates the subject. An incident-light meter reads the brightness of the source light from the position of the subject with the meter pointed toward the camera. This method assures consistency of flesh-tone reproduction with a given subject regardless of differences in reflectance from surrounding objects. The same is true of the consistent reproduction of other objects within a scene. In other words, the introduction of either brilliant or dark components within the exposure-measuring area that might affect exposure values is not relevant to outcome since exposures will be constant, subject to modification only in the same manner as one would interpret other exposure measurements, particularly the gray-card-reflectance readings. As in the case of reflected-light meters, the assumption with incident-light meters is that the scene being illuminated has average reflectance properties. Hence, adjustments must be made either for a target subject or for the scene as a whole, depending upon exposure strategy.

If a scene has average reflectance, you should get the same reading with an incident-light meter as with a reflected-light meter, or with an 18 percent gray reflectance card held to intercept the line from camera to subject.

72

Once you have taken an incident-light reading, you can use it for all subsequent picture taking of the same scene or of scenes of similar reflectance qualities, provided you make adjustments if you should change your angle of picture taking or if the subject should be turned to reveal different patterns of light and shade.

The most common method of using an incident-light meter is to attach a hemispherical translucent receptor on the light-receiving portion of the exposure meter. This serves as the light collector to pick up all incident light falling on the subject from all frontal directions. For indoor use, particularly, the 180-degree sphere may be replaced by a flat disc, which will measure the effect of specific lighting sources in order to obtain lighting-contrast ratios of brightness from the subject position.

When the outdoor light falling on the subject is the same as that falling on the camera—using the 180-degree sphere—you can take a reading from the camera position, provided the incident-light meter is directed toward the subject. This will be particularly true when the sun is behind a cloud cover.

To take account of differences in scene brightness, open or close the lens aperture from one-half to one stop more or less than indicated by the meter. To favor brighter objects or areas, use a smaller lens opening. To favor darker areas, open the lens appropriately. When scenes have mixed light reflectance, one technique is to take a compromise reading between that achieved with an incident-light meter and that achieved with a reflected-light meter.

When taking pictures of sidelit subjects, you may wish to emphasize either the bright or the shadow areas of the subject. To emphasize the latter, turn the light receptor so it faces midway between the lighting axis (line of direction from subject to camera and beyond) and the darker area of lighting source. To emphasize the brighter side of the subject, turn the light receptor so that it picks up more of the main source of illumination.

The use of the flat incident-light plate is particularly suitable for flat subjects, especially when an average exposure is desired of subjects that have great contrasts. The flat-plate method is ordinarily not suitable for the photography of solid subjects, but some compromise can be achieved by directing the light-receiving surface toward an intermediate point between the main light source and the camera.

A reflected-light meter can be used as an incident-light meter provided an aperture or shutter-speed adjustment of four stops is made. This is the equivalent of a 16 times exposure value increase. Under this method, the exposure meter is used without attaching a translucent plate. This method is suggested for expediency only; it does not assure accuracy of readings. Also, adjustments must be made consistent with the flat-plate type of incident-light reading discussed above.

Cadmium Sulfide (CdS) Cell Problems

Built-in exposure meters of some Nikon and Nikkormat finder/meter systems utilize CdS photoconductive cells for reading light intensities. Most independent exposure meters also use such cells, although a few are available that use selenium cells for light measurement. The CdS cells are battery-powered, while the selenium cells are self-powered, which causes a meter needle to respond to variations in the intensity of light falling upon the cells. CdS cells are most commonly in use because of their ability to measure light under low level conditions. They do, however, have certain attributes that might occasionally cause

difficulty if they are not understood. These include brightness memory, biased readings of deep colors, and temperature sensitivity.

When a bright target has been measured by CdS cells for any length of time, it may take several seconds before a shift can be effected to a lower light level. This might be noted visually as a lack of stability during the time it takes for the cells to give up their brightness memory. The effect is usually not noticeable under average conditions of shooting, but is most pronounced when readings are taken for prolonged periods under very bright light conditions. If a direct reading of the sun is made (only through an appropriate sun filter to avoid damage to the eye!) the meter might hold its memory of the sun's brightness for 10 minutes or longer. When taking stop-down readings after having first viewed a subject under full aperture, a brief period—some seconds—should elapse before taking what may be regarded as a stabilized exposure reading. When the camera is not in use, the lens should be covered with a lens cap as additional security.

Color sensitivity or insensitivity may be noted with CdS meters when using deep-colored filters, for CdS cells have little or no blue sensitivity, but are especially sensitive to red light. Hence, light sources of either color predominance may give false readings. The recommended procedure with dark filters is to take an exposure reading without the filter in place and then to make an adjustment for the filter factor manually. With automatic exposure controls, the use of the manual override is recommended. The same principles pertain to readings of predominantly red or blue subjects, even where filters are not used. With predominantly blue subjects, indicated exposures should be shortened consistent with the amount and richness of blue color. Predominantly red sub-

jects should be given more exposure than indicated by the metering system.

CdS cells may give different readings under different temperature conditions, particularly when contrasted between hot and cold. If in doubt when taking pictures outdoors, refer to the subjective reading system described below.

Some of the newer models in the Nikon line make use of silicon cells in their metering systems. Among these cameras are the Nikon F2Sb (Photomic finder DP-3), Nikon F2AS (finder DP-12), Nikon EL2, and the Nikon FE. Silicon cells do not suffer from the problems associated with CdS cells in regard to brightness memory, color bias, and temperature sensitivity.

Since these unfavorable attributes of CdS cells are not often encountered in actual use, the photographer may consider the main advantage of silicon cells, from a practical standpoint, to be their ability to make accurate light readings in extremely dim existing light. Generally speaking, a metering system utilizing silicon cells will be able to make accurate exposure measurements in light levels 2 or 3 EV below that measurable by a similarly designed CdS system. This advantage permits through-the-lens metering at slower shutter speeds than was previously possible. The newer Nikon models permit shutter-speed selections of up to 8 seconds.

The Nikon FM uses gallium photodiodes in its metering system. These cells offer improved reliability over temperature extremes and less sensitivity to infrared radiation.

Subjective Reading Methods

The standard subjective reading method outdoors is known as the 1/ASA system. The basic exposure in bright frontal sunlight with a subject of average reflectance combines a lens aperture of $f/16$ with a shutter speed closest to the reciprocal of the film's ASA rating.

This system can be used as an emergency substitute for a nonfunctioning meter, as a means of checking on the performance of the·meter, or as a means of determining exposure without a meter.

Although the basic exposure is predicated on bright frontal sunlight, the subjective 1/ASA system is convertible for other conditions of daylight in accordance with the f/stop variation in light attributes described earlier in this chapter. With brilliant or super-bright lighting, a reduction in exposure should be made equivalent to one f/stop. Going the other way, hazy-bright sunlight would call for opening up an additional f/stop, while cloudy-bright sunlight would indicate opening up two additional f/stops as a variation from basic. Thereafter, you can reciprocate apertures and shutter speeds within each exposure value series.

Notwithstanding the exposure-meter readings, if you have any uncertainty as to your interpretation of departures from average in subject reflectance, particularly when you must get the picture exposed properly without having a second chance, you should make use of the exposure-bracketing technique.

Portrait readings often call for subjective adjustments. Exposure readings for average light skin may be increased one-half f/stop or more beyond what is indicated by the meter. Readings from dark-skinned subjects would call for decreases in exposure values to offset the disposition of the meter to achieve middle-tone renditions regardless of brightness or darkness of the subject.

When the exposure-reading area in the viewfinder embraces a high contrast range without middle tones, you must decide whether you want to achieve an average of the two extremes (which is not likely to be satisfactory at all), to recompose the picture, or to expose for the more important of the reflectance or tonal areas. This is where a spot meter can be useful to yield more accurate selective readings. Alternatively, a long focal-length lens can be used to take selective readings at narrower angles of acceptance; the appropriate lens for picture-taking purposes is substituted for making the actual exposure.

FILMS AND FILTERS

Films fall into two categories—reversal and negative—which are governed by how they present the original tonal values after development. Color reversal films are popularly called slide or transparency films, for they show the original scene or subject in natural or near natural colors (provided they have been properly illuminated and exposed). Ordinarily they are viewed as projections on a screen or as transparencies illuminated in·a hand or tabletop viewer. Some black-and-white films are also intended for use as reversal films; these mainly are films intended for document reproduction. Reversal films are first developed as negatives and then bleached, re-exposed, and developed again to reverse original tones, thereby leading to the descriptive term *reversal* film.

Most black-and-white films are intended to yield negative images whose tones oppose or negate those found in the original subject. A white subject is recorded on film as black, while the latter is recorded as white; light subjects are recorded as dark, while dark is recorded as light. The original tonal representations are restored through printing on paper (or, in some cases, another film)

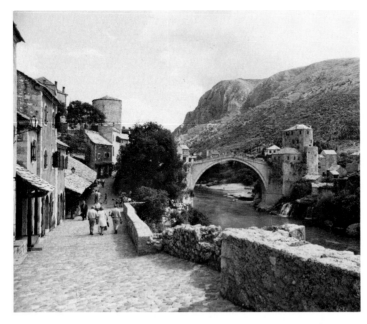

Joseph D. Cooper

Turkish settlement and bridge at Mostar, Yugoslavia. Yellow filter used to darken sky. See small reference picture made without filter for comparison. Yellow filter also lightens foliage. 24mm lens.

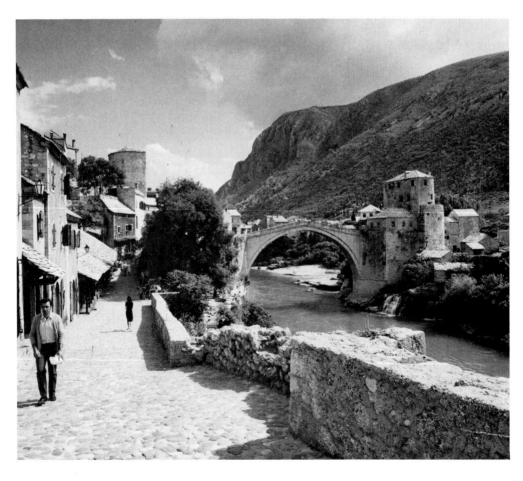

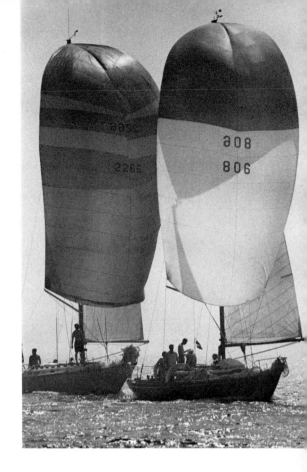

Douglas T. Mesney

Sails are transilluminated and water caps highlighted. Direction of low-angle sun from side indicated by highlight and shadow pattern at top of sails; gives some form and depth to figures which otherwise would have been silhouetted completely. Block Island, Rhode Island. 200mm f/11, 1/250 sec.

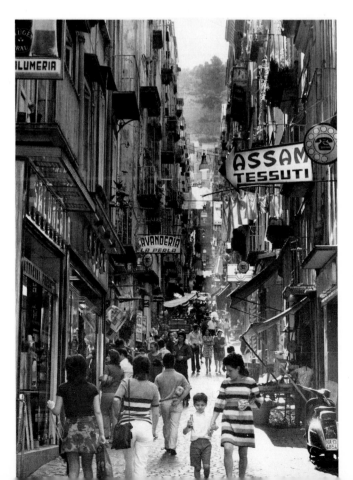

Joseph D. Cooper

Narrow streets are difficult subjects for they admit light mainly at high noon or if on axis with rising or setting sun at particular times of day. Some dodging and burning was done to equalize light and shade on this Naples street. 80mm length of 80–200 Zoom-Nikkor.

77

Dusk at Lake Bled, Yugoslavia. Low angle of light indicated by church tower. Small silhouetted boat in foreground gives depth to scene. Composition selected by zooming with 80–200mm Zoom-Nikkor, 1/250 sec., Kodak Tri-X.

Joseph D. Cooper

Backlit scene, sun near horizon, brings out catchlights and silhouettes piles on which gulls are resting. Slow shutter speed records more catchlights, for surface of water is constantly churning. Building in background contributes to feeling of depth. Composed with 80–200 Zoom-Nikkor. 1/30 sec., Kodak Tri-X.

either by direct contact printing or, most commonly with 35mm film, by projection through an enlarging apparatus. In effect, a reversal is then accomplished, for the projected tonal areas are recorded and developed as opposites; what is a light area on film develops out as a dark area on paper, what is dark on film is represented on paper as a light area. Color negative films also record images as tonal opposites, both in respect to the light/dark phenomenon and color opposites, but otherwise they are also intended for use as intermediates leading to further printing on paper or film in any size desired.

Negative films afford greater flexibility in the treatment of tonal contrast and in correction for underexposure or overexposure than do reversal films. Black-and-white negative films offer the greatest latitude in these respects and, additionally, can be used more flexibly in darkroom manipulation to achieve what the photographer perceives to be a normal or other intended effect. When paper prints are to be made from color slides, reproductions are first made on special negative color films called internegatives. There are also several systems for making prints directly from transparencies, such as Cibachrome and Kodak Type 1993 RC.

This part describes only the ordinary intended uses of films. Creative photographers can achieve fascinating effects called *diversifications* or *derivations,* depending upon the techniques employed. These include manipulation of tonal contrast, alteration of color effect through interposition of color filters or gels placed in front of the light source or the lens, or the use of altered negative images as positives.

The balance of this chapter includes a discussion of technical characteristics of films bearing on their selection and use, characteristics of black-and-white films and filters intended for use with these films, characteristics of color films and filters intended for use with them, and filters that can be used with either black-and-white or color films to achieve certain effects or correction.

General Characteristics of Films

Films are usually described in terms of their speed or relative sensitivity to light, designated by the initials ASA or DIN followed by a scale number; contrast characteristics; exposure latitude; grain; resolving power; and acutance or contour sharpness. Aside from film speed, all of the other characteristics bear upon each other to yield various effects as interpreted by the viewer, in terms of apparent sharpness and dynamic impact.

The elements of speed, contrast, and exposure latitude will be treated together, since they ordinarily are interrelated in any given film with unique exceptions.

Speed, contrast, and exposure latitudes. The interrelatedness of film speed, contrast, and exposure latitude has already been discussed in a preceding section of this chapter. Briefly, the slower the film, the greater the contrast and the lesser the exposure latitude. Conversely, with faster films, contrast decreases, and exposure latitude increases. These trade-offs are relevant when selecting films. The photographer can manipulate these characteristics by coupling exposure and developing techniques, such as increasing contrast through underexposure and overdevelopment and decreasing contrast through overexposure and underdevelopment. Some relevant techniques are discussed in the section on low-level light conditions in the succeeding chapter. These techniques are also useful in slide duplicating, and have particular significance for astronomers and others who photograph the night sky.

Grain. The characteristic known as graininess relates to the fine or coarse

clumping together of microscopic grains of silver, making up the photosensitive components of film emulsions, as a consequence of chemical development. The slowest films ordinarily have the finest grain while the fastest films approach or attain coarseness. Graininess is least apparent in a negative, slide, or contact print, but may be increasingly apparent with increasing magnification on paper or on a projection screen. Graininess also may be observed visually under high-powered magnification of the film. In the range of descriptive terminology, manufacturers describe films as extremely fine, very fine, fine, medium fine, moderately coarse, and coarse. In using these terms, the manufacturer assumes that the films will be developed under ideal or optimum conditions. Both overexposure and overdevelopment will coarsen the grain properties of film. Graininess also is relevant to the degree of intended magnification by enlargement; a coarse-grained film will yield excellent results when printed snapshot size, while a giant mural or wall-sized print made from a negative of the finest grain will display a breaking apart of fine details when viewed at too close range. In ordinary enlargements, the appearance of grain is most apparent in middle tones and in blurred or out-of-focus areas. This has more to do with psychological perception than with photochemical characteristics; it is a by-product of looking for sharpness of detail and, not finding it, concentrating instead on the grain pattern. The finest-grained films are characterized by smooth, homogenous rendition of tonal areas, while the coarser-grained films have a characteristic pepper-and-salt texture in the middle tones and shadow areas; these can contribute to or detract from pictorial effects depending upon the kind of subject being recorded.

Acutance or contour sharpness. Grain characteristics of films have been improved progressively by manufacturers over the years. While fine grain in itself may be desirable, bearing in mind that developing technique is important, acutance or contour sharpness may be equally or more important, depending upon the distance from which the photograph is viewed. Acutance pertains to edge sharpness when dark and light tonal areas are separated from each other. A film with excellent acutance properties shows a knife-edged separation. Poor acutance is observed as a softening of the edges of tonal areas that tend to blend into each other. At a normal viewing distance, excellent or sharp acutance heightens the effect of overall image sharpness, superseding the grain pattern in importance. While acutance properties are important in all films, they are particularly important in the faster films in order to make up for any tendency toward coarseness.

Resolving power. The term *resolving power* relates to the ability of a film (or paper) to record fine details distinctly without overlap. When measuring resolving power, parallel lines and spaces of the same width are photographed at great reduction until a point is reached beyond which the lines fuse together into a solid mass. The number of clearly distinguishable lines at this point is referred to as the lines per millimeter of resolving power of the particular film. Resolving power is not a property, rather it is a synthesis of grain, acutance, and contrast characteristics capable of being refracted by a lens and perceived by the human eye in sound condition. Copying films have extremely high resolving power, above 225 lines per millimeter. Relatively slow films such as Kodak Panatomic-X have very high resolving power in the range of 136–225 lines per millimeter. Medium-speed films usually have a high resolving power in the range of 96–135 lines per millimeter. The most popular fast black-and-white films have medium resolving power in the range of

69–95 lines per millimeter, while even faster films have a lesser resolving capability.

Black-and-White Films

Black-and-white films today are selectively very popular, although they are far behind color films in total sales and usage. In commercial photographic reproduction as well as in the ordinary darkroom, black-and-white photography is less expensive and simpler to control. The photographer who wants to control his printing effects can most readily do so with this medium. In a sense, the black-and-white medium is the more challenging one since the photographer is unable to lean upon the dramatic qualities of color alone to achieve pictorial interest and dramatic color effect. The subject must have its own strong interest qualities. This medium is particularly advantageous in depicting textures and recording what might be called documentary scenes and moods. Since the photographer is operating within one monochromatic range from white to black with intermediate shades of gray, he is obliged to focus critically, avoid blur, and achieve technically good results in contrast and grain; the viewer is more likely to be conscious of defects in the absence of pleasant or distracting colors.

The gray-scale rendition of different colors in the spectrum can be modified by using color filters specifically designed for black-and-white film, as described below. Also, pictorial contrast can be controlled or modified more readily through exposure, development, and darkroom manipulation than in the case of color.

The film speeds of black-and-white films can be correlated with the properties of fine grain, film contrast, and acutance. The slower black-and-white films tend to be more contrasty but also yield practically grainless results and smooth texture if properly exposed and developed. The most commonly used black-and-white films are the high-speed films of ASA 400 or DIN 27. Even these films exhibit very acceptable grain if properly exposed and developed. These include Agfa Isopan Ultra, Ilford HP5, and Kodak Tri-X Pan. The intermediate Isopan ISS (100), Ilford FP4 (125), and Kodak Plus-X Pan (125). The slower speed films are almost in the category of specialty films in that they are used by people who want to have exceptionally fine, plastic, almost grainless results for giant blowups or in photocopying. The most commonly used films in this category are in the range of ASA 25 through 50 (DIN 15 through 18), including Agfapan 25 and Agfa Isopan IF (40), Ilford Pan F (50), and Kodak Panatomic-X (32.)

A summary listing of these and other films available throughout the world, although not necessarily in each country, is included in the accompanying table. This table also includes films not listed above, particularly specialty films used in copying, extreme fine-grain reproduction, infrared photography, extreme low-level light photography, and photomicrography.

The high-speed black-and-white films are sometimes rated by photographers at higher film speeds and then given forced or pushed development. For everything, of course, there is a trade-off. In this case, forced development is at the expense of increased grain size. Best results are achieved with low-contrast subjects illuminated fairly evenly.

Many of the films listed in the accompanying table are available in bulk loads for use either in loading one's own film magazine or for loading the special 250-exposure and 750-exposure magazines intended for use with Nikon motor drives. Motion picture films having identical names as films packaged for 35mm

NIKON FILTER USAGE

Film	Type		Designation	Filter factor		Use
				Daylight	Tungsten light	
Black & white and color	Skylight		L1A	1	1	Reduces bluish cast of scenes taken with color film in open shade, distant landscapes, etc. to produce more natural effect. Also cuts haze to reveal more details. L1B produces more prominent effect and it has remarkable filter stability. Leave L1B on lens as a protector.
			L1B			
	Ultraviolet		L37	1	1	Completely cuts out ultraviolet light invisible to naked eye. Has no effect on visible light. Cuts out haze. L37 absorbs ultraviolet light shorter than $370m\mu$ in wavelength while L39 cuts out wavelength shorter than $390m\mu$. Exposure factor is approximately 1. Suitable for general use, if more clear-cut results are desired. Leave L37 on lens as a protector. Use L39 instead to produce a more prominent effect in black-and-white photography.
			L39			
Black & white	Yellow	Light	Y44	1.5	1	Absorbs moderately ultraviolet, violet, and blue light for darkening skies and making clouds stand out with black-and-white film. Light yellow filters are suitable for outdoor portraits as they produce more natural rendering of skin tones. As filter factor increases, color deepens and effect becomes more pronounced.
		Medium	Y48	1.7	1.2	
		Deep	Y52	2	1.4	
	Orange		O56	3.5	2	Has wider absorption range than yellow filters for more pronounced contrast. Accentuates any subject in which yellow, orange, or red predominates. Good for accenting detail in textures of trees, stone, sculpture, etc.
	Red		R60	6	5	Creates most striking contrast and brings out distant scenes. Red and orange are especially emphasized. Red filters are sometimes used to create night-time effect by underexposing. Also used for infrared photography with infrared film.
	Green	Light	X0	2	1.7	Absorbs ultraviolet, blue, and red, either partially or completely. Color balance of subject must be considered carefully because of filter's tendency to cut out both blue and red simultaneously. Each color reproduced with almost same balance of light and shade as seen by naked eye. Suitable for portraits and for multicolored subjects in general. X1 filter used under tungsten light to prevent overemphasis on red areas of subject.
		Deep	X1	5	3.5	
Black & white and color	Polarizing		Polar	2-4	2-4	Eliminates various degrees of reflected light from glass, water, tile and similar surfaces. Useful for photographing through glass windows or underwater. Not effective for metal surfaces because polarization is imperceptible.
	Neutral density		ND4X	4	4	Subdues all colors uniformly. Useful for photographing extremely bright subjects like light sources or when lens is used at large aperture to minimize depth of field. Can be used with either black-and-white or color films as filter itself is colorless.
			ND8X	8	8	
			ND10X	10	10	
Color	Amber	Light	A2	1.2		Used with daylight film to avoid blue tinge likely to occur when photograph is taken in shade, in cloudy weather, or indoors using light from north window in fair weather.
		Deep	A12	2		Used with color film balanced for tungsten light when shooting outdoors in fair weather. Reduces blue tinge.
	Blue	Light	B2	1.2		Used with daylight film to prevent red-yellow cast characteristic of shots taken three hours or so before sunset or after sunrise.
		Medium	B8	1.6		Used with daylight film and clear flashbulbs to eliminate excessive red-yellow cast.
		Deep	B12	2.2		Used with daylight film to avoid red-yellow cast caused by using photo-flood lamp indoors.

still cameras are not necessarily the same. Their emulsion characteristics and development requirements may vary substantially. Also, they do not have the same protective backing as still camera films to minimize scratching.

Color Films

The two different types of color films were discussed at the beginning of this section. A few additional notes on usage are added here. Color slides, made with reversal or color positive film, are intended primarily for hand-viewing or screen-projection, although prints can be made from them by first making an additional internegative, which in turn is printed on paper. Although this is an indirect approach, many people prefer it to using the original color negative films in the camera for reasons of convenience and cost. The difficulty in selecting pictures from strips of negative color film is that the color tones are all reversed and therefore do not approximate original colors. Selection for print-making is more convenient with color slides because they do show subjects more or less in their natural colors.

For projection purposes, the simplest and least expensive procedure is to use reversal film in the camera. If desired, however, pictures in negative color can be converted into color transparencies by most color photofinishers or in personal darkrooms. Another advantage of negative color is that it can be used for making black-and-white prints; for this purpose, special papers are recommended, such as Kodak Panalure.

Color slide films are designed for use with specified types of illumination—daylight, photoflood lamps whose color temperature is 3400 K, and studio lights whose color temperature is 3200 K. Each type of color film must be used with the light source for which it is designated.

If it is to be used with another light source, a conversion filter specified by the film manufacturer must be placed over the camera lens. In both theory and practice, mixing two or more different types of lighting in the same scene should not be done since the film will respond differently to each. Nevertheless, there are some occasions when the warm effect of ordinary indoor lighting might be desirable in a mixture with light coming in through the windows for exposure on daylight film.

Ordinarily, a daylight film would not be used with artificial light as the primary source, even with a conversion filter for the artificial light, unless the camera happened to be loaded with that film. The reason for this is that suitable conversion filters for this adjustment substantially reduce the film-speed rating, thus restricting flexibility of use under indoor lighting conditions.

Color slide films made for use with artificial light are designated as tungsten films. They can be used in daylight with some reduction in film speed because of the conversion filters. Usually, the adjusted or converted film speed is comparable to that of a daylight version of the same film. In practice, however, this procedure is more satisfactory with rangefinder-type cameras than with single-lens reflex cameras, since placing salmon-colored filters in front of the lens interferes with normal viewing and focusing. Nevertheless, it is well to keep in mind that a tungsten film can be used outdoors with the appropriate filter.

Two artificial light sources balanced for daylight films are electronic flash and blue-tinted flashbulbs. Therefore these can be used with daylight films both indoors and outdoors. When used indoors, their power is usually sufficient to overcome the effects of existing household illumination.

Some electronic-flash units tend to yield slightly bluish tints in pictures be-

EXPOSURE* AND FILTER COMPENSATION FOR THE RECIPROCITY CHARACTERISTICS OF *KODAK* COLOR FILMS

Film	Exposure Time (Seconds)					
	1/1000	1/100	1/10	1	10	100
KODACOLOR II Film	None No Filter	None No Filter	None No Filter	+½ Stop No Filter	+1½ Stops CC10C	+2½ Stops CC10C + CC10G
VERICOLOR II Professional Film, Type S (Short Exposure)	None No Filter	None No Filter	None No Filter	Not Recommended		
VERICOLOR II Professional Film, Type L (Long Exposure)	Not Recommended		None No Filter	+⅓ Stop No Filter	+⅔ Stop No Filter (5 Sec.)	+1⅔ Stops CC20Y (60 Sec.)
EKTACHROME 64 Professional Film, Daylight Type	+½ Stop No Filter	None No Filter	None No Filter	+½ Stop No Filter	+1½ Stops No Filter	Not Recommended
EKTACHROME 200 Professional Film, Daylight Type	+½ Stop No Filter	None No Filter	None No Filter	+½ Stop CC10R	Not Recommended	
EKTACHROME 50 Professional Film, Type B	None No Filter	None No Filter	+½ Stop No Filter	+1½ Stops No Filter	+½ Stop No Filter	+1½ Stops No Filter
EKTACHROME 160 Professional Film, Type B	None No Filter	None No Filter	None No Filter	+½ Stop CC10R	+1 Stop CC10R	Not Recommended
KODACHROME 25 Film, Daylight Type	None No Filter	None No Filter	None No Filter	+1 Stop CC10M	+1½ Stops CC10M	+2½ Stops CC10M
KODACHROME 64 Film, Daylight Type	None No Filter	None No Filter	None No Filter	+1 Stop CC10R	Not Recommended	
KODACHROME 40 Professional Film, Type A (3400 K)	None No Filter	None No Filter	None No Filter	+½ Stop No Filter	+1 Stop No Filter (5 Sec.)	Not Recommended

*The exposure increase, given in lens stops, includes the adjustment required by any filter or filters suggested.

Note: The data for each film in the above table apply only to the type of illumination for which that film is balanced, and the figures are based on average emulsions.

Exposure and filter compensations for the reciprocity characteristics of Kodak color film. (Courtesy Eastman Kodak Co.)

cause the flash output is somewhat higher color temperature than daylight film. Manufacturers have corrected this in many or most cases by tinting the flash window. If, however, your own flash unit yields excessively blue pictures, this may be corrected through use of an appropriate warm-tinted gelatin in front of the window.

Color print or negative film can, in theory, be used with any one source of illumination. In practice, they are used most commonly outside of photographic studios in daylight or with electronic or blue flash or a combination of these. When photoflood lamps (3400 K) are used, an 80B filter is recommended with an exposure factor of about 3.2. When studio lamps whose color temperature is 3200 K are used, an 80A filter whose ex-

posure factor is 4× is recommended.

With any of the color film types, selection of a particular brand is a matter of personal preference. Some film brands reproduce original color more faithfully than others do—some have a tendency to be cool and others tend to be warm. No color films reproduce all of the colors of nature with absolute fidelity even under the most ideal circumstances. What is a pleasing effect for one photographer or viewer may not be pleasing for another. Hence, film selection is a personal matter. It is, however, influenced by what one is accustomed to seeing most predominantly in his country.

One of the most widely used color films has been Kodachrome II, now superseded by Kodachrome 25. Both are extremely fine-grained and therefore capable of producing enlargements of maximum size. Kodachrome II tended to exaggerate color contrasts and to oversaturate hues and so endeared itself to publications with mass readerships. Many editors actually demanded Kodachrome transparencies from their staffers and freelancers. Kodachrome 64 similarly replaced Kodachrome-X.

The Kodak films are discussed here because they are the most extensively used. The photographer who does most of his picture taking within the same geographic area may make individual decisions regarding the use of alternative films. The photographer who travels a great deal and needs to be assured of ready availability of films with which he is familiar, or which can be processed quickly in his own laboratory or through a commercial laboratory that he uses regularly, may wish to concentrate on the Kodak films. Photographers in Germany might, in the same vein, prefer Agfa, Ilford in Britain, and Fuji in Japan, as examples, although Kodak films are available in these countries also. Problems of film selection are covered in the concluding section of this chapter.

In the range of film speeds, from slow to fast, differences in grain, acutance, and contrast will be evidenced as described in the earlier discussion in this chapter. Additionally, it may be said that the slower films tend to be more saturated—richer color rendition—than do the high-speed color films.

Black-and-White Films for Existing-Light Photography

The standby black-and-white film for low-light photography is Kodak Tri-X Pan rated by the manufacturer at ASA 400 and sometimes "pushed" to exposure indexes of 650, 800, 1200, 1600, or even 3200. The manufacturer—who has a stake in helping you get the best results with his product—insists that for the best full-tonal-scale outcome you should use the film as rated at ASA 400. (The difference in nomenclature between ASA and EI is that the former is an official rating while an exposure index is anything you select for your purposes, whether official or personal.) When you assign a higher exposure index to a film it will actually be underexposed for normal development. In order to build up the image for normal printing you have to "push" development by extending its duration with a normal developer or by using a special-purpose developer which will have its unique time-and-temperature requirements to achieve optimal negative density. What does this accomplish? Wherever there is an image recorded on film its density will be built up through pushed or forced development; wherever you have no recorded image details you will not be able to build up density of any kind. Stated otherwise, you can always multiply something that exists; you cannot multiply zero.

Let us now see how this works out in three situations—high contrast, full tonal

range from high to low, and low contrast. Referring to contrast we have in mind the combined effects of the dark-to-light ratios of the scene itself and the illumination that is put into that scene. A high-contrast scene is characterized by a mixture of highlights and shadows and an absence of predominant middle tones. Under the best of circumstances, it is difficult for the film to accommodate good exposure for both. If you expose for the highlights, you have no shadow details recorded on film while if you record for the shadow details, you will burn out the highlights through overexposure. Under low-light conditions where you decide to expose for the highlights and achieve adequate negative density through pushing both the exposure index and development you will achieve the following results: (1) highlight density will be adequate for printing, (2) shadow details will continue to be lacking, thereby increasing contrast, and (3) film grain will be coarser. With some minor exceptions, as noted below, any forcing of additional speed out of the film will be offset by an increase in graininess, the extent depending on corresponding increases in time and temperature during development.

When the scene has an average distribution of highlights, middle tones, and shadow areas, with the middle tones predominating, you will in most cases expose for the scene average or the middle tones. With forced development the results will be: (1) there will be no increase in shadow details if these would not be recorded under normal exposure and development, (2) middle tones will be developed to a density adequate for printing with increases in graininess corresponding to treatment in development as described above, and (3) highlights will be blocked up on the negative so that they will print without detail.

The ideal condition for low-light photography is a low-contrast scene consisting mainly of middle tones or a short, compressed range of tones from high to low. With pushed development, you get these results: (1) push-processing might improve pictorial contrasts with some offsets in the form of coarser grain, subject to extent of pushing, (2) shadow details will be rendered more clearly because they will have been recorded on film in the first place, and (3) highlights will retain detail sufficiently so that they can be brought out through printing on paper.

The official Kodak recommendation for Tri-X is that its film speed of ASA 400 can be multiplied by $4\times$ (or 2 stops) for low-contrast or short-scale scenes resulting in an exposure index of 1600. For scenes of medium tonal range or contrasts, the multiplier can be 2.5 yielding an exposure index of 1000 (double the 400 to get 800 and add one-half of 400 to get 1000). For high-contrast scenes, Kodak recommends that increase be kept to $2\times$ or ASA 800. The use of any higher ratings, notwithstanding the developer chosen or the technique followed, would build up contrast without increasing shadow detail.

Ilford HP 5 is comparable in many respects to Tri-X. When developed in Kodak D-76 or Ilford ID-11, according to instructions, this film should be exposed at the recommended standard rating of ASA 400. When, however, the film is processed in Ilford Microphen it can be exposed at a rating of ASA 650. Furthermore, Ilford designed this film for applications requiring push-processing to EI 1600 or higher. Best results, however, are obtained at ASA 400.

An advantage of the ASA 400 group of films offered by leading manufacturers is that they are inherently less contrasty than the slower films. Hence, when pushed to ASA 800 they readily absorb pressures on contrast while not impairing fine-grain qualities noticeably. When rendition of shadow detail is important,

pushing of these films should be done only in low-contrast situations.

Thus far, we have discussed a strategy for obtaining the best technical yield from negatives under exposure and push development, considering such factors as blocking of highlights, increasing contrast, and building up of grain. Let us now consider another strategy: you might wish to enhance the feeling or impression of starkness. Your pictorial strategy might be to emphasize deep shadows in contrast with bright highlights within an overall impression of graininess. Governed by these criteria you can push to your heart's content.

Ever since 35mm photography came into its own, there has been some mumbo jumbo, witchcraft, and magic associated with both the low-light condition problem and the enhancement of fine-grain characteristics. (The early miniature camera clubs and some camera dealerships became focal points through which pioneer 35mm enthusiasts exchanged folklore and secret formulae.) Over the years, various commercially available developers had maintained an acceptability of their claims to develop films for satisfactory printability at exposure indexes far beyond those recommended by the manufacturers. While these do have a role in the darkroom, the principle still holds that no developer in the world will bring out shadow details that have not been recorded on the emulsion. If shadow details are not to be recorded at ASA 400, they are certainly not more likely to be recorded at ASA 3200 which represents 3 stops less exposure or 1/8 the amount of light recorded on film as compared to an exposure at ASA 400. To the extent that the specialty developers achieve claimed results, this stems from the ability to work up *recorded* shadow details without blocking highlights. For this reason, the specialty developers yield their best results in situations in which there is fairly even illumination over a scene in which there is no great range of contrast from high to low as regards significant details.

Chemical fogging constitutes another hazard of forced development to achieve adequate negative density at high exposure indexes. This is just another example of the truism that no advantages are attainable without some trade-off in cost, quality, or convenience.

This can be seen in the super speed Kodak 2475 Recording Film (ESTAR-AH Base), available both in 36-exposure cartridges and in bulk loads. The official data sheet suggests exposure at ASA 1000 as the norm and ASA 1600 for use as a "pushed" film, in both cases with development in Kodak DK-50. The advantage in using this film at either exposure rating is not apparent, for neither appears to perform as well as Tri-X at exposure indexes of 800 and 1200 in such standby developers as Kodak D-76 and Acufine. It is suggested that Kodak 2475 Recording Film is a go-for-broke film to be used at extreme exposure indexes such as ASA 6400 with development in a specialty developer such as Diafine. Grain will be gravelly, shadow detail will be practically nonexistent and the chemical fog level will be high, but you will record an image that otherwise might escape from posterity. Since Kodak 2475 Recording Film is coated on a thin-base Estar film, you can get as many as 50 exposures loaded onto the spool of a standard 36-exposure cassette. This would exceed the capacity of regular 35mm developing reels. Hence, you cannot load a spool to full capacity.

If you do not develop your own films, you must send them to custom photofinishers for development at other than standard exposure ratings. You must tell the custom finisher the exposure index you used so that he will be able to adjust development accordingly. Many photofinishers will let you specify a developer of your own choice.

Color Films for Existing-Light Photography

The existing-light favorite of photographers is Kodak Ektachrome 160, Type B, rated ASA 160. Its daylight counterpart is Kodak Ektachrome 200, rated ASA 200.

Some photographers who use both black-and-white and color films standardize on an exposure index of ASA 400 for both, in order to avoid confusion when changing from one to the other. The ASA 400 rating is achieved with Ektachrome 200 by increasing time in the first developer. For indoor work, other than with daylight room lighting or a mixture of daylight and tungsten, Ektachrome 160 Type B must be used; it can be exposed at ASA 400 or 640 depending on the length of time in the first developer.

Quality loss in pushed color reversal film shows up in increased graininess, at least slight shifts in color, increased contrast, and loss of true blackness.

The most recent breakthrough in available-light color photography concerns the introduction of the ASA 400 color-negative films, such as Kodacolor 400 and Fujicolor 400. These high-speed films have a "universal" color balance, which helps to achieve acceptable results under conditions of mixed lighting.

A Professional Viewpoint on Film Selection

One chooses a film with due regard for all of its working attributes, as described above. Selection and use of a black-and-white film must take account of the exposure rating to be used—the officially recommended one or a modified rating—and the best match of developers. Inevitably this brings up the subject of pushing of film speeds and the selection and use of magical developers. Such topics have carried the talk of zealots far into the night. The early miniature camera clubs thrived on the swapping of secrets of the developing tank.

How do present-day professionals make use of black-and-white films and what special treatment, if any, are they given in the darkroom? Presented here are the views of Al Wadman and Bill Moravek, active principals in the operation of Image, Inc., a leading custom laboratory serving the Washington, D.C. area. (This custom lab is not to be confused with any other having the same name in any other city.)

Although they process films of just about every make and acknowledge that there are many good films on the market which successfully compete with the Kodak films in one or more respects, they point out that there must be some particular reasons why professional photographers, in the United States at least, gravitate overwhelmingly to the Kodak yellow box. (The author, having seen wonderful black-and-white prints made by his British friends, as well as photographers in other countries who use Ilford films and papers, observes that they, too, have worked out reasons for their preferences. Above all, professionals demand predictability. They find combinations of film, exposure ratings, and development that give desired control. It is possible for British or German preferences to be substituted for what follows, but not as to world-wide availability.

The reasons given for the popularity of Kodak films are flexibility, pushability, and availability.

Flexibility. The principal Kodak emulsions are designed to provide the widest possible latitude in exposure and have unusually fine grain compatible with available film speeds. The working photographer knows that his films will be forgiving in exposure requirements and will permit extreme enlargements when necessary to permit picture-crops which were not feasible when composing the picture on location due to time or equipment limitations or human error.

Pushability. Tri-X, HP-5, and color films such as Ektachrome 400, Ektachrome 200,

and Ektachrome 160 (Type B) can be used to produce full-scale prints and sharp transparencies under astonishingly wide variations in available light ranging from dimly lit churches and nightclubs to brilliantly illuminated deserts and seascapes. The pro can limit his inventory, especially when travelling, to only a few emulsions—or even to one—because of the elasticity of film speeds (coupled with developing) of the several films.

Availability. The assurance that Kodak films are likely to be found in most places in the world and all over the United States enables the photographer to carry on with his accustomed procedures without having to switch over to emulsions with which he has had little or no experience. Stated otherwise, the busy professional, having calibrated his procedures for one or two emulsions in black and white and color, respectively, need not be diverted into fumbling with exposure controls due to the use of unfamiliar materials, but remains free to concentrate on the crux of his task—visualizing and capturing a fine image.

"Miracle soups, magic pre- and after-treatments, fancy emulsions that may be hardly available and a plethora of other chemical prestidigitations have all had their day in court," say the Image people. "Amid the babble we find here and there a truth, now and then an insight and an occasional schorlarly and precise treatment so carefully worded as to be meaningful only to the most sophisticated and persistent believer. Attempts at the spectacular overlook the few, simple, and widely used (if not always understood) realities that govern the working professional."

These realities are discussed here in terms of what is undoubtedly the hardest worked black-and-white 35mm film in the world—Kodak Tri-X Pan. Its official exposure rating is ASA 400. This rating has been determined in accordance with professionally agreed standards of the American National Standards Institute (previously the American Standards Association). The ASA rating is a sensitivity index which will enable the photographer to give just enough exposure to the film to record as a barely separable tone the deepest shadow in the scene with which he is working. It is a characteristic of the film that "no soup, no magic, no amount of talking, manipulation or even self-deception can change," say the Image experts, and we include UFG—of which we use a lot—Acufine borax hop-ups and all the other potions conceived by man. The speed is 400. If you want shadow detail, expose at that rating; you won't get it with pushing. Kodak D-76 used as instructed will exploit all of the film speed and will achieve the finest grain the film can produce.

The achievement of the finest shadow detail is not, however, necessarily the ultimate objective of a photographer. There are times—perhaps more often than not—when getting a picture, recording any kind of an image, in fact, will take priority over the niceties of shadow detail. The Image people say that this occurs frequently with their professional customers. The photographer makes a conscious decision to abandon detail in the shadow areas in order to get a picture under existing-light conditions in an office, meeting room, home, or institution. He sets his meter at ASA 800 or higher so that he may be able to move the zone of effective exposure to cover middle tones and highlights. The film is then "pushed" or overdeveloped in a compensating developer such as UFG, Acufine, and others to yield highlights that are separated by the compensating action.

The Image people have advised their customers for years to shoot their Tri-X at an exposure index of 650. "This is a practical compromise for professionals," they say. In obtaining better tonal separations in the highlights, they sacrifice only a half-stop of shadow detail.

For the best of all worlds, Image recommends Tri-X exposed at a standard ASA 400 and developed in one of the Great Compensators such as UFG to yield a full, delicately rendered, tonal range bringing out deep shadow details and maximum possible separation of highlight tones. The fine grain permits the making of giant prints measured in feet, rather than inches, say Wadman and Moravek.

In summary, they recommend:

1. With plenty of light, expose Tri-X at 400, but process in UFG, Acufine, or a similar compensating developer.

2. Under average light, expose Tri-X at 650 for an extra margin of safety both in getting the picture and obtaining good highlight separation.

3. Under poor light, expose at the least pushed rating which will give you acceptable combinations of shutter speeds and lens apertures, but expect to lose shadow detail and, incidentally, latitude, in direct proportion to the amount of pushed exposure. E.I. 1600 is a practical maximum.

The Image strategy with Ektachrome 200 and Ektachrome 160 is somewhat different, particularly since it involves the use of their own laboratory facilities. Although the normal exposure ratings for Ektachrome 200 (Daylight) and Ektachrome 160, Type B (Tungsten) are ASA 200 and 160, respectively, Image offers a developing process which permits the shooting of pictures at exposure indexes of ASA 400, 600, 800, 1000 and 1200. Color shots otherwise totally infeasible have thus been reaching the press and magazines, for Image caters particularly to photojournalists. The pushed speeds for these films with Image developing yields true color rendition and maintains normal contrast. There are no color shifts with increasing push, although at the top speeds of ASA 1000 and 1200 the slightest red stain may be detected through careful check with a color densitometer. Grain increases with push, however, for this process requires overdevelopment in the first developer. Under some circumstances, this will be objectionable, but the demand for color photography of scenes that otherwise would not be captured may be a compelling argument in favor of this procedure or any other that enterprising laboratories elsewhere might offer to their customers. A note of caution: At high speeds, metering must be done carefully and precisely, for a one-third f/stop error at E.I. 1000 could be a monumental disaster.

Color films have much less latitude for exposure and darkroom manipulation than do black-and-white films. Accordingly, the latter are still the favorites when the photographer wants to be sure of getting his picture.

Black-and-White Filters

The function of any filter is to allow that part of the visible light spectrum that corresponds to the color of the filter to pass through to the film while screening out or holding back other parts of the light spectrum. Thus, a red filter holds back light from the blue side of the spectrum so that, in black-and-white photography, a blue sky appears darker in a print because less of its light reaches the film to build up density. A red rose against the blue sky would appear lighter, since the red light passing through without interference is given additional exposure. For this reason, a red filter is not likely to be used in making a portrait of a woman with red lips since they would be likely to come out unduly light. To similar effect, a green filter will lighten green foliage while rendering colors from the red end of the spectrum much darker. Green filters are used in portraiture because they accentuate the warmer tones of lips and face.

The uses of filters in black-and-white photography include changing the tonal qualities of colors reproduced in monochrome; eliminating haze due to excessive ultraviolet radiation; reducing over-

FILTER FACTOR AND APERTURE INCREASE

Filter Factor	Aperture Increase	Filter Factor	Aperture Increase	Filter Factor	Aperture Increase
1.1X	1/7 stop	1.9X	6/7 stop	3.4X	1 4/5 stop
1.2X	1/4 stop	2.0X	1 stop	3.6X	1 5/6 stop
1.3X	2/5 stop	2.2X	1 1/7 stop	3.8X	1 6/7 stop
1.4X	1/2 stop	2.4X	1 1/4 stop	4.0X	2 stop
1.5X	3/5 stop	2.6X	1 2/5 stop	4.5X	2 1/6 stop
1.6X	2/3 stop	2.8X	1 1/2 stop	5.0X	2 1/3 stop
1.7X	3/4 stop	3.0X	1 3/5 stop	5.5X	2 1/2 stop
1.8X	5/6 stop	3.2X	1 2/3 stop	6.0X	2 3/5 stop

all light levels when working with excessively fast films in daylight; and improving contrast in long-range photography. One of the accompanying tables describes all of the Nikon filters and the effects achieved with each. The other table is a guide to selecting filters that will lighten or darken subjects of indicated colors.

The main use of filters in black-and-white photography, other than in altering tonal qualities of particular objects, is in darkening the sky to emphasize cloud formation. Yellow, orange, or red filters are used for this purpose; the most pronounced effects are achieved with the orange and red filters. These filters are also used to bring out detail in long-distance photography by enhancing tonal contrasts.

Haze or fog effects may be accentuated by using a blue filter. This filter also accentuates the halo effect around automobile headlights and street lamps.

Through-the-lens exposure readings will automatically compensate for the reduction in light caused by the use of filters provided they are light or moderately light. The deeper-toned filters may affect exposure-reading accuracy. In such cases, exposure readings are made without filters in place and exposure settings are adjusted for particular filter-exposure factors.

In critical focusing, filters should always be in place as the plane of sharp focus might be altered if filters are added after focusing.

The use of UV, polarizing, and neutral density filters is discussed at the end of this chapter in relation to both black-and-white and color films.

FILTER SELECTION GUIDE
Black-and-White Films

Color of Subject	Filter Selection To Lighten	To Darken
BLUE	blue	red or orange
BLUE-GREEN	blue or green	red or orange
BROWN	orange or red	blue
GREEN	green or orange	red or blue
MAGENTA	red	green
ORANGE	yellow, orange, or red	light green or blue
PINK	red	green
PURPLE	blue	green
RED	red	blue or green
VIOLET	blue	red, green, orange, or yellow
YELLOW	yellow, green, orange, or red	blue

FILTER RECOMMENDATIONS FOR
BLACK-AND-WHITE FILMS IN DAYLIGHT

Subject	Effect Desired	Suggested Filter
Blue Sky	Natural	Yellow
	Darkened	Deep Yellow
	Spectacular	Red
	Almost black	Deep Red
	Night effect	Deep Red plus polarizing screen
Marine Scenes When Sky is Blue	Natural	Yellow
	Water dark	Deep Yellow
Sunsets	Natural	None or Yellow
	increased brilliance	Deep Yellow or Red
Distant Landscapes	Addition of haze for atmospheric effects	Blue
	Very slight addition of haze	None
	Natural	Yellow
	Haze reduction	Deep Yellow
	Greater haze reduction	Red or Deep Red
Nearby Foliage	Natural	Yellow or Yellow-Green
	Light	Green
Outdoor Portraits Against Sky	Natural	Yellow-Green, Yellow, or polarizing screen
Flowers—Blossoms and Foliage	Natural	Yellow or Yellow-Green
Red, "Bronze," Orange, and Similar Colors	Lighter to show detail	Red
Dark Blue, Purple, and Similar Colors	Lighter to show detail	None or Blue
Foliage Plants	Lighter to show detail	Green
Architectural Stone, Wood, Fabrics, Sand, Snow, etc. When Sunlit and Under Blue Sky	Natural	Yellow
	Enhanced texture rendering	Deep Yellow or Red

Filters for Color Films

Necessarily, filters for color films have been discussed in some measure in the course of describing the different types of color films that are available. Here, we will cover the three major types of filters used with color films to achieve conventional effects. For unusual effects, any filter may be used. For example, orange-red filters may be used to simulate sunsets or to darken the sky in wide-angle lens photography, when there is a great deal of sky included in the picture, especially when the sky may be burned out as compared to ground objects or when the sky is otherwise colorless.

The three types of filters most commonly used with 35mm color films are color conversion filters, light balancing filters, and color compensating filters.

Color conversion filters permit the corrected use of tungsten films in daylight and vice versa. Filters that convert from tungsten to daylight are in the Wratten 85 series and are recognizable by their salmon color. Conversion from daylight to tungsten is accomplished with blue-tinted filters in the Wratten 80 series.

Light balancing (LB) filters are used to achieve minor adjustments to bring the color temperature of the light source and that of the film into balance. This need could occur indoors when there are fluctuations in line voltage or when light sources have aged so that in either case there is a departure from standard output. Other uses pertain to shifts in color temperature of sunlight before and after high noon. To be exact one would need to use a color-temperature meter since this is the only objective method for evaluating the color output of the lighting sources.

Color compensating (CC) filters are used to make changes in the overall color balance of a scene as well as to compensate for basic qualitative deficiencies in a light source. A common example of the latter is the use of filters to compensate for the excessive green output of fluorescent illumination.

Also, some filter manufacturers now offer single filters for each of the two types of films—daylight and tungsten.

CONVERSION FILTERS FOR COLOR FILMS

Filter Color	Filter Number	Exposure Increase in Stops*	Conversion in Degrees K	Mired Shift Value
Blue	80A	2	3200 to 5500	−131
	80B	1⅔	3400 to 5500	−112
	80C	1	3800 to 5500	−81
	80D	⅓	4200 to 5500	−56
Amber	85C	⅓	5500 to 3800	81
	85	⅔	5500 to 3400	112
	85N3	1⅔	5500 to 3400	112
	85N6	2⅔	5500 to 3400	112
	85N9	3⅔	5500 to 3400	112
	85B	⅔	5500 to 3200	131

*These values are approximate. For critical work, they should be checked by practical test, especially if more than one filter is used.

SELECTED PRACTICAL SOURCES OF ILLUMINATION AND THEIR COLOR TEMPERATURES

Source	Color Temperature (Degrees Kelvin)	Mired Value
Sunlight (mean noon)	5400	185
Skylight	12000 to 18000	83 to 56
Photographic Daylight*	5500	182
Crater of carbon arc (ordinary hard-cored)	4000	250
White-flame carbon arc	5000	200
Flashcube	4950	202
High-intensity carbon arc (sun arc)	5500	182
Clear zirconium foil-filled flash	4200	238
Clear aluminum foil-filled flash	3800	263
500-watt (photoflood) approx. 34.0 lumens/watt	3400	294
500-watt (3200 K photographic) approx. 27.0 lumens/watt	3200	312
200-watt (general service) approx. 20.0 lumens/watt	2980	336
100-watt (general service) approx. 17.5 lumens/watt	2900	345
75-watt (general service) approx. 15.4 lumens/watt	2820	353
40-watt (general service) approx. 11.8 lumens/watt	2650	377

*Condition of daylight which best represents that encountered in typical photographic situations.

KODAK LIGHT BALANCING FILTERS

Filter Color	Filter Number	Exposure Increase in Stops*	To Obtain 3200 K from:	To Obtain 3400 K from:	Mired Shift Value
Bluish	82C + 82C	1⅓	2490 K	2610 K	−89
	82C + 82B	1⅓	2570 K	2700 K	−77
	82C + 82A	1	2650 K	2780 K	−65
	82C + 82	1	2720 K	2870 K	−55
	82C	⅔	2800 K	2950 K	−45
	82B	⅔	2900 K	3060 K	−32
	82A	⅓	3000 K	3180 K	−21
	82	⅓	3100 K	3290 K	−10
No Filter Necessary			3200 K	3400 K	—
Yellowish	81	⅓	3300 K	3510 K	9
	81A	⅓	3400 K	3630 K	18
	81B	⅓	3500 K	3740 K	27
	81C	⅓	3600 K	3850 K	35
	81D	⅔	3700 K	3970 K	42
	81EF	⅔	3850 K	4140 K	52

*These values are approximate. For critical work, they should be checked by practical test, especially if more than one filter is used.

COLOR FILM—LIGHT SOURCE—FILTER

(for color films not listed here, see film instruction sheet)

Film	Daylight		Any Clear Flashbulb		3400 K Photoflood		3200 K Photoflood		Any Blue Flashbulb or "Daylight" (blue) Photoflood	
	Film Speed	Filter	Film Speed	Filter	Film Speed	Filter	Film Speed	Filter	Film Speed	Filter
Kodachrome 25 Daylight	25	none	12	80C	8	80B	6	80A	25	none
Kodachrome 64 Daylight	64	none	32	80C	20	80B	16	80A	64	none
Kodachrome 40	25	85	32	81C	40	none	32	82A	25	85
Kodacolor II	100	none	50	80C	32	80B	25	80A	100	none
Kodacolor 400	400	none	200	80C	125	80B	100	80A	400	none
Vericolor II Professional Film, Type S	100	none	50	80C	32	80B	25	80A	100	none
Ektachrome 64 Daylight	64	none	32	80C	20	80B	16	80A	64	none
Ektachrome 200 Daylight	200	none	100	80C	64	80B	50	80A	200	none
Ektachrome 160 Type B	100	85B	125	81C	125	81C	160	none	100	85B
Fujichrome 100	100	none	50	80C	32	80B	25	80A	100	none
Fujicolor N-100	100	none	50	80C	32	80B	25	80A	100	none
Agfachrome 64	64	none	32	80C	20	80B	16	80A	64	none
Agfachrome 100	100	none	50	80C	32	80B	25	80A	100	none

Note: Flashbulbs have no true Color Temperature. However, for purposes of comparison, the following approximate Color Temperature ratings may be used: Clear foil-filled flashbulbs—3800 K. Blue filtered flashbulbs—5500 K.

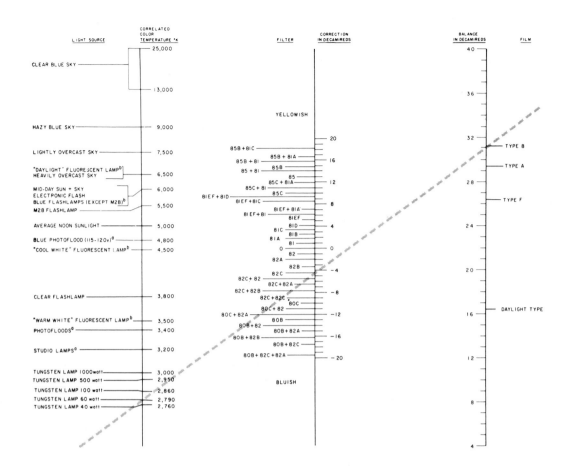

Color Filter Nomograph. Here's how to select the proper filter for almost any combination of color film and light source. Place a straight edge across the nomograph above so that it lines up with the color film and light source you're using. Read the proper filter at the point where the straight edge crosses the middle column. Dotted line example shows that for Type B film and 60-watt tungsten source, the proper filter is an 82C. This chart, prepared by C. S. McCamy of the National Bureau of Standards in Washington, D.C., is reprinted here courtesy of *Modern Photography* Magazine.

MIRED VALUES OF COLOR TEMPERATURES FROM 2000–6900 K

K	0	100	200	300	400	500	600	700	800	900
2000	500	476	455	435	417	400	385	370	357	345
3000	333	323	312	303	294	286	278	270	263	256
4000	250	244	238	233	227	222	217	213	208	204
5000	200	196	192	189	185	182	179	175	172	169
6000	167	164	161	159	156	154	152	149	147	145

Neutral Filters

The three different kinds of filters that may be used either with color or black-and-white films, in that they do not alter light-spectrum characteristics or overall color tones, are ultraviolet (UV), polarizing, and neutral density (ND).

Almost any filter will screen ultraviolet radiation as a secondary function, but only UV filters will perform this function exclusively without otherwise interfering with color rendition. The main use of a UV filter is to exclude excessive ultraviolet radiation in outdoor photography, especially when there is a great deal of sky reaching into the distance. The aim is to minimize the effect of a blue haze, which accounts for the term *haze filter*. In large measure, the coating of Nikkor lenses performs a UV-screening function. Such a filter is desirable, nevertheless, when there is excessive or pronounced radiation, as indicated. A secondary use for the UV filter is in providing protection for the front surface of the lens, particularly under windy, dusty, or wet conditions.

Polarizing filters are probably the least understood of the entire range of filters, yet they offer diverse opportunities for controlling pictorial effects with both black-and-white and color films. Conven-

tionally, the most commonly understood uses for polarizing filters are for darkening the sky (but only blue sky) without altering the tonal or color properties of the rest of the scene and for removing unwanted reflections from glass, water, and highly polished or bright (non-metallic) surfaces. An additional use of the polarizing filter is that of a neutral density filter corresponding to the indicated exposure factor. Probably the most important use of polarizing filters in color photography is for improving color saturation by screening out ambient reflections from particulate matter in the air. In some measure, even black-and-white scenes are improved in this regard. In discussing these various applications, the most conventional uses will be covered first.

To darken a blue sky, the polarizing filter is rotated in its mount while you observe the effect on the viewing screen. The darkest sky effects are achieved when the sun is at a 90-degree angle from the optical axis. Hence, the most pronounced effects are achieved either early or late in the day.

The elimination or minimization of unwanted reflection is also achieved by observing effects of the polarizing filter as it is being rotated in its mount. Cam-

SOME CHARACTERISTICS OF NEUTRAL DENSITY FILTERS

Density	Per cent of Transmission	Approximate Fraction of Light Passed	Approximate Increase in Stops	Approximate Equivalent Filter Factor
0.10	80	4/5	$\frac{1}{3}$	1.25
0.20	63	2/3	$\frac{2}{3}$	1.6
0.30	50	1/2	1	2.
0.40	40	2/5	$1\frac{1}{3}$	2.5
0.50	32	1/3	$1\frac{2}{3}$	3.1
0.60	25	1/4	2	4.
0.70	20	1/5	$2\frac{1}{3}$	5.
0.80	16	1/6	$2\frac{2}{3}$	6.3
0.90	13	1/8	3	7.9
1.00	10	1/10	$3\frac{1}{3}$	10
2.00	1.	1/100	$6\frac{2}{3}$	100
3.00	0.10	1/1,000	10	1000
4.00	0.010	1/10,000	$13\frac{1}{3}$	10,000

era position may need to be altered because the greatest control of reflection is achieved when the camera is positioned so that its optical axis is at an angle of 32–37 degrees from the target surface, with the optimum angle being 34 degrees. The important reflections to be controlled in this way are those bounced off eyeglasses, water, store windows, and other nonmetallic polished or shiny surfaces. Sometimes, however, you don't want to use a polarizing filter to eliminate reflections from store windows or other surfaces, because you want to retain some very interesting effects. To minimize reflections from metallic surfaces, you would need to use polarizers on both the lens and the light source. You must be careful, however, to avoid achieving dull, flat effects.

In the case of paintings, textured materials, and irregular surfaces, bright highlights beyond the contrast range of the film are recorded as burned out points. These range from tiny to broad areas. The broad measurable areas are recognizable for what they are, but the tiny reflections bring about a dilution of color saturation. Since the reflections are at infinitely variable angles to the optical axis, selective positioning of the camera is likely to accomplish very little if anything. From whatever shooting position one chooses, however, when using a polarizer, there will be a dramatic reduction in specular reflections. These effects are pertinent even with portraits, since skin is also textured and, additionally, perspiration and oily prominences add to specular highlights.

In open scenes, a diffused mass of particulate matter also reflects light that, superimposed upon the overall scene, reduces subject contrast. Obviously, the camera cannot be positioned at any particular angle due to the random reflective pattern from tiny irregular surfaces. You can, however, experiment for optimal effect. In any event, the result is a better saturation and enrichment of colors due to the elimination of the diluting ambient reflection. Because of the random angles of reflection, departing from the optimal 34-degree angle of reflection will subordinate enough highlight reflections to bring about dramatic improvements in effect.

The one important trade-off when using polarizing filters is that they reduce substantially the amount of light reaching the film. From a procedural standpoint, this is referred to as exposure factoring. The exposure factor indicated for the polarizing filter can be used as a general guide, but it is well to individualize the factor by taking readings with and without the filter for individual exposure circumstances. Maximum effects (accompanied by maximum reductions in available light for image recording) are attainable' when polarizing filters are used both at the light source (in indoor photography) and at the lens. The exposure factors for the separate filters must be multiplied (not added). Optimal effects are achieved when the double polarizers are at right angles to each other.

Polarizing filters can be used in combination with color screening filters. Again, the exposure factor is obtained by multiplying the two separate factors. Some specialty filter manufacturers offer combination filters that combine in a single piece of glass a color screening filter and a polarizing filter. Two polarizing filters can be used in front of the lens to achieve variable degrees of neutral density filtering. By separately rotating the individual filter, more or less light (to the point of total blackout) can be used for exposure control.

An interesting creative use of the polarizing filter is to simulate night scenes. This is done by combining the polarizing filter with a yellow, orange, or red filter in the daytime and using black-and-white films.

Another interesting use of polarizing filters is for making projection charts.

Bright or luminous colored inks are used to draw chart information on a black background. These charts are then photographed with polarizing filters in front of the lens.

Polarizing filters can be used in front of both the lens and the light source for maximum effect, including flash illumination.

Neutral density filters are used to reduce the amount of light reaching the film either when use of the fastest shutter speed and smallest f/stop is not sufficient to reduce excessive illumination or when exposure values are to be reduced without altering f/stops. An example of the latter in which there is no other option is when simulated f/stop reduction is to be accomplished with reflex (mirror) lenses, which lack adjustable diaphragms. Neutral density filters are available in a wide range of transmission capabilities. The ND 2.00 filter is used in preflashing (or preexposure) film to reduce subject contrast. This filter transmits only 1/100 of the light.

Tips on Filters

Filters can be used in combination, but as a general rule the minimum number of filters should be used that will accomplish a desired effect. One reason for this is that each glass surface adds cumulatively to the amount of reflection, notwithstanding the coating of filters. Also, added glass in front of the lens changes optical performance, both as to focal length and spherical aberration. As a rule of thumb, no more than two filters or close-up lens attachments or combinations of any of these should be used in front of a lens.

In ordinary usage, individual filters are not likely to have much effect upon performance. Some small effects can be observed, however, with high-speed lenses at full aperture, when taking close-up pictures, when using thick filters, and when using inferior filters. The plane of sharp focus may shift slightly due to the use of a filter. A filter in front of a lens shortens its focal length slightly while a filter behind the lens lengthens it. This is why you are urged to focus with the filter in place. Focusing should be done on the most important image plane, for peripheral rays tend to fall in a different plane than do the central rays of light. The displacement of sharp focus from the center to the edge is equivalent to about one-third the thickness of the filter. Accordingly, there is a greater relative image displacement with shorter focal-length lenses than with longer ones. Under the most critical conditions with the use of artificial-light sources, an alternative that offers the greatest control is to filter the light sources themselves.

The Nikon line of filters is recommended because of the critical standards by which they are manufactured. They are made of solid glass with both surfaces critically parallel to each other, and they are hard-coated. Bargain filters should be avoided; some may be of excellent quality, but you would need assurance in each case in order not to impair performance quality of an expensive lens by using a cheap, inferior attachment. When independently made filters are used, you must be sure that they come from a source whose quality standards have been well established. Any optical distortions found in a filter of inferior make will be magnified by the lens, particularly by telephoto and long-focus lenses.

Filters should be handled with the same care as is given to lenses. They should be kept free of finger soil and, when cleaned, should be treated in the same manner as the lens itself.

The preferred order of closeness to the camera lens when attaching supplementary lenses or filters is: (1) close-up attachment lens, (2) polarizing filter, and (3) color filter. Again, the use of more than two of these simultaneously should be avoided.

CHAPTER 3

Flash, Flood, and Existing-Light Sources

This chapter covers both photographic and existing-light sources. The former consists of flash and flood sources intended specifically for use in photography while the latter consists of whatever available- or existing-light sources one needs to utilize in the home, office, factory, shopping center, or entertainment center. Because, in a technical sense, outdoor lighting is also available or existing lighting we will use the term low-level artificial lighting which, in the context of this chapter, we may also shorten to low-level lighting.

Artificial (or indoor) lighting is in many respects a more dependable source than outdoor lighting. With indoor lighting you can control backgrounds and you can put lighting sources where you want them to achieve predetermined contrast ratios, highlights, and shadows. Color temperature is more easily controlled without regard to time of day and atmospheric conditions due to standardization of light sources.

The main difference between management of daylight and artificial-light sources is that the former provides even illumination in depth so that foreground, middle ground, and background objects of the same reflectance qualities will be exposed on film identically. With artificial-light sources, one encounters the phenomenon of the inverse square law which has to do with the fall-off of intensity of light as it travels away from its source. Hence, because objects at different distances from the same light source will receive and reflect different amounts of light, thus causing variations in exposure, strategies must be followed to overcome or utilize light fall-off, as required in each situation. Also, the indoor photographer must be concerned with the reflection properties of walls, ceiling, and floor, for they add both light and color.

Exposure-measurement techniques with continuous-source artificial lighting are basically the same as those covered in the preceding chapter except for the problem of light fall-off. The measurement of flash illumination presents a basically different problem, for one must cope with an instantaneous or pulsar emission of light of 1/500 or 1/1000 sec. with most popular flash units. Accordingly, specific attention will be given to the various methods for determining proper flash exposure.

GENERAL CHARACTERISTICS OF
ARTIFICIAL LIGHTING

For purposes of this chapter, the term *artificial lighting* covers both flash (pulsar) as well as continuous-source lighting. Here we will take up the particular attributes of artificial-lighting sources including the inverse square law (light fall-off), effects achieved with the different kinds of lighting sources, and problems of background management including shadows, background reflectance, and background object placement.

The Inverse Square Law

All light diminishes in intensity as it travels away from its point of origin. The rate of fall-off diminishes with increasing distance from source. While theoretically this is applicable to light from the sun, differences in intensity of light falling on objects at different distances from the camera are not measurable due to the infinitely great distance of the sun from the earth as compared to distances separating objects on earth.

The inverse square law (or the law of light fall-off) may be stated as follows: *The intensity of light varies inversely with the square of its distance from its source.* To compare lighting intensities at different distances from the same light source, you must compare the squares of their distances. For example, to compare lighting intensities at distances of 3 feet and 5 feet from the same source, you would divide the square of 3 feet into the square of 5 feet or 9 into 25; this reduces to approximately 3, indicating a light fall-off ratio from front to rear object of about 3:1. As the distance between objects increases, measured from the same light source, the ratio of light intensity fall-off increases geometrically. Thus, between 3 and 6 feet the ratio of squares is 9 and 36 or 4:1; between 3 and 8 the ratio increases to 9:64 or approximately 7:1 when the figures are reduced and inverted.

When the two comparison targets are both at greater distances from the same light source, the rate of intensity fall-off is reduced. For example, where the distances are 5 feet and 7 feet from the same lighting source, the squares are 25 and 49 which reduce to almost exactly 2:1. The closer object will receive twice as much light as the more distant one. Note that in the first example of two objects at distances of 3 feet and 5 feet there were only 2 feet separating the two objects, but the light intensity ratio was 3:1.

The inverse square law provides the formula for the distribution of light traveling away from its source. Control of lighting ratios in multiple-flash photography is aided by knowledge of distance factors in placement of lighting units. In this diagram note that beam of light spreads out as it travels away from light source and that its intensity diffuses accordingly. At two feet each point receives one-fourth the light received at one foot. At three feet each point receives one-ninth the amount of light as at one foot. At four feet the point illumination would be one-sixteenth that of one foot. As a general rule, exposure settings at close distances must be critically correct. Close objects should be more or less at the same subject distance. Still another rule, which takes account of reflectance, is that a dark object can be a little closer than a light one, and vice versa. The lighting ratio between 1 and 2 feet is 1:4; between 2 and 3 feet it is 1:2.25; between 3 and 4 feet it is 1:1.8; and between 10 and 11 feet it is 1:1.2.

This concept of light behavior and measurement is applicable both to metric and foot systems. The following general rules may be stated in summary:

1. At very close distances, exposure calculations must be made precisely.

2. When working at a very close distance to a main lighting source, place the most important objects at about the same distance from that source.

3. To minimize differences in exposure when objects are at different distances from the same light source you can: (a) increase the distance of the light source from the two objects (using a longer lens if a flash is attached to the camera and is used in frontal lighting), (b) place a darker object closer to the light source than a lighter object, (c) use reflectors or supplementary lighting to compensate for fall-off, or (d) employ a combination of these techniques.

4. With black-and-white films you will have some margin of accommodation due to the generous exposure latitude of such films. With color films, however, you will have very little latitude for lighting differences. Hence, with color you must be more critical in the setting up of lighting arrangements and in making exposure determinations.

The foregoing is particularly applicable to direct or frontal lighting. The problems of uneven distribution of light due to the workings of the inverse square law may be overcome in large part through techniques of bounce illumination and other procedures for increasing the distance between lighting source and subjects.

The Dynamics of Light and Shade

Shadows are essential to give form and depth to objects and scenes. A single light source, as in daylight, may illuminate individual objects adequately, but the phenomenon of light fall-off makes it difficult, if not impossible, to obtain uniform distribution of light throughout an indoor area. Each lighting unit or fixture is the center or projection source for an area of illumination of diminishing intensity. Hence, for an ordinary room area, a photograph would show uneven distribution of lighting, sometimes with important objects or areas concealed in shadow. The lighting task in such a situation is to fill in shadow areas through combinations of direct and indirect lighting. Ordinarily, such lighting arrangements need to be set up only for limited room areas. There are, however, situations such as parties or other group functions in which one or more people are to be photographed apart from others. Possible approaches to such situations include the use of indirect or diffuse illumination (bounce or bare bulb) to enable the photographer to move around freely; an alternative possibility is to work fairly close to subjects so as to take advantage of a rapid rate of light fall-off to yield dark backgrounds.

The management of lighting of three-dimensional objects is also the management of shadows. If you work with multiple light sources you also are working with multiple shadow effects. Main light sources are ordinarily used to establish light levels and to give form to principal objects while secondary light sources, including reflectors, are usually employed to open up shadow areas or to eliminate them entirely.

Highlights also become a problem of management both through lighting control and through object control. A highlight is a bright spot located at a point on the object that forms an angle of reflection from a light source toward the lens. The brightness or concentration of the highlight will be governed by the reflectance properties of the surface, including texture and curvature. Highlights usually need to be subdued or

avoided entirely because they appear as distractions in a background or as hot spots devoid of color in the foreground.

This discussion of problems of light and shade is covered here in order to put the selection of lighting apparatus into some practical framework. More detailed suggestions on lighting techniques and setups are given below.

The High-Speed Light Mixer

The light emitted from any source travels at the rate of 186,000 miles per second; it is reflected at the same rate of speed from any object or surface within its path. When the light is reflected it may be dispersed to illuminate other objects from diverse angles, thereby filling in shadows. This is the basis for the use of the bounce-lighting technique in which light is directed toward a wall or ceiling from which it is reflected broadly onto the object or area to be photographed. The important point to keep in mind, however, is that even with direct lighting you must anticipate the additive and moderating effects of reflections from objects in the path of the light. These can be both good and bad, depending upon their placement. Quite often, as in portraiture, you will want to put reflectors in the path of the light, but out of reach of the lens, in order to redirect light toward shadow areas.

The color of the reflecting surface, if not neutral, will modify the color properties of the reflected light, thereby altering the color-reflectance properties of key subjects.

Single-Point Direct Lighting

A point-source light, whether continuous or flash, produces many of the same effects as direct sunlight. When it is overhead, as the sun is at high noon, a portrait subject will have shadows in his eye sockets and under the nose and chin. Early morning or late day effects are replicated by a light placed lower and to the side. Most flash units emit light that is characteristic of a single-point source.

The stark realism of a concentrated point source may, for some pictures, be particularly suitable to emphasize drama, tension, and harsh reality. The single-point source will, however, create problems of shadow management as described above.

The performance characteristics of existing light fixtures in the home or office will vary considerably depending upon design. Some lights will come under the heading of single-point sources, but others will create more diffuse patterns of illumination because of their enclosure in large diffusers. If a light is mounted close to the ceiling, the latter serves as a flat diffusing reflector. A bare light suspended some distance from the ceiling would be the center of an area of diffuse illumination as described below under the topic of *bare-bulb illumination*.

Lamp reflectors control the distribution of light within a narrow-to-wide angle depending upon the curvature of the reflector. They control brilliance or diffusion qualities of light both through their curvature and their surface properties. Optimal output is achieved with a *parabolic* reflector; this has a moderately deep recess leading to the lamp socket. The more shallow the reflector, the wider will be the angle of light distribution. Conversely, the deeper the reflector, the more concentrated will be the beam of light reflected and driven by it.

The typical amateur or professional flash unit incorporates a reflector that projects a beam of light whose coverage is adequate for a moderate wide-angle lens of 35mm focal length. With wider angle coverage—28mm or less—you may have darkening toward the corners and horizontal ends of the image area. Typically, flash units sold for use with combustible flashbulbs, such as the Nikon BC-7, are of the collapsible fan design with an embossed pattern on the fan

blades which helps to diffuse the light while the shallow spread of the fan blades distributes the light for broad field coverage.

The physical configuration of the reflector governs the pattern of light distribution—circular or rectangular. The most popular portable electronic-flash units have a rectangular configuration and therefore should be mounted on the camera or held to correspond with the vertical or horizontal position of the camera, as the case may be, for best light distribution.

The larger professional flash units are generally provided with deep bowl reflectors for more efficient distribution of light. This is true also of reflectors for continuous lighting sources. Deep reflectors concentrate the light into a narrow beam which can illuminate objects at greater distances while shallow reflectors trade a wide angle of coverage for a shorter distance of effective illumination.

Spotlights throw brilliant, harsh beams of light due to a combination of reflector and optical design. They are used commonly in portraiture as accent lights, when suitably diffused, to brighten the hair or to add highlights through surface skimming. Small spotlights are used in close-up photography. Surface textures may be brought out more clearly through the use of small spotlights placed at oblique angles in order thereby to form minute shadows within the surface textures. (These shadows may be opened up to reveal their detail through front fill-in lighting.) The harshness of spotlight illumination is identified commonly in stage photography in which harsh shadows are cast behind facial features.

To control the direction of lighting, to restrict the area of output of a lighting source, to soften the quality of light, and otherwise to change brightness and color temperature qualities, various professional devices are available as described here briefly. A *snoot* is a tubular device that restricts the spread of light from the lamp into a tight circular pattern. A *barndoor* is a swinging sheet that widens or narrows the area of coverage of light. A *scrim* is a neutral filtering device used to reduce light intensity. A *half scrim* can be rotated to control only part of the beam of light so that half is at full brilliance while half is reduced. *Polarizing screens or filters* are placed over the lighting source both to control reflections from the target subject and to reduce light output from the lamp. A *cookaloris* is a patterned screen with cutouts causing the light to project soft shadow patterns on the subject or the background.

A cluster of lamps covered by a single piece of diffusing material can be described, for photographic purposes, as a single, broad-surface light source. Such a source might be several incandescent light bulbs within a single fixture, or two or more fluorescent strips behind a single enclosure. Either would yield an effect somewhat like that of hazy-bright sunlight. The same would be the case with a single fluorescent strip. Highlights and shadows are discernible, but shadow edges are not sharply defined. A subject very close to the diffused multiple light source might show multiple highlight and shadow patterns, but at a greater distance, these all tend to overlap in a pattern of diffusion.

Multiple-Point Lighting

The typical portrait lighting setup, whether in the home or in a professional studio, utilizes multiple sources of lighting, including reflectors, to illuminate and model the subject and to control shadows and background effects. The selection and placement of each light source is governed by desired portrait contrast ratios, shadow characteristics, and desired brightness, tone, and color of the background.

Originally, multiple-source lighting entailed setting up cumbersome lighting units connected to the electrical mains.

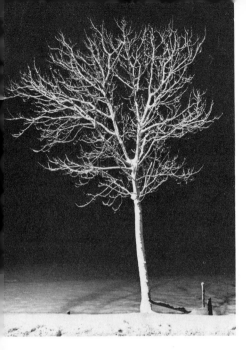

Roelf Backus

Tree covered with hoar frost. Illumination by street lights; utter blackness in background due to absence of reflecting objects. 50mm f/1.4 lens, at f/5.6 for 2 sec. on tripod. Kodak Tri-X.

Al Satterwhite

Brilliant stage spot-lighting illuminates areas of bright reflectance and loses others, especially when exposure and development are for the highlight areas, thus creating odd effect in this picture. 180mm f/2.8 at full aperture, Kodak Tri-X.

Francisco Hidalgo

Interpretation of Manhattan with two images superimposed made with 80-200mm f/4.5 Zoom-Nikkor, 30 sec., wide open, Kodak Tri-X.

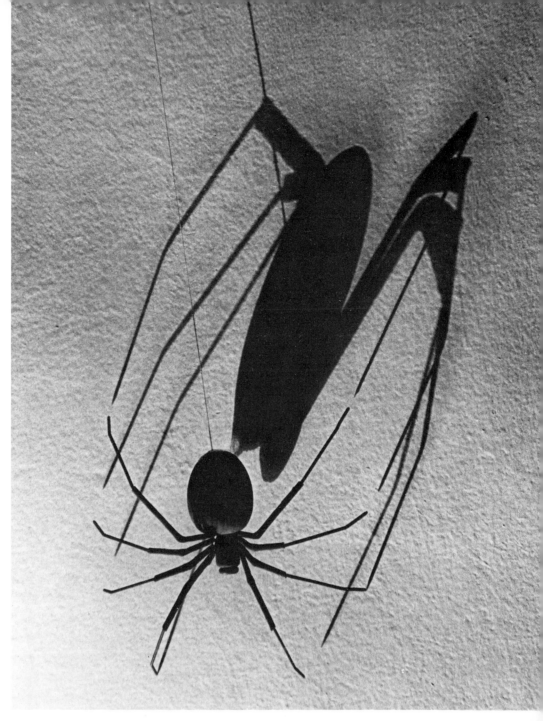

Bill Goldstein
Wooden spider strung from wall and illuminated by single high-intensity lamp illustrates many attributes of artificial lighting. Darkening tone away from lower left corner is typical of fall off of light intensity with increasing distance from source. Oblique illumination throws a long shadow but it also brings out surface texture of the wall. Nikkormat FTN, 50mm f/2 lens.

Ted Schwarz

Bill Cosby photographed from the wings. Note directional quality of light which creates harsh, long shadows. 200mm lens, Kodak Tri-X.

Joe DiMaggio

Slices of action and people depicted by brilliant stage spot-lighting.

Gerry Cranham

Boxer Jimmy Ellis at training camp in America, TV lighting, exposed for highlights at E.I. 800, 105mm lens, f/4 for 1/60 sec. Kodak Tri-X.

Douglas Lyttle

Typical theatrical lighting yields black backgrounds except for bright reflections and harsh contrasts, often suggesting sharpness that doesn't exist. Exposure made for highlights at E.I. 800, Kodak Tri-X, Acufine developer. 200mm lens wide open.

John Minihan

Scene from Othello photographed by stage lighting during rehearsal, exposure for highlights on Kodak Tri-X rated at E.I. 2000, 1/30–1/60 sec.

Both pictures separated from background by backlighting, but one at left has more facial depth due to greater emphasis on backlighting and more subtle front fill. Ilford Pan F, practically grainless. 135mm lens.

Bill Risdon

Fred Santomassino

Lighting source was two diffused 150-watt bulbs in reflectors plus diffused daylight. Nikkormat FT, 50mm *f*/2 lens at *f*/5.6 for 1/60 sec. Kodak Tri-X.

109

While studio setups could accommodate these, their combined load often exceeded ordinary household electrical capacities. Multiple-source lighting has now been simplified from an equipment standpoint through the availability of compact flash units that can be fired in tandem through the use of slave-triggering devices or through being wired in series.

Secondary reflectors may be considered as broad-surface light sources. Their purpose is to redirect the output of principal light sources in order to fill in shadow areas from opposing directions. In portraiture, reflection boards and fabrics are supported on floor stands. In close-up photography, correspondingly smaller reflection materials are positioned to redirect lighting as desired.

The brightest reflectors have hard, shiny surfaces, but they present the disadvantage of reflecting hot spots onto the subject. On the other hand, a reflector with a dead white or matte white surface will soften the reflected light but it will be less efficient in utilization of light. A compromise is a reflector of satin-finish silver material. Any neutral, light surface can be utilized as a secondary reflector. It may be aluminum foil that has been crumpled and flattened onto a sheet of supporting cardboard, white mounting board, a piece of beaded or lenticular screen material, a pillowcase, or, among other things, a sheet of newsprint. A Rowi portable reflector folds to about 12.5 \times 20cm and opens to about 60 \times 70cm. Fully opened, it consists of 20 reflecting sections separated from each other by fabric hinges so that they bounce light toward the subject in nonparallel patterns. The open reflector can be curved, if desired. One model is coated with silver while another with gold-colored material for warm-tone effects.

GUIDE TO FLASH EQUIPMENT

This section covers the respective advantages of flashbulb units and electronic flash, Nikon bulb-flash and electronic-flash equipment, and electronic-flash equipment in general, including various types of independently made electronic-flash units. Flash operating techniques, including the use of slave units in multiple-flash setups, use of automatic flash, calculation of exposure using guide numbers, and use of reflectors are covered in the succeeding section.

Bulb Flash Versus Electronic Flash

While most of the treatment in this chapter is on electronic flash, which grows in versatility, the place of the flashbulb should not be overlooked. The person who uses flash only on rare occasions is best off with flashbulbs as a matter of simple economics. At least that has been the argument. The more recent trend has been to make electronic units so inexpensive as to negate the argument of high initial costs. Moreover, even the bulkiness of electronic units has been eliminated through advances in electronic engineering. The electronic-flash user who takes many pictures has a definite advantage in both savings and convenience, even if AG-1B bulbs do take up little space. Electronic flash affords better action-stopping and it tends to be a bit softer in its lighting than does the flashbulb. On the other hand, an electronic flash requires recharging maintenance even when it is not in use.

Flashbulbs have their own advantages. They pack a great deal of illuminating power in their small glass enclosures. They are usually dependable, which may not always be the case even with quite

expensive electronic gear whose electrical components are subject to unexpected deterioration, notwithstanding rigorous quality checks. The best advice is to use flashbulbs for occasional shooting and to have them in reserve if you use electronic flash extensively.

The color temperature of the light emitted by the flash must be matched to the color film type. This is not necessary with black-and-white films. Clear flash-bulbs can be used with indoor color films. For daylight color films, blue-coated flashbulbs, approximating the sun at noon, must be used for proper color temperature match. Electronic-flash lamps, though clear, emit a light similar to that of noon sunlight. Should you find that your pictures are too warm or too cool, usually the latter, you can alter the effects by placing the appropriate filter over the flash unit or over the lens itself. Suitable warming filters are in the 81 series—usually 81A is adequate—or you may use UV or CC10Y filters. You can

make a filter selection by viewing a representative selection of slides through the CC filters from which you might choose and reshoot the picture with a filter of one-half the density than that which produced correct color rendition in the slide.

Modern fabrics are often saturated with optical brighteners that cause colors to be intensified when viewed under UV-saturated illumination. To offset these effects when using electronic flash, tape a piece of plastic UV filter over the lamp-head.

Combustible-Bulb Flash

The Nikon Flash Unit BC-7 is designed specifically for cordless use with Nikon cameras and with the Nikkormat EL, the latter with the AS-2 adapter. It may be used with other cameras by attachment to an accessory shoe and connection by an optional 20cm synch cord BD-1. A one-meter extension cord BD-2

1. Reflector
2. Three-way socket
3. Flash terminal

4. Test button
5. Synch socket

6. Ejector
7. Charge test button
8. Test lamp
9. Exposure-calculator disc
10. Rear-cover clip

Parts Nomenclature for Nikon Flash Unit BC-7

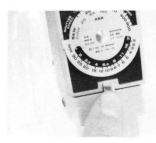

Flash unit powered by single 15v battery. To install, push rear-cover clip downwards to remove. Vinyl tape should be under battery for easy removal later. Align positive (+) and negative (−) terminals.

For cordless use, flash unit slides directly onto accessory shoe of Nikon F2, F, and Nikkormat EL cameras. With earlier Nikkormat models, optional accessory shoe fits over pentaprism housing to accept BC-7 with additional synch cord.

For off-camera flash, optional 1m synch cord BD-2 connects flash unit with Nikon cameras. Connector tip fitting flash terminal has locking screw for positive connection.

Use of Nikon Flash in head-on position and in bounce flash position.

Reflector tilts upward through arc of 120 degrees with click stops every 30 degrees for bounce flash.

When flash unit is mounted, wind film-advance lever, depress test button for a few seconds and press shutter-release button on camera. Do this prior to film loading. Test lamp should light instantly to indicate that all is in order. Test button is immediately below lamp socket.

Fan reflector has grained surface to diffuse light evenly. When hooked to first position, angle of illumination is about 65 degrees, for even distribution with 35mm wide-angle lens and longer focal lengths. At second position, fan configuration is deeper and should be used with 45mm and longer focal lengths.

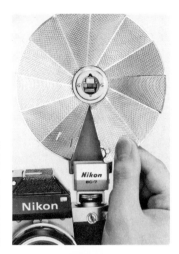

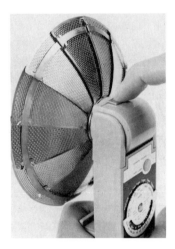

BC-7 unit accepts three different classes of flashbulbs — FP, M, or MF—simply by pushing into place without special adjustment. To remove, depress ejector on top of unit.

Unit begins to charge only when flashbulb is inserted. This occurs immediately, but to test for full charge, press white button on side of unit. Test lamp will light if fully charged. As battery runs down, longer period of time is required for test lamp to light up.

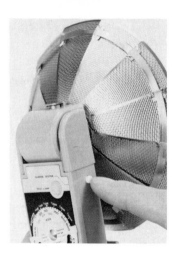

is available for *off-camera* use with any camera. The unit accepts miniature bulbs of these types: S.C. bayonet base, miniature base (such as M2 and M3), and AG-1 (all glass). The illuminating angle is 65 degrees. The reflector tilts at click stops of 30, 60, 90, and 120 degrees for bounce flash. The capacitor is automatically charged when a bulb is inserted in the socket. The 15v dry battery (Eveready 504 or equivalent) is standard. A test lamp checks the synch circuit, charging circuit, and adequacy of the bulb connection. An exposure dial on the rear of the unit provides aperture-setting information and also indicates flash guide numbers as a by-product.

Three flashbulb types best suited to focal-plane camera use are the AG-1, M3, and FP 6 or 26, and the blue equivalents of these designated by the letter B at the end, in each case, as in AG-1B. These bulbs have relatively long flash peaks. The FP bulbs are most versatile because they can be used at any shutter speed. The M3 is a better choice than the AG-1. Clear bulbs can be used with black-and-white films as they deliver a little more power than their blue brothers and their reddishness will go undetected in your black-and-white pictures. Blue bulbs must be used with daylight color. If you use both types of film, it is best to standardize on blue.

For consistent results, batteries should be replaced without trying to use them to their last sparks. (Alkaline batteries should not be used for flashbulbs.) The spring contacts that hold the battery in place should be cleaned occasionally. Care must be taken not to bend the wire bases of AG-1 bulbs. Do not put the bases of flashbulbs in your mouth as doing so will cause damage eventually to the bulb socket of the flash unit. Do not carry bulbs loose in your pocket or camera bag as friction may set them off.

Electronic-Flash Basics

The selection of flash equipment is an individual matter governed by the kind of shooting to be done and the available budget. The professional in the studio has a need for multiplicity and power to achieve diverse effects, particularly with slow films. Even when he travels, the professional prefers heavy-duty equipment, for he must get his pictures without excuses. He may take four or more powerful portables with him. The amateur cannot afford the same multiplicity, but he finds increasingly more powerful equipment available to him with shorter recycling times. The shorter recycling times are important for the pro who is working in fast-moving situations and cannot afford to risk key pictures just because he is waiting for the charge to build up. The hobbyist, however, can usually spare the waiting time.

A standard of measure of flash power has been the number of watt-seconds of output (also called "joules"). This is a measure of the energy delivered by the storage condenser to the flash lamp. It does not measure final output, which is affected by reflector design and flashtube efficiency. The more generally accepted standard is the BCPS rating (beam-candle-power-seconds), which is a measure of light output at the center of the beam of light. As there is some fall-off

toward the sides of the beam, some prefer another measure, the ECPS rating (effective-candle-power-seconds), which measures uniformity of distribution across the entire beam. The former rating (BCPS) is more generally used, although manufacturers tend also to describe the light-coverage properties (ECPS) of their units. Another rating standard is the Kodachrome 25 guide number. For a combination of portability and power, the dividing line begins with units that deliver about 200 watt-seconds. What all of this means in terms of guide numbers is discussed further under "Flash Operating Techniques."

The discussion following deals mainly with equipment that the advanced amateur may use or that the professional might consider light-duty, depending on viewpoint.

The Nikon Speedlight Unit

The Nikon speedlight unit features maximum power when the ready signal lights up, a very short recycling time, the availability of a variety of battery and AC power inputs, ringlight accessories, and a unique eyepiece pilot lamp, which brings the ready lamp into view while the eye is at the finder.

The general attributes of the unit are:

1. Constant light output and uniformity of guide-number performance throughout the life of every type of battery through employment of an automatic voltage stabilizer.

2. Neon pilot lamp (ready light) signalling maximum output (95 percent) as soon as it lights up.

3. Recycling time of 4 seconds with NC batteries with full power output and as short as 1.5 seconds with 510v battery.

4. Angle of illumination of 65 degrees, sufficient for even illumination with 35mm wide-angle lens.

5. Tilting bracket for bounce flash, with mechanical indications every 30 degrees from 0 to 120 degrees backward.

6. Flash duration of 1/2000 sec.

7. Color temperature of 6000 K.

8. Guide numbers: for color ASA 25–46 (feet) and 14 (meters); for black-and-white ASA 125–149 (feet) and 43 (meters).

9. Open-flash button.

10. Life of flashtube of about 30,000 flashes.

11. Weight: basic unit about 670 g; bounce bracket about 270 g; AC unit and charger about 1000 g.

12. The AC unit can also be used as charger.

13. Input voltage adjustable for 100, 117, 220, and 240v.

The open-flash button is used for firing with the shutter held open at "B." It is also used for test firing and for discharging the flash when the unit is being reformed.

The unit at its simplest is used with a nickel-cadmium (NC) battery SN-1. When the power switch is turned on a high-pitched oscillator hum is heard. This cuts out as soon as the neon pilot lamp (ready lamp) lights up. Thereafter, while the unit is on, before firing, oscillation beeps at short intervals will be heard, indicating that the light output is being maintained at its steady state. When the shutter is released, the flash fires and the cycle repeats itself. Recycling takes four seconds.

The AC Unit/Charger SA-1 may be used as a power source with or without the NC battery inside the unit. Before using, make sure the voltage selector is set for the proper voltage.

If the unit has been used for about 40 flashes—say to expose a 36-exposure roll of film—a complete recharge to make up this output of about 50 percent will take seven to eight hours. The optional quick acting NC Battery Charger SH-1 cuts full charge time to three hours.

As many as three Nikon speedlight units may be connected in series and fired at the same time.

All eye-level finders for the Nikon F2-and F2A-series cameras have a built-in ready light in the eyepiece for use with certain Nikon speedlight models. The Nikon FE has a viewfinder ready light for use with the SB-10 flash unit.

The Eyepiece Pilot Lamp SF-1 for the speedlight unit is attached both to it and to the finder eyepiece of the Nikon F or Nikkormat camera. It enables you to keep your eye concentrated on the subject while waiting for the unit to recycle, for the glow of the pilot lamp can be seen directly through the eyepiece. Also, when the lamp goes out for a few seconds, you can tell that the flash has been fired. To attach the eyepiece pilot lamp to Nikon F cameras, first screw in the fastening ring to the finder eyepiece of the camera. If the eyepiece has no attaching screw, the accessory eyecup adapter must be obtained. To attach the pilot lamp to Nikkormat cameras, remove the eyepiece window and screw in the pilot lamp. Attach the removed eyepiece window to the inside of the attaching ring. With the camera in vertical position the lamp may be adjusted 90 degrees for convenience, after the attaching ring has been released. The three-pin plug is connected to the synch socket of the flash unit while the PC-synch cord is connected to the synch outlet of the camera. The pilot lamp of the main unit will not light up when the eyepiece pilot lamp is in use.

Other Speedlight Power Sources

Other power sources that may be used include the AC Unit/Charger SA-1, 510v Battery Pack SD-3, and the D-cell pack. These are explained in the related pictures and diagrams.

Ringlight Attachments

The ringlight is a circular lamp which attaches to and surrounds the lens for the purpose of doing shadowless photography, particularly in medicine and dentistry.

Parts Nomenclature for Nikon Speedlight Unit SB-1

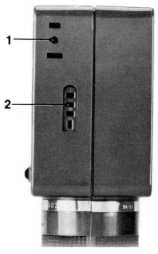

1. Extension socket
2. Ringlight socket

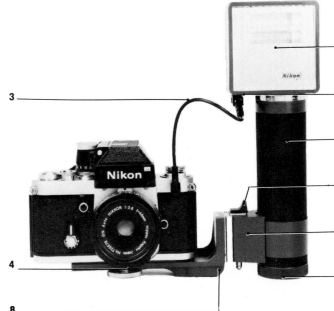

3. Synch cord SC-5	8. Bracket SK-2
4. Locking screw	9. Quick-release catch
5. Flash head	10. Bracket clamp
6. Synch socket	11. Bottom cap
7. Grip	

12. AC socket

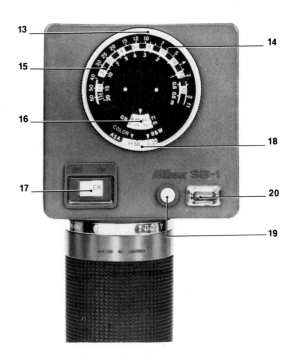

13. Exposure-calculator disc	17. Power switch
14. Flash-to-subject distance scale	18. Film-speed scale
15. f/number scale	19. Open-flash button
16. Guide-number scale for GN Auto Nikkor	20. Ready light

Speedlight bracket SK-2 has three holes to accept any Nikon or Nikkormat camera with or without motor drive. Locking screw in first round hole is for use with Nikon motor drive F-36. Center slot is for use with Nikon F2, F, Nikkormat, and motor drive MD-1. Third slot (longest) is for use with Cordless Battery Pack for motor drive F-36 and 2¼-inch square SLR.

Synch arrangements for different camera models. F2-series, set shutter dial to red mark between 60 and 125 and plug in accessory synch cord SC-5. F-series, set shutter dial at 1/60 sec. or slower, lift and turn knurled synch-selector ring around shutter dial until FX appears in selector window, and connect accessory synch cord SC-5 to synch terminal. All Nikkormat models, set shutter dial at 1/125 sec. or slower; with EL, connect cord SC-5 to single terminal; with other Nikkormat models connect to X terminal.

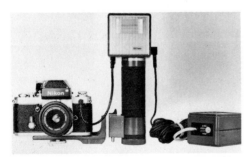

AC Unit/Charger SA-1 which comes as standard equipment adapts speedlight to any standard house current and can be used with or without NC battery in place. Make sure voltage selector is set for proper voltage by aligning red indicator opposite voltage number. If AC unit is to be used for a long time, remove NC battery. Recycling ordinarily takes five seconds. If speedlight has not been used for some time, it may take longer for ready light to light up. Fire flash several times with open-flash button to restore to normal operating condition. Charger can also be used to restore NC battery even when speedlight is in use on AC power. Turn off power switch on main unit when charging. Recharging time varies with condition of battery. Completely depleted batteries take 14 to 16 hours. After about 40 flashes, 7 to 8 hours should be sufficient. Quick Charger SH-1 cuts recharging time to 3 hours.

Sliding power switch to ON uncovers red area as reminder that unit is charging, but buzzing sound and ready light to extreme right of back also indicate that flash is in charge mode. Open-flash button next to ready light is used for test firing and for discharging unit to "reform" capacitor after long periods of disuse. Also used for firing with shutter open at B setting.

Exposure-calculator disc helps find f/number for correct exposure at any flash-to-subject distance in same manner as for BC-7, but shutter speeds are not applicable. Guide-number scale included for 45mm f/2.8 GN Auto Nikkor. To find correct GN, set film speed opposite triangular index mark (color or B&W) on film-speed scale. Guide number will appear opposite arrow on GN scale. Diagram shows intermediate film-speed markings not printed on scale.

Ready Light Adapter SC-4 connects Nikon speedlight with ready light built into finder eyepiece of F2-series cameras.

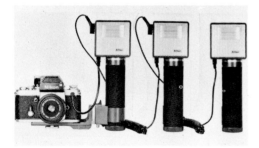

As many as three speedlight units may be connected in series and fired at same time. One unit is connected to camera, second to first with extension cord SE-2, and third to second similarly.

Eyepiece Pilot Lamp SF-1 for Nikon F lights up to let you know when capacitor is charged without removing eye from viewfinder.

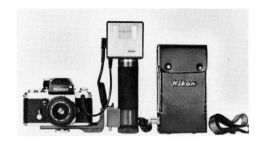

510-Volt Battery Pack SD-3　　　　　**D-Cell Pack SD-2**

510-volt battery pack SD-3 holds single 510-volt battery to power flash and four 1.5-volt AA-type batteries to operate built-in voltage stabilizer which insures constant light output. High-voltage battery cuts recycling time to 1.5 seconds and delivers up to 700 flashes. When used, the power switch on the battery pack overrides the one on the main unit which should be turned off. Turn off battery pack switch when not in use temporarily. For longer periods of nonuse, remove batteries.

Characteristics of D cells

Type	Recycling time	Number of flashes
General	6 —7 sec.	about 160
High-rate	5 —6 sec.	about 300
Alkaline	3.5—5 sec.	about 1000

D-Cell Pack SD-2 houses six D-size batteries. Number of flashes and recycling time for different types of batteries are given in accompanying table.

CONVERSION TABLE FOR USE WITH MACRO RINGLIGHT SM-1

Film speed (ASA)	Light output FULL		Light output ¼	
	Exposure factor	Correction in f/stop	Exposure factor	Correction in f/stop
25	1x	—	4x	+2 stops
32	1/1.3x	−⅓ stop	3.2x	+1⅓ stops
50	1/2x	−1 stop	2x	+1 stop
64	1/2.6x	−1⅓ stops	1.6x	+⅔ stop
100	1/4x	−2 stops	1x	—
125	1/5.2x	−2⅓ stops	1/1.3x	−⅓ stop
160	1/6.4x	−2⅔ stops	1/1.6x	−⅔ stop
200	1/8x	−3 stops	1/2x	−1 stop
400	1/16x	−4 stops	1/4x	−2 stops

Assumed as a standard (= 1) or the light output FULL and the film speed ASA 25.

Arrangement for assembling ringlight SM-1, lens, BR-2 ring, and bellows. Ringlight has regular female lens receptacle to accept lens in ordinary manner while BR-2 ring connects front of lens and bellows front. Ringlight is set up in same manner as for SR-1. To focus, depress lens-aperture opening button on right side of ringlight; this opens lens diaphragm to full aperture and light focusing lamp.

The Ringlight SR-1 is an accessory for the Nikon speedlight. It is a compact, lightweight unit designed to provide shadowless lighting for short range work.

To use the ringlight, attach the camera to the main speedlight unit and screw the ringlight into the front of the lens by turning the knurled ring in the center. The synch cord should have been disconnected before you do this. Connect the 4-pin plug at the end of the power cord into the ringlight socket on the flash head. Plug the synch cord into the synch terminal of the camera. Switch on the power switch on the back of the flash head. The ready light lights up when the unit is charged and ready to fire.

For subjects at distances greater than 0.6m (2 feet), use the guide numbers given in the accompanying table. For subjects closer than 0.2m, the Macro Ringlight Unit SM-1 is recommended.

Example: If the Nikkor-H Auto 50mm $f/2$ lens is used with film rated ASA 25 at distance of 364mm measured from the film plane using the extension ring K-1, the table shows $f/11$ as the correct aperture.

The exposure calculating diagram is based on exposure indexes for ASA 25 film at $1/4$ reduced power. For other combinations use the $f/$number indicated by the exposure calculating diagram and consult the table for the exposure correction factor. Add or subtract the number of $f/$stops indicated for the combination in use.

The Macro Ringlight SM-1 is identical to the ringlight SR-1 except that it is designed for use with lenses from 24mm to 135mm for reproduction ratios greater than 1:1 (life size).

To set up the unit, position the lens in the bayonet mount of the ringlight, lining up the dots. Twist the lens counterclockwise until it clicks into place. Then mount the lens/ringlight assembly on the bellows camera, using the BR-2 Macro Adapter Ring.

Insert the 4-pin plug of the power cord into the ringlight socket on the main unit, and plug the synch cord into the synch terminal on the camera.

Switch on the power switch on the main unit. The ready light will light up when the unit is ready to fire. Depress the lens-aperture opening button on the right side of the ringlight. This opens the lens diaphragm to full aperture and lights the focusing lamp.

To remove the ringlight, depress the spring catch on the ringlight and turn it clockwise.

Ringlight SR-1 designed for shadowless lighting at short range, emitting 65-degree angle of illumination. Fits any Nikkor lens from 35mm to 200mm with exception of 180mm f/2.8. Recycling time and number of flashes same as for main unit. Switch on top of ringlight permits use at full or 1/4 output. To attach, disconnect synch cord and screw ringlight into front of lens by turning knurled ring in center. Connect four-pin plug at end of power cord into ringlight socket on flash head. Then connect synch cord to flash terminal of camera. 510-volt power pack SD-3 cannot be used as power source. Extension flash is not possible.

With the Ringlights SR-1 and SR-2, use regular guide-number system for subjects beyond 0.6m (2 ft.) For subjects closer than 0.6m, exposure-calculating diagram at right gives correct f/numbers for ASA 25 film when ringlight is used at ¼ output. Measure distance from subject to film plane and read off f/number for that distance. For subjects closer than 0.2m, use the Macro Ringlights SM-1 or SM-2. For film speeds other than ASA25, start with indicated exposure from diagram at right, then find correction for ¼ or FULL in the table below.

Exposure factors for film speed (ASA)

Film speed (ASA)	Light output FULL		Light output 1/4	
	Exposure factor	Correction in f-stop	Exposure factor	Correction in f-stop
25	1/4x	−2 stops	1x	—
32	1/5.2x	−2-1/3 stops	1/1.3x	−1/3 stop
50	1/8x	−3 stops	1/2x	−1 stop
64	1/10.4x	−3-1/3 stops	1/2.6x	−1-1/3 stops
100	1/16x	−4 stops	1/4x	−2 stops
125	1/20.8x	−4-1/3 stops	1/5.2x	−2-1/3 stops
160	1/25.6x	−4-2/3 stops	1/6.4x	−2-2/3 stops

Assumed as a standard (= 1) for the light output 1/4 and the film speed ASA 25.

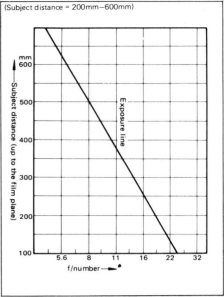

Exposure calculating diagram (ASA 25, Light output 1/4)
(Subject distance = 200mm–600mm)

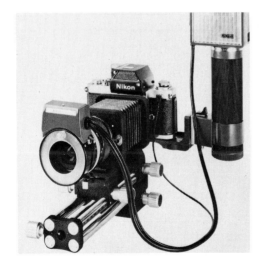

Macro Ringlight SM-1 is identical to SR-1 except that it is designed for lenses from 24mm to 105mm for image ratios greater than 1:1. Ringlight has bayonet mount for attachment to lens mounted in reverse on bellows unit. Built-in focusing lamp illuminates subject for precise focusing. Selector switch on back of ringlight permits use at full or ¼ output. 510-volt power pack SD-3 cannot be used. Extension is not possible.

EXPOSURE CALCULATING DIAGRAMS FOR MACRO
RINGLIGHTS SM-1 and SM-2

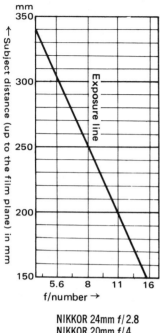

NIKKOR 24mm f/2.8
NIKKOR 20mm f/4

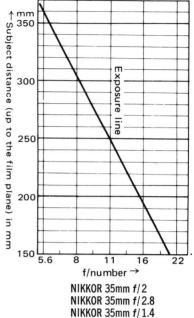

NIKKOR 35mm f/2
NIKKOR 35mm f/2.8
NIKKOR 35mm f/1.4
NIKKOR 28mm f/3.5
NIKKOR 28mm f/2

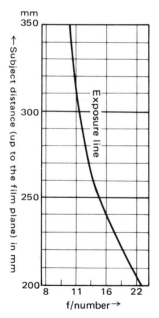

NIKKOR 50mm f/1.4
NIKKOR 50mm f/1.8
NIKKOR 50mm f/2
Micro-NIKKOR f/3.5

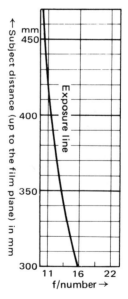

NIKKOR 105mm f/2.5
NIKKOR 85mm f/1.8
NIKKOR 85mm f/2

These diagrams give f/stops for stated lenses at distances of subject from film plane, based on ASA 25 film at full power and ASA 100 film at one-quarter power. If ASA 25 is used at one-quarter power, open lens two f/stops. For other film speeds, see accompanying conversion table. Use f/stops engraved on lens without additional conversion for lens extension. To find f/stop, read across from vertical distance scale until exposure line is intersected. Then read downward to f/stop scale on bottom.

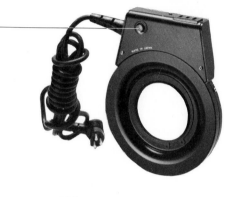

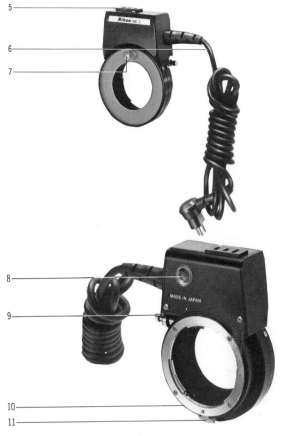

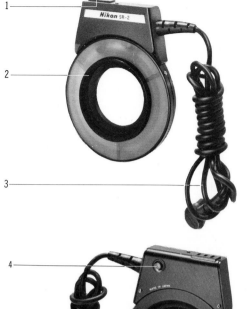

SR-2:	SM-2:	
1. Synch socket	5. Synch socket	9. Lens diaphragm
2. Attachment ring	6. Power cord	opening button
3. Power cord	7. Focusing lamp	10. Bayonet mount
4. Ready-light	8. Ready-light	11. Spring catch

The Nikon SR-2 Ringlight mounts on the 52mm filter threads of Nikkor lenses of focal lengths from 35mm to 200mm. It operates down to a distance of 20cm (8 in.) The guide number (ASA 100, meters) is 16 when the unit is used at distances of more than 0.6m.

The Nikon SM-2 Ringlight bayonets to the rear of Nikkor lenses with focal lengths of 20mm to 135mm and can be used for macrophotography and close-ups. Conventional guide numbers are not applicable at the close distances at which the SM-2 is intended to be used; refer to the accompanying charts for exposure determination.

Both units have a light output selector which allows selection of full or $1/4$ output, depending on film speed and lens aperture.

Power is provided by either one of two sources: the DC power unit LD-1 or the AC power unit LA-1. (These are the same power sources used by the 200mm $f/5.6$ Medical-Nikkor.)

The SM-2 features a button that simultaneously opens the lens diaphragm and turns on a focusing light for the precise focusing that is required in macro photography.

123

Nikon Speedlight SB-5

The Nikon Speedlight SB-5 is a versatile, high-powered, professional handle-mount thyristor (energy-saving) electronic flash unit. It attaches to the camera with the SK-3 mounting bracket. This bracket permits connecting the SB-5 at 12 different angles at 30° intervals, for bounce flash.

The Speedlight SB-5 can be operated in the manual mode at three power settings. The lower two of these permit use of the flash with motor drives at up to 3.8 frames per second. Automatic operation is possible at three aperture settings using the Extension Cord SC-9 and the Sensor Unit SU-1.

When the Speedlight SB-5 is used in the manual mode, the calculator dial on the back of the unit (see illustration) is helpful in determining exposure. Enter the film-speed value by turning the outer rim of the calculator until the ASA number aligns with the film speed index. Then turn the output power selector (in the center) until the desired power level index for "FULL," "1/4," or "MD" also aligns with the film-speed index.

Now look at the distance and aperture scales and read off the f/number that appears opposite the flash-to-subject distance.

At full power, the SB-5 has a Koda-chrome 25 guide number (feet) of 52. The guide number is 26 at the "1/4" setting and 13 at the "MD" setting.

The variable output setting of the SB-5 is most useful for synchro-sunlight fill-flash situations in which the flash is often found to be too powerful for the fill-in effect desired. Setting the output at "1/4" reduces the flash intensity by 2 f/stops. The "MD" setting provides a 3 f/stop reduction. Changing the power setting is much more convenient than the alternatives of changing the flash-to-subject distance or covering the flash head with a handkerchief.

Operation of a motor-drive-equipped camera with the Speedlight SB-5 is possible at any speed up to 3.8 frames per second (fps). To achieve a firing rate of greater than 1 fps, the flash unit must be set for either the "1/4" or "MD" output power setting and is, thus, used without automatic operation. For high-speed settings, refer to the accompanying table.

NOMENCLATURE: NIKON SPEEDLIGHT SB-5

1. Flash head
2. Light sensor socket
3. Light reflector
4. External power socket
5. Neckstrap guide belt
6. Synch cord SC-5
7. Handgrip
8. Battery chamber cap
9. Bounce flash adapter
10. Adapter release button
11. Mounting bracket SK-3

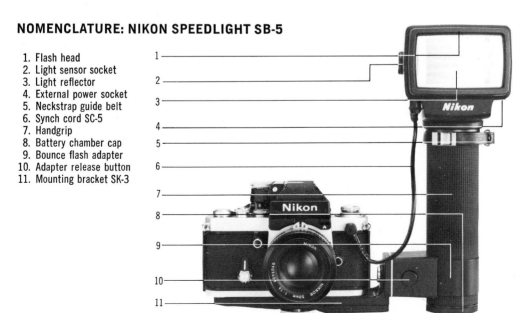

When the flash is used for rapid-sequence operation, it should be periodically turned off to allow the batteries to recuperate. A protective circuit will prevent the flash from firing if it begins to overheat as a result of rapid-sequence use.

The SB-5 can be used in the automatic energy-saving mode in conjunction with the Sensor Unit SU-1. When the Extension Cord SC-9 is used, the SU-1 attaches directly to the camera body. It may also be attached directly to the side of the flash unit when a regular synch cord is used. The Sensor Unit provides a choice of three auto apertures, which are determined by the speed of the film in use. For ASA 100 film, the corresponding apertures are $f/4$, $f/5.6$, and $f/8$. The automatic feature can be used at distances from 2–26 feet at maximum aperture and from 2–13 feet at minimum aperture.

Two power sources are available for the Speedlight SB-5: the SN-2 NC battery, which fits in the unit's handle, or the external Battery Pack SD-4. The accompanying graph compares the performance of the unit when used with either of these sources. The NC Battery Quick Charger SH-2 brings the NC Battery SN-2 to full charge in three hours. The Battery Pack SD-4 uses two 0160-type (240v) batteries or one 0160W-type battery. These cannot be recharged.

Repeating Flash Unit SB-6

The Nikon Repeating Flash SB-6 is a sophisticated unit designed primarily for use with high-speed motor-driven cameras and motion picture cameras, and for stroboscopic operation. It can also be used as an energy-saving automatic flash when used with the Sensor Unit SU-1 and Extension Cord SC-9. In manual mode, the flash functions as a powerful, variable-output unit.

The SB-6 is powered by the SA-3 AC Power Unit. The AC input voltage is adjustable to accommodate power sources of 100v, 117v, 220v, and 240v. The Power

12. Ready-Light
13. Auto range indicators
14. Output power selector
15. f/number scale
16. Flash-to-subject distance scale
17. Film speed index
18. Open flash button
19. Power switch
20. Guide number index
21. Guide number scale
22. Film speed scale
23. Power level index

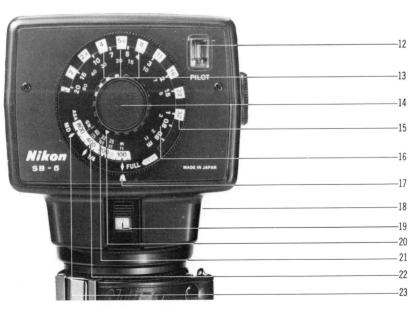

Unit can also provide power for the motor drive in use.

The Repeating Flash Unit mounts directly to the flash shoe of Nikon F, F2-, and F2A-series cameras. The Extension Cord SC-9 permits synchronization via the flash shoe when the SB-6 is used off-camera. When the PC connector of the camera is used instead of the mounting shoe, connection is made with Synch Cords SC-5, SC-6, or SC-7.

The SB-6 can be used as a variable-output manual flash unit. To help determine the correct aperture, the SB-6 has an exposure calculator built into the back of the flash (see photo). First, set the flash's mode selector to "SINGLE" and turn the output power selector dial until the desired power ratio appears adjacent to the power-level index. Turn the outer ring until the film speed is lined up with the film-speed index. Then read out the aperture that corresponds to the flash-to-subject distance. The Kodachrome 25 guide numbers available are 74, 52, 37, 26, 18, and 13 at "FULL," 1/2, 1/4, 1/8, 1/16, and 1/32 power settings, respectively.

At its lower power settings, the SB-6 is designed to synchronize with motor-driven cameras up to a maximum of 3.8 frames per second. Although the motor drive's own power source may be used, it is more convenient to connect the motor drive directly to the flash, using the Connecting Cord MC-2. In this way, the SA-3 AC Power Unit powers both the flash and the motor drive. The voltage output for the motor-drive power supply can be set at either 12v or 15v.

When it is set at the 1/16 or 1/32 power settings, the SB-6 can synchronize with motion picture cameras at 18 or 24 fps. Due to the heat produced by this

Shooting speed with fresh batteries (Frames per second)

Firing rate setting		MD				¼		
Motor drive unit and power source		H, M3	M2	M1	L	H, M3, M2	M1	L
Motor Drive Unit MD-1 or MD-2 (for Nikon F2)	Ten penlight batteries (Zinc-carbon or Alkaline-maganese)	—	3 o+	2 o+	1 o+	—	2 +	1 o+
	Two NiCd battery units MN-1 or AC/DC converter	—	3.8 o+	2.5 +	1.3 o+	—	2.5 o+	1.3 o+
Motor Drive Unit F36 or F250 (for Nikon F)	Eight penlight batteries or eight C- type batteries or AC/DC converter	—	3 o+ *	2.5 +	2 o+	—	2.5 o+	2 +

o 40 consecutive exposures possible when using NiCd battery SN-2
+ 40 consecutive exposures possible when using battery pack SD-4
* Reflex mirror should be locked up

Recycling time (man.):

Setting / Type of battery	Full	¼	MD
NC battery SN-2	2.6 sec. (max.)	0.5 sec. (max.)	0.25 sec. (max.)
Battery pack SD-4	1.5 sec. (max.)	0.4 sec. (max.)	0.25 sec. (max.)

Recycling time (auto.):

Index / Type of battery	Orange	Yellow	Blue
NC battery SN-2	0.25 sec. (max.)	0.25 sec. (max.)	0.5 sec. (max.)
Battery pack SD-4	0.25 sec. (max.)	0.25 sec. (max.)	0.5 sec. (max.)

(When fired at a subject of average reflectivity from a distance of two meters)

Battery performance:

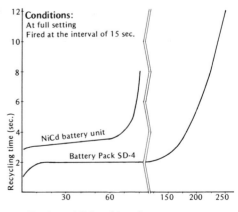

Conditions:
At full setting
Fired at the interval of 15 sec.

NiCd battery unit

Battery Pack SD-4

Recycling time (sec.)

Number of firings (times)

type of operation, the shooting time is limited to approximately 30 seconds at 18 fps.

When the mode selector is set at "MULTI," the SB-6 can be used for stroboscopic operation. The open flash button is depressed for the length of the sequence. The firing rate varies from 5 flashes per second at 1/4 power to 40 flashes per second at 1/32 power. To prevent overheating, the flash should be fired in short bursts with rest periods in between.

Speedlights SB-7E, SB-8E, and SB-10

The Speedlights SB-7E, SB-8E, and SB-10 are essentially similar thyristor (energy-saving) units with these minor differences:

The SB-8E and SB-10 use the ISO-type hot shoe for direct connection to the cam-

era. The SB-7E uses the Nikon mounting shoe for direct connection to Nikon F, F2-, and F2A-series cameras.

The SB-10 has an electrical contact for activation of the eyepiece ready light of the Nikon FE. It will also automatically set the shutter speed of the Nikon FE to 1/90 sec. when it is mounted to the hot shoe. The SB-7E has an electrical contact which activates the eyepiece ready light of the Nikon F2- and F2A-series.

All three units are automatic, energy-saving flash units with a choice of two

1. Exposure calculator	11. Mode selector
2. Flash-to-subject distance scale	12. f/number scale
3. Sensor socket	13. Pilot light
4. Tripod mounting post	14. Synch cord socket
5. Sensor accessory shoe	15. Output power selector
6. Reflector	16. Power level scale (Film speed index)
7. Flash tube	17. Power level index
8. Flash tube protector	18. Locking ring
9. Motor drive socket	19. Mounting foot
10. Film speed scale	20. Flash button

NOMENCLATURE, NIKON REPEATING FLASH UNIT SB-6

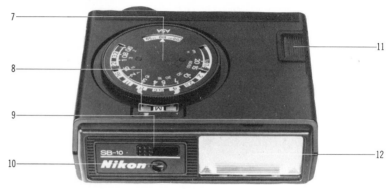

NOMENCLATURE, SPEEDLIGHTS SB-7E, SB-8E, SB-10

1. Power switch
2. Ready light/
 Open-flash button
3. Synch socket
4. Locking nut
5. Mounting foot
6. Ready-light contact
 (not on SB-8E)

7. Exposure calculator
8. Shooting mode indicator
9. Shooting mode selector
10. Light sensor
11. Battery compartment
12. Flash tube

auto apertures (f/2 and f/4 with ASA 25 film, f/4 and f/8 with ASA 100 film). The manual guide number for Kodachrome 25 (feet) is 40. Power is supplied by four 1.5v AA alkaline batteries, which provide approximately 160 full-power flashes. Recycling time is approximately 8 seconds in manual operation, and 1–8 seconds in automatic operation. The distance range for automatic operation is 2–20 feet at maximum aperture, and 2–10 feet at minimum aperture. An optional diffuser attaches to the flash head to broaden the illumination angle when 28mm wide angle lenses are used. The Synch Cords SC-5, SC-6, or SC-7 connect

the units to cameras which have no hot shoe.

Speedlight SB-9

The pocket-sized Speedlight SB-9 operates in the automatic mode with a choice of two apertures (f/4 and f/2.8 with ASA 100 film). Manual operation is possible only by covering the sensor with black tape, in which case the Kodachrome 25 guide number (feet) is 23. Power is supplied from two 1.5v AA batteries, which provide about 55 flashes. An open flash button is provided. Synchronization is through an ISO-type hot shoe or Synch Cord SC-10.

Speedlights SB-2 and SB-3

The Speedlights SB-2 and SB-3, now discontinued, are similar to the SB-7E and SB-8E, respectively, with the following differences:

Both units provide for three auto apertures ($f/2$, $f/2.8$, and $f/4$ with ASA 25 film).

The units provide about 140 full-power flashes with four 1.5v AA alkaline batteries. Both the SB-2 and SB-3 can be used with the SA-2 AC adapter for an unlimited number of flashes from standard house current. The SB-2 and SB-3 are further described on page 130.

Speedlight SB-4

The pocket-sized Speedlight SB-4 (discontinued) operates either in the energy-saving automatic mode (auto aperture $f/4$ with ASA 100 film) or in the manual mode with a Kodachrome 25 guide number (feet) of 26. Recycling time is 9–13 seconds in the manual mode, and 1–13 seconds in the automatic mode. Two 1.5v AA alkaline batteries provide approximately 140 full-power flashes. An open-flash button is provided. Synchronization is through an ISO-type hot shoe or Synch Cord SC-8.

Connecting Speedlights for Multiple Flash

Nikon Speedlights SB-2, SB-3, SB-4, SB-5, SB-7E, SB-8E, or SB-10 can be connected for multiple-flash setups according to the following instructions:

The Nikon Speedlight units employ a special low-voltage triggering circuit to prevent electric shock and damage to the hot-shoe contact. Nikon does not recommend mixing Speedlight units with flash units of other makes for multiple-flash photography, unless slave sensors are used for remote triggering. The Speedlight SB-6 should not be used with any flash unit other than another SB-6, unless slave sensors are used. Otherwise, incorrect operation and/or damage to the units may result.

The shooting mode selector should be set to "manual." If the selector is set on "auto," correct exposure cannot be assured.

With the SB-2 or SB-7E flash unit mounted on the camera's hot shoe, the flash unit's synch socket may be used for connection to another flash unit for multiple flash operation. However, this does not hold true for the SB-3, SB-8E, or SB-10.

When the camera is not fitted with a hot shoe, the flash unit has to be connected to the camera via the synch cord. Consequently, synch connection is not possible for multiple-flash use. In this case, use slave sensors for triggering the remote flash.

By using the SB-3, SB-8E, or SB-10 as the main flash unit mounted on the camera's hot shoe, up to two flash units can be used altogether. Up to three units can be used with the SB-7E or SB-2. In this case, use both the Synch Cord SC-6 and the Extension Cord SE-2.

The units may inadvertently trigger while you are connecting them. This is normal and is no cause for concern.

Flash Unit Couplers AS-1 and AS-2

The Flash Unit Coupler AS-1 adapts units such as the SB-10 and SB-9 to the Nikon F, F-2, and F2A-series cameras, eliminating the need for a synch cord. The Flash Unit Coupler AS-2 adapts such units as the SB-7E and SB-2 to cameras with ISO-type hot shoes, such as the Nikon FM and the Nikkormat models. It eliminates the need for a synch cord. The AS-2 should not be used with the Nikonos cameras or with Nikon movie cameras because a short circuit will develop.

Automatic Flash

Automatic flash, computer flash, thinking flash—all are terms for a flash system in which exposure is controlled by reflection of the flash output from an illuminated object back to a sensor on the flash unit. The lens setting, governed by the exposure or ASA speed of the film, remains the same for all average conditions even though distances are changed. The flash output and duration vary automatically with the distance of the subject from the flash head. For a close object, the flash puts out less light; for a distant one it expends more light. The amount of light emitted is governed by how much is picked up by a sensor as reflection from the central subject.

The sensor acts like an exposure meter balanced for 18 percent gray reflectance. Reciprocity failure at the extreme speeds of $1/30,000$ and $1/50,000$ sec. at very close distances does not seem to be a problem. If anything, there might be a slight shift toward magenta.

A standard automatic flash unit has a built-in sensor located near the flash head so that the feedback axis from subject center to the flash sensor is almost in line with the flash-to-subject axis. This type of unit is intended for use mounted on the camera. It is not intended for off-camera usage nor for bounce-flash adaptation. Typical of the compact automatic flash units are the Nikon Auto Speedlight Units SB-2 and SB-3. The SB-2 fits cameras of the Nikon F and F2 series while the SB-3 fits the Nikkormat EL. Both units make direct contact to the hot-shoe contact on the respective cameras, thereby eliminating the need for a synch cord (except for the Nikkormat FTN). The foot of the SB-2 unit connects directly to the built-in ready light of Nikon F2- and F2A-series cameras. Specifications of the SB-2 and SB-3 units are otherwise identical. In the manual mode they offer a guide number (feet) of 40 for Kodachrome 25. In the automatic mode they offer a choice of three f/numbers, varying according to the ASA rating of the film. For ASA 100 film, the choices are $f/4$, $f/5.6$, and $f/8$. The automatic shooting range is governed by the aperture setting: 2–20 feet at maximum aperture setting, 2–15 feet at medium aperture setting, and 2–10 feet at minimum aperture setting. The angle of coverage is 56 degrees horizontal; 40 degrees vertical. These units are powered by four 1.5v AA batteries; they can also be powered by AC current with the aid of an SA-2 converter. For use in the manual mode in bounce-flash, the flash foot tilts through an arc of 180 degrees.

The main problem with these units is in aiming. You must be sure the flash is pointed toward the main subject, for if it is missed, the sensor could pick up a closer or more distant object, thereby confusing the exposure. This might be a problem, for example, if you were shooting through a doorway at a person beyond. The sides of the door could be in the included angle or the flash might pick up too much of one side, if not aimed properly. Hence, it is good practice to have important reflecting objects in approximately the same plane. Aiming is more critical, though, at close distances, when the sensor must be carefully directed toward the main object. The sensor assumes an average subject (equated with 18 percent reflectance). Extreme contrasts will throw off the results. Thus, a pencil against a dark or bright background is best exposed in manual mode, for it will not be averaged in. The same pertains to line copy.

When using the automatic mode you have to think differently about background effects and about light reflectance effects on exposure. When photographing a group of dancers, densities for the people will be the same whether they are close or distant from the camera and

flash. The backgrounds will vary, however, with the distance of the subject from the flash. When the dancers are close, the background will receive less light and will be darker; when they are more distant and close together the background will be lightened as it will receive about the same light as the dancers.

In manual mode, a light or small room would be overexposed unless you stopped down. With automatic flash, you have to open up from one-half to one stop or you will underexpose. Conversely, in automatic mode in a large or dark room or outdoors, where reflectance is poor or absent, you must stop the lens down or be overexposed. When the main object is very shiny, you must also open up the lens. As with all flash units, for the greater distances you should allow about one-half stop additional exposure. At close range, no compensation is needed for automatic flash, unlike other units.

To shoot at 1/50,000 sec., you have to deceive the sensor. You take a small piece of lucite, trimmed to fit snugly in the sensor opening and bent with heat to fit over the front of the flash head. This becomes a lucite light pipe, which guides a spin-off of the most brilliant output of the flash to the sensor, so that it "thinks" it is working close to a real object and therefore cuts itself off right after it gets started. Exposure? You will have to run test strips to get your private guide number. Also, a Polaroid Land camera, preferably with color film, will give you instant readings. A flash meter might work at this fast speed. It might not. If you get a consistent reading, no matter what, you can equate this with your test run.

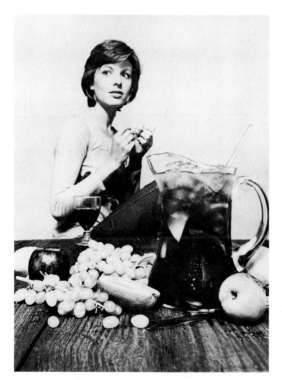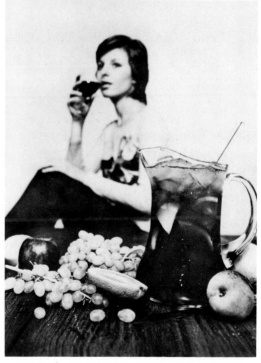

Conventional flash units are designed to work at single best lens apertures for given distances appropriate to film and other conditions. Some automatic flash units permit selection of lens aperture with automatic emission of sufficient flash illumination to achieve correct exposure. By first selecting aperture, photographer can control depth of field. Picture at left made at f/11; right at f/5.6; both with Metz 202 Telecomputer.

Automatic flash units suitable for bounce-flash work will have the sensors separated from the flash head. Some makes have the sensor located on the battery housing facing toward the subject; others have an "off-line" sensor connected to the flash unit by a cord and mounted independently as close as possible to the lens. In either case, the flash head can be pointed in any direction on or off the camera while the sensor, pointed toward the subject from the viewpoint of the lens, picks up the light value of photographic significance reflected from the relevant target subject.

Automatic units can be used as slave-triggered main lights off to the side. The front-fill flash would be used as the trigger source; its output would have to be lower in order to achieve a desired lighting contrast ratio. You can also use an automatic unit as a side-fill source, but deceive the unit by assigning a higher ASA rating. Thus, assuming that your film is rated ASA 64 and you want to have a side fill of one half the light value of the frontal lighting, you would set the automatic flash unit for ASA 125.

For greater flexibility with any automatic flash unit in order to increase depth of field or to work at closer ranges, you can use neutral density filters taped over the sensor in order to reduce the amount of light picked up as reflection from the subject. If the neutral density filter has a $2\times$ exposure factor you decrease the lens aperture by one f/stop. A $4\times$ filter would call for an aperture decrease of 2 f/stops, and so forth.

Automatic extension flash, wired to a master unit, is also possible. See the reference in the section below on multiple flash.

Bare-Bulb Flash

The bare-bulb flash unit—whether electronic or combustible-bulb flash—does not have a reflector to drive the light emitted by the flash lamp. The lamp is positioned in a vertical mode so that its light beams out in all directions uniformly just as though it were the light of a candle. The effect of this type of illumination is a combination of a point source and a diffuse illumination. In effect, all of the closest walls, ceilings, and other surfaces become elements of a complex reflector driving light from different angles onto objects within camera view. There is great evenness of illumination despite differences in distance from the camera as well as the flash.

One advantage is that the bare-bulb technique permits the use of wide-angle lenses which otherwise would record images showing light fall-off toward the edges. With bare-bulb units, the wide-angle lenses have greater uniformity of coverage.

Some electronic bare-bulb outfits are sold without reflectors, but some are available with optional reflectors so that they can be used in both ways. The Nikon BC-7 flashbulb unit can be used as a bare-bulb unit by collapsing the fan and tilting the bulb-receptacle component so that the bulb points directly toward the ceiling.

Bare-bulb flash units are often used in conjunction with umbrella reflectors. Typically, bare-bulb units are mounted on light stands and positioned in a corner of a room about one foot away from the ceiling. In this way, the two walls and the ceiling surface act as a giant reflector throwing diffuse illumination over the area of coverage. In some cases, for maximum uniformity, two bare-bulb units are used, synchronized either by common wiring inputs or by use of flash slave units. Of course, the units must be so placed that they are outside of the viewing range or scope of the camera lens, particularly when wide-angle lenses are being used. Additional notes on bare-bulb flash are to be found in the section below on flash operating techniques.

Another type of flash intended mainly for studio use, including home studios, has a built-in modeling lamp for purposes of previewing the light and shade patterns which are to be achieved at different heights and distances from the subject. The modeling lamp is a low-level continuous source of lighting. When the desired lighting effect is achieved with two, three, or four modeling lamps, all of them supported on light stands, the shutter release on the camera is depressed and the flash units are fired with the assurance that the actual exposure will yield equivalent results, assuming that the correct lens aperture is chosen. The light from the continuous-source modeling lamp will not materially alter the final exposure.

Stroboscopic-flash units make multiple exposures on a single frame of film in rapid sequence. Thus, a stroboscopic picture of a golfer swinging his club at a ball would appear as a series of individual pictures showing the progressive stages of the swinging arm and golf club, each clearly and sharply delineated. Two inexpensive stroboscopic units on the market can be set to flash up to 30 times a second at a duration of about 1/10,000 sec. each. On a single negative or color transparency set for a time exposure of three seconds, you can record an action sequence through approximately 100 separate images.

Stroboscopes are used for time and motion studies, quality control analyses, special effect and advertising photography, and special teaching purposes. A convenient way of firing the unit so as to record the beginning of an action is to attach to it a sound slave trigger, described below.

Multiple Flash and Slaves

Multiple flash consists of two or more flash units fired simultaneously to make a single exposure. One of the earliest multiple-flash techniques was to "paint with light," making several exposures in darkness or subdued light with the shutter open at "T." Multiple flash today has been simplified and made more exciting by the improvement of slave flash units. These cordless units are activated by the flash burst of a control or master unit, which alone is directly linked to the camera-synchronization mechanism.

In a studio, it is much more convenient to use multiple flash in wired synchronization. Each unit is connected to a main power supply, which has a direct linkage through one of the flash units directly to the camera. This is a more positive, controllable, and reliable arrangement, but it is less suited for portability.

Without too elaborate a setup, two or more flash units can easily be wired together through use of a three-way connector. Some means would be needed to hold the separate units in place—either tripods or human supports. Care would have to be taken that the PC-connector cords, which lead from the flash units to the three-way connector (there are also two-way connectors), do not come loose.

Extension units have been devised for at least one automatic flash system—the Mecablitz 202 Telecomputer as main source to which one to four Mecatwin 202 extension flash units can be wired.

Lighting setups for multiple flash will be discussed below. The uses of slave units, briefly, are to lighten backgrounds, backlight the main subject, fill shadows, provide side-fill, or serve as main lighting sources with the flash at camera serving as secondary fill in addition to being trigger.

The important characteristic of a slave unit is that it be highly selective in picking up the brilliant burst of the flash, even at some distance and even from bounce reflection, without, at the same time, being susceptible to ambient light which, by its brilliance, might acci-

dentally fire the slave unit. The buyer cannot go by brand name alone, but in the absence of convincing specifications as to low sensitivity to ambient light, it might be prudent to purchase solid-state slaves—they are as small as nuts—which have some brand name back-up. The solid-state units require no batteries, for they provide their own power. There is little to go wrong with them.

Such slave units are easily attached to the electronic flash. The slaves are usually fitted with two male prongs, which fit into standard female receptacles on the flash unit, similar to household plugs. If the flash unit does not have a detachable PC cord, the slave must be attached to the PC tip of the flash connector cord. For this you will need a PC-H converter, available from well-stocked dealers and from the larger mail-order supply houses. Cost is nominal. The converter has a male PC tip on one end and a female receptacle for a two-pronged plug on the other end. Some miniature slaves are designed to connect via PC tips.

Polarity, which relates to the direction of flow of electrical current, must be maintained. When you charge the flash and hook up the slave, it should then fire. If not, reverse the connections.

The attached slave receptor must be in line of sight of the master unit. The flash head itself may be pointed in another direction. If this takes the slave receptor out of direct sight, intermediate devices can be improvised to hold the receptor properly and rigidly in place. For example, a short length of heavy-duty electric iron appliance cord can be further stiffened by wrapping electrical tape around it; it can then be positioned quite flexibly. A three-way cube tap, ordinarily used for extension cords, provides a right-angle deviation. There is also a hinged three-way tap, which can be used flexibly.

When using multiple flash, the professional takes along suitable light stands as supports. In a pinch you can use human helpers.

More sophisticated slave equipment is available, mainly for studio use. The slave may be combined with the flash itself. Then there are modeling slave units, which provide continuous light for setting up the subject and prechecking lighting effects and synchronized flash for actual picture taking.

Miscellaneous Triggering Devices

In many areas of activity—wildlife watching, intruder surveillance, micromotion analysis, and sports and action photography, among others—electronic assists are needed to make it possible to catch the critical moment of action. The skilled photographer might be able to anticipate and catch the impact of a baseball bat on a ball, but catching the falling apart of a coffee cup fractions of a second after it hits the floor is too much to expect.

Two kinds of triggering are in common use; they may or may not be coordinated. One is automatic firing of the flash due to an external event acting upon a receptor, which relays an electrical impulse to the flash. The chain of events involving a slave receptor is a case at point, with the external event being the light signal from another flash unit. The second kind of triggering is some action that causes the camera shutter to be activated in synchronization with the flash. For the latter to occur, a signal receptor or a hand-governed switch would have to convey a signal by wire to some device that would release the camera shutter, or by wireless to a receiver that would also set off the events leading to synchronized exposure with flash.

The Nikon motor drives can be connected to radio receivers to pick up an impulse communicated by wireless from

distant locations that may or may not be in the line of view. The motor drives can also be connected by wire to a sound-activated trigger or to a relay that is activated by beam interception, with uses ranging from criminal surveillance to bird-watching.

An interesting device of this kind is the Honeywell Wein Sound Trigger, which utilizes a microphone and a sensitivity control. Its power is derived from the flash unit to which it is connected. It is self-activating. The sound trigger converts the energy of sound into an electrical impulse, which fires the flash. The placement of the sound trigger controls the timing of the flash. Since sound travels at the rate of 1100 feet per second, a tiny lag occurs between the event that causes the sound and its pick-up by the monitoring device; hence, if the coffee cup or egg is dropped on the table, the momentary lag, which may be more or less than 1/100 sec. depending on distance of the sound trigger, would cause the flash to go off at or near the critical action point. For the filled coffee cup, the flash would catch the splashing, breaking rebound rather than the first impact, when the triggering sound occurs.

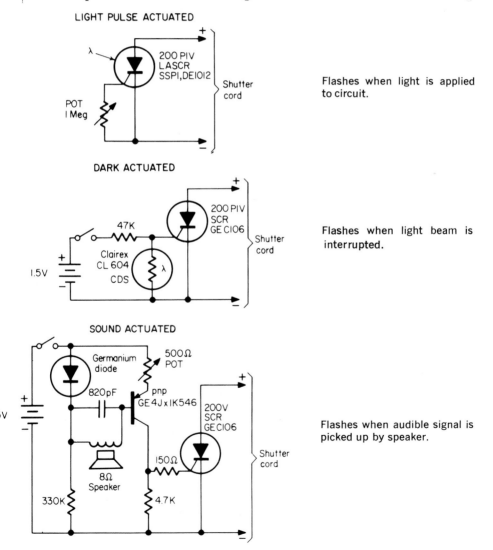

LIGHT PULSE ACTUATED

Flashes when light is applied to circuit.

DARK ACTUATED

Flashes when light beam is interrupted.

SOUND ACTUATED

Flashes when audible signal is picked up by speaker.

Triggering circuits suggested by Honeywell. Light-pulse actuator is commercially available via solid-state slave receptors. Sound-actuated units are also available inexpensively.

FLASH EXPOSURE MEASUREMENT
(MANUAL MODE)

The key problem in arriving at a correct exposure for a flash-illuminated scene is to anticipate or predict the amount of light which will be reflected from the subject to form an image on film. This may be contrasted with the procedure followed in picture taking with continuous lighting sources when you can take measurements of the actual conditions before the exposure is made. An exception to this is through the use of modeling lamps which enable you to take exposure readings under low-light-level conditions and to extrapolate from them to the more brilliant outputs from the same lighting sources when the actual flash exposure is made. This kind of procedure, however, is best suited for professional and home studios and for more elaborate mobile lighting setups.

Flash exposure determinations are made in one of the following ways:

1. Using the exposure guide-number system, which sets a light value on the specific bulb or electronic-flash output for a specific film and enables the photographer to determine beforehand the settings for different working conditions and distances for each light source.

2. Using a flash meter, which takes a reading after a trial flash during which the shutter is not released, thereby eliminating all guesswork in the particular picture-taking situation.

3. Using the 45mm $f/2.8$ GN Auto Nikkor lens for automatic distance and lens-aperture adjustments, assuming a correct guide number is initially set on the lens. When the guide-number coupler is set to the appropriate guide number on the guide-number scale, the diaphragm ring turns with the focusing ring, and the correct aperture is selected automatically.

4. Using the dial computer on the back of the flash unit. This is actually a modification of the guide-number method; the dial performs the calculations.

The Guide-Number (GN) System

The guide-number system for determining exposure settings utilizes a basic light value assigned by the manufacturer of the flashbulb or electronic-flash unit for a film of a given exposure index or speed. Most commonly, for example, electronic-flash units are rated or advertised as having particular guide numbers for Kodachrome 25, this being the standard of comparison in the American market. Often, the user may rely on a lower or higher guide number than the rated one, based on experience under normally encountered conditions. The guide number (G) for a particular film is the product of the lens aperture (A) and distance (D), expressed in the formula G=AD. Knowing the guide number and the working distance from the subject, the photographer uses the formula A=G/D to find the necessary lens setting. Thus, assuming a guide number of 40 for a particular film and a distance of 5 feet, the required aperture is found to be $f/8$ (the result of the division of 40 by 5).

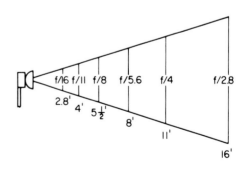

The guide number (GN) is a shortcut for finding correct lens apertures at different distances. Distance is divided into guide number of particular flash for specific film under average room conditions. Nikon Speedlight has GN 46 for Kodachrome 25. At 2.8 feet setting would be $f/16$, while at 16 feet setting would be $f/2.8$. At 11 feet, lens would be set at $f/4$, and so on. Note that multiplying combinations of distances and f/stops yields approximately the same product, which is the guide number.

Guide-number tables for the various film speeds or exposure indexes (EI) are furnished by manufacturers of flash equipment. If, however, you have only the guide number for the one film, you can find other film guide numbers through use of the following formula:

$$GNa = GNb \times \sqrt{\frac{EIa}{EIb}}$$

Where: GNa = Guide number for film a

GNb = Guide number (unknown) for film b

EIa = Exposure index for film a

EIb = Exposure index for film b

Another formula for determining guide numbers when you have the BCPS rating of the electronic flash (discussed below under equipment heading) and the film exposure index is:

$\sqrt{0.05} \times BCPS \times$ daylight EI of film

= Guide number

Alternatively, without the use of mathematics you can refer to one of the accompanying sources: the table of guide

GUIDE NUMBER MULTIPLYING FACTORS
(For Higher Exposure Index Ratings)

Times faster	Multiply guide number by
2	1.4
2.5	1.6
3	1.7
4	2.0
5	2.2
6	2.4
7.5	2.7
8	2.8
10	3.2
12	3.5
16	4.0
32	5.5

To find the guide number for a higher film speed, divide the lower into the higher to obtain the "times faster" number. Multiply the known guide number by the number in the righthand column. Note that manufacturers tend to rate guide numbers for black-and-white films more generously than for color films to take advantage of the black-and-white printing latitude.

numbers for electronic flash or the nomograph, which provides essentially the same information in schematic form.

Flashbulb guide numbers are fairly reliable, for an electrical spark ignites the combustible material stored within the glass envelope. The key variables are reflector and shutter speed which, for FP settings, may be set anywhere within the shutter-speed range. Published guide numbers are usually based on use of parabolic (bowl-shaped) reflectors. With either a dull-finished parabolic or a folding fan reflector, one additional f/stop will be needed. Alternatively, the guide number may be modified by multiplying by 0.7. With a shallow or flat pan

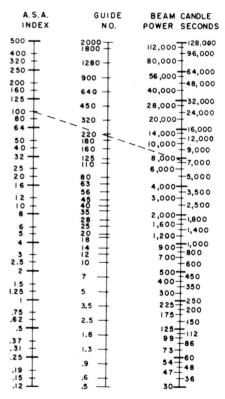

To find a guide number for a particular flash unit when you have a film-speed number and the BCPS output, lay a straightedge over these two points; the intersection with the central line will be at the guide number. Given the guide number and the ASA film speed, the BCPS output can be found by projection of the straightedge to the third column. Courtesy, Berkey Technical Corp., Ascor Division.

137

GUIDE NUMBERS FOR ELECTRONIC FLASH

ASA FILM SPEED FOR DAYLIGHT	BCPS OUTPUT OF ELECTRONIC FLASH UNIT									
	350	500	700	1000	1400	2000	2800	4000	5600	8000
10	13	16	18	22	26	32	35	45	55	65
12	14	18	20	24	28	35	40	50	60	70
16	17	20	24	28	32	40	50	55	65	80
20	18	22	26	32	35	45	55	65	75	90
25	20	24	30	35	40	50	60	70	85	100
32	24	28	32	40	50	55	65	80	95	110
40	26	32	35	45	55	65	75	90	110	130
50	30	35	40	50	60	70	85	100	120	140
64	32	40	45	55	65	80	95	110	130	160
80	35	45	55	65	75	90	110	130	150	180
100	40	50	60	70	85	100	120	140	170	200
125	45	55	65	80	95	110	130	160	190	220
160	55	65	75	90	110	130	150	180	210	250
200	60	70	85	100	120	140	170	200	240	280
250	65	80	95	110	130	160	190	220	260	320
320	75	90	110	130	150	180	210	250	300	360
400	85	100	120	140	170	200	240	280	340	400
500	95	110	130	160	190	220	260	320	370	450
650	110	130	150	180	210	260	300	360	430	510
800	120	140	170	200	240	280	330	400	470	560
1000	130	160	190	220	260	320	380	450	530	630
1250	150	180	210	250	300	350	420	500	600	700
1600	170	200	240	280	340	400	480	560	670	800

To find the guide number of any film when you have only the BCPS rating of the flash unit, read down the nearest BCPS column and read across the ASA film speed column for the particular film; the guide number will be at the intersection of the vertical and horizontal rows. When you have a guide number for a specific unit stated in terms of a certain film—often Kodachrome 25—read across the film-speed column until the stated guide number is reached; then read up to the top figure, which will be the BCPS output for that unit. Thereafter, guide numbers for any film can be found by the first method. Courtesy, Eastman Kodak Company.

reflector, the guide-number multiplier is 0.5, which is the equivalent of an adjustment of two f/stops.

Electronic-flash guide numbers are subject to greater variation because of the more complex system governing light output. An electrical charge is released into a gas-filled lamp, but the potency, volume, or strength of the charge is subject to manufacturing variation and to different patterns of equipment usage by photographers. There may be differences between rated and actual performance at time of manufacture, but there are also changes in performance of electrical components over a period of time. In addition, the guide numbers assume a full charge, but the storage condenser of the flash is often used without reaching full charge. When the ready signal of the flash unit lights up, it may have only about a 65 percent charge in most cases. (The Nikon speedlight is designed to reach 95 percent charge of the condenser when the ready signal lights up.) Over a period of time, battery performance may deteriorate due to age and to manner of recharging. Overall performance may also be affected by whether or not the flash is periodically reformed, as discussed below. Hence, for any equipment it is good to make periodic tests of performance in order to find the true guide number for your equipment as of the time of test.

A test of the ready light should be made with successive exposures when the ready light comes on at the end of the recycle time, another at recycle time plus 50 percent, a third at double recycle time, and at least a fourth at one full minute for recharge after the last flash.

(The recycling time is the interval from the last firing of the flash until it becomes recharged sufficiently to take another picture.) A comparison will give you an approximate guide to exposure adjustment, if needed. Then, if you must shoot at ready-signal time, you can use a modified guide number.

To find the individual guide number for your equipment under your shooting conditions and habits, make a series of test exposures at a distance of about eight feet with an average subject under average (for you) conditions. Use a moderately fast color film, such as Kodachrome 64, for range flexibility. The series of test shots should be made at half-stop intervals. You might shoot one series at ready-light time and another at full-charge time, if necessary for your equipment. Then you will have two guide numbers: one for sequence and one for full charge.

Notwithstanding your guide numbers, make adjustments for room reflectance: open up one f/stop each for large and/or dark rooms; close down one f/stop each for bright and/or small rooms.

At three feet or closer, or beyond 15 feet, open the lens one-half f/stop to make up for reflector inefficiency.

ADJUSTING GUIDE NUMBERS FOR UNDEREXPOSURE OR OVEREXPOSURE

When pictures are consistently:

Underexposed by	Multiply guide number by
½ f/stop	0.8
1 f/stop	0.7
1½ f/stops	0.6
2 f/stops	0.5

Overexposed by	Multiply guide number by
½ f/stop	1.2
1 f/stop	1.4
1½ f/stop	1.7
2 f/stops	2.0

Using this adjustment chart for either over- or underexposure calls for some guesswork. When you look at a dark slide, can you surely say it is 1 or 1½ stops underexposed? Some experimenting is indicated.

In general, for close-in subjects, exposure settings must be carefully judged, particularly with color films, because of abrupt scaling down of light output, as determined by the inverse square law. An alternative is to achieve more latitude by using longer-focus lenses and backing away from the subject.

The reflector of the flash unit drives the light from the unit toward the subject in a more or less concentrated pattern. For flash indoors, the room enclosure itself acts as a giant secondary reflector, which bounces light in a diffuse pattern. It may therefore be employed to achieve desired illumination of the subject in specifically designed ways, as discussed below. Most exposure guides are based on average light-reflecting properties of the walls, ceiling, floor, and drapes. The larger the room or the darker, the less reflectance and the less useful light will fall on the subject. Conversely, smaller and brighter rooms mean more light on the subject with an accompanying reduction in necessary size of the f/stop. In color photography, the hue of a reflecting wall or ceiling alters the color properties of the light falling on the subject. Umbrella-type reflectors have come into wide use as a means of directing broad, diffuse, soft patterns of light toward the subject. Furthermore, reflector materials such as crumpled sheet aluminum or sprayed aluminum on heavy paper or board may be placed where desired to bounce additional light onto the subject.

Multiple Flash Exposure Determination

Exposure with two or more units depends upon their placement. If more than one flashbulb or electronic flash is aimed at the subject from a main picture-taking position in order to increase light output, such as when working at a considerable distance from the subject or in a large room, multiply the guide number for one lamp by the square root of the

number of lamps being fired. For two bulbs, this would give you a multiplier of 1.4; for three bulbs or flash lamps, the multiplier would be 1.7, while for a cluster of four identical lighting sources or lamps, the multiplier would be 2.

If one flash unit is used as a main light source with others used for filling in shadows or providing supplemental highlights, exposure is based on the distance of the main lighting source from the subject. In other words, the use of supplemental lighting sources does not alter the exposure computation since it is governed by the effect achieved by the principal lighting source. The only adjustment ordinarily to be made is when working in a small, brightly decorated area in which some of the additional flash illumination may be expected to bounce back onto the subject. In that case, you might have to set the lens aperture from one-half to one full f/stop smaller.

In a wired arrangement of multiple flash units all will be fired simultaneously when the shutter-release button is pressed. Hence, you can use the X or FP flash terminals or settings as appropriate to the type of flash source together with allowable shutter speeds. With electronic flash, using the X terminal you can use a shutter speed of 1/60 sec. or slower. With FP-class bulbs (6 or 26) you can use any shutter speed. With AG-1 or M-3 bulbs (and their PF equivalents in some countries) you can also use any shutter speed with the FP terminal. With all other flashbulbs you would use the X terminal and a shutter speed of 1/30 sec. or slower.

When using the flash slave system you must allow for the lag between the firing of the master unit and the reaction-firing of the slave units. When the slaves are to be triggered by an electronic flash or an FP-class bulb as master, you can set the shutter for any slow speed up to 1/60 sec. When flashbulbs are to be fired use a shutter speed of 1/30 sec. or slower.

Flash Meters

A flash meter takes readings of all the light falling on the subject under actual conditions of exposure at predetermined shutter speeds. Such a meter replaces guide numbers and subjective estimates of the influence of reflective surroundings on a formula-based exposure. A typical flash meter is connected to the flash source or sources and a test firing made either at the subject position facing the camera (for an incident-light reading) or at the camera position facing the subject (for a reflected-light reading). The reading for a particular shutter speed is obtained by reference to the f/stop scale on the meter.

The relative advantages of reflected- and incident-light readings were covered in the preceding chapter. With multiple flash, incident-light readings might be preferred when you are able to stand at the subject position. A spherical diffuser would be used to measure all sources of illumination falling on the subject. A flat diffuser would be used to measure output of individual flash sources. The advantages and uses of both were described in the preceding chapter.

Since a reflected-light reading is based on average reflectance, you must make adjustments for the reflectance characteristics of the subject—setting a little larger lens aperture for brighter subjects and a somewhat smaller lens aperture for darker subjects, again depending upon the effects you want to achieve.

Flash meters may be used to find a guide number for a given flash setup. After finding the f/stop for use at a given distance from the subject, you multiply it by the distance. You must, however, be in line with the camera and the subject.

To determine how much fill-in flash is needed you measure main and fill outputs separately. The ratio between the two can then be altered through additional trials, as necessary.

FLASH OPERATING TECHNIQUES

The basic lighting concepts covered here pertain to the use of continuous lighting sources as well, such as in the use of reflectors, umbrella reflectors, bounce-flash, and bare-bulb technique in particular. Hence, the section on continuous lighting sources should be consulted for additional information and vice versa.

On-Camera/Off-Camera Flash

Most amateur photographers'—and many professional photojournalists'—run-of-the-mill flash pictures are taken with the flash unit mounted on the camera so that both camera and flash are at the same distance from the subject. This affords greatest mobility by eliminating the need for, and worry over, extension cords, light stands, and people to help you move this equipment when you want to change positions. However, the pictures leave much to be desired, since they do not replicate the natural lighting conditions under which most subjects are observed. The effect with on-camera flash (unless you tilt the flash unit for a bounce-light effect as described below) is a front-lighting thrust which casts a deep shadow directly behind the subject in line with, above, or below the subject depending upon the shooting angle.

With the camera and flash at eye level, using color film, you may get the notorious "red eye" effect which is caused by the reflection of the light illuminating the subject's retina. Another problem is glare from highly reflective or shiny surfaces such as polished furniture, mirrors, bright metallic objects, glass surfaces, and so on. For both the red eye and the reflection problem one solution is to shoot at an angle or to get the subject to look away from the camera. In the latter case this introduces a restriction on

picture-taking freedom. In the case of red eye, extending the flash unit some inches away from the lens at a close working distance will widen the angle made with the optical axis and the subject, thereby overcoming the problem. The further away you get from the subject, however, such as when using a long-focus lens, the narrower will be the angle and the greater will be the possibility of achieving the undesired effect.

With the flash at the camera all you need to do is divide distance into guide number to obtain the f/stop, subject to modification up or down depending upon conditions or variables described above. An alternative is off-camera flash which enables you to place the main flash source at any position which will give you the desired highlight and shadow effects. Typically, when using one flash unit away from the camera it is held high and to the side through extending your left arm rigidly at an angle.

Unless you use wireless slave-triggered flash, the second unit is connected to the camera through the use of a flash extension cord. This connects to the tip of the flash-unit cord and at the other end connects to the appropriate flash terminal on the camera. The only problem you might encounter is that a loose-fitting connector cord could become detached somewhere along the line of extension and connection. Nikon flash extension cords are designed to be slip-proof.

When shooting with the extended flash in your arm so that you do not materially increase the distance of the flash from the subject, use the same guide-number computation as though the flash were on the camera. If you are increasing light-to-subject distance—usually something close to you and lower than your own line of sight—recompute the exposure based on the estimated new distance of the flash from the subject. If

the flash is placed on a stand closer to the subject (but out of the field of view of the camera lens) compute the exposure based on the distance of the lamp from the subject rather than the camera from the subject.

When holding the camera with one hand and the flash in the other, a good precaution is to have a neck strap in place to guard against any inadvertent slippage of the camera from your hand. Also, instead of a light stand or a handy human helper for the off-camera flash, you might use a clamp (available from most well-stocked camera shops) to attach the flash unit to a convenient lamp stand, bookcase, door frame, and the like.

Bounce Flash/Secondary Reflectors

In bounce flash you point your flash equipment so that the lamp is targeted toward a point on the ceiling (most commonly) from which the light is reflected onto the subject. The effect is to diffuse the light, thereby taking away from its harshness, and to extend its distance of travel so as to achieve greater uniformity of exposure. The Nikon BC-7, SB-2, SB-3, and other flash units are designed for tilting to make bounce flash more convenient. Bounce-flash adapter brackets from independent manufacturers, which can be fitted to the base of the flash unit, are available. Otherwise, the flash must be hand-held off the camera and tilted as desired.

Walls and other room-reflecting surfaces can also be used as giant, secondary reflectors. The inverse square law, described earlier in this chapter, is still somewhat applicable: if you bounce light off a single surface it will illuminate subjects over a wide area in some depth, but the light will still tend to grow weaker as it travels.

Flash bounced off the ceiling at an angle gives the photographer much more

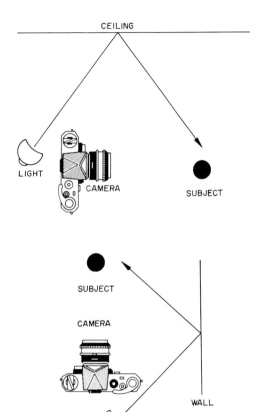

Basic bounce-lighting schemes.

latitude for movement toward and away from the subject without having to adjust lens apertures finely.

Unusual effects can be achieved by bouncing a flash off the wall facing the subject or off the wall behind the subject. In the latter case, it would be necessary to use a secondary reflector or a fill-in flash. A flat reflector or a very shallow one, when pointed toward the ceiling, will spill some light directly at the subject. The effect is to fill in shadows under prominent features—eyes, nose, lips, and chin—comparable to a high-positioned hazy sunlight. The reflector should be at the same level as the subject's face.

Exposure is influenced by the reflective properties of the wall or ceiling; the combined distance from flash unit to reflecting surface and from there to the

subject; and the reflective properties of the subject itself. There are no certain procedures which will guarantee precisely correct exposures every time by formula because each room and its contents have their own reflective properties in relation to the distance of the flash unit from reflective surface and subject. The ideal solution for measurement is to use a flash meter because this takes account of all the variables operating simultaneously through a test exposure. A suitable automatic flash unit does the same. The measurement procedures given below pertain in the absence of either of these more certain methods.

Fast films should be used—medium- and high-speed black-and-white films and high-speed color films. (Color films will pick up the tint of the ceiling, walls, and other reflective surfaces.) From here on out various rules-of-thumb are used to find the best lens aperture for the particular situation, when you have to compute exposure by formula rather than through the use of a flash meter. You could calculate the combined distance of flash to secondary surface to subject and then divide this into the guide number. Then, you would open the lens an additional one or two f/stops depending on size of room and surface-reflection characteristics. Another rule-of-thumb is to calculate the f/stop needed for the distance across the open space between flash and subject (as though you were using straight flash) and then open up at least two additional f/stops. Depending upon the darkness of the reflecting surfaces, you could open up one or two more f/stops providing you have this latitude. Conversely, in an exceptionally bright room you might have to cut back on the size of the lens aperture.

When taking existing-light pictures, an additional use for the bounce-flash technique is to fill in shadows. The fill flash must be much weaker in light output than the existing-light source—perhaps in the ratio of 1:2—in order to retain the existing-light effect. A handkerchief thickness over the flash will cut light output by one half.

Ordinary room light, if reasonably bright, should be taken into account because you will be using wider lens apertures which permit existing light to register on the film. Take an independent exposure reading of the subject under existing-light conditions to estimate how much effect it will have. Dimly lit rooms do not require use of this technique.

Exposure can also be computed by the simulation method, using a continuous light source. Point a flood lamp at the reflective surface toward which you will subsequently point the flash source. Then, take an exposure reading from a principal subject. Now, point the same flood toward the same subject. Find the ratio between the two lighting techniques. Then, when using bounce flash, calculate the exposure for direct flash and reduce it by as many f/stops as would have been necessary if you used flood. This technique will hold for the particular situation, but after a while you can derive experience from many situations to obtain your own rule-of-thumb in making bounce-flash exposures.

Umbrella Flash

The umbrella reflector overcomes disadvantages of direct flash and bounce flash. The disadvantage of direct flash is that it produces too much contrast between highlights and shadows and tends to burn out and lose detail in each, respectively. This is overcome somewhat through the use of bounce flash, but it entails complications of color tint reflected from surrounding surfaces onto the subject, difficulty of exposure computation except when flash exposure meters are used, and loss of illumination.

The main advantages of the umbrella reflector are that it concentrates light of

known output, quality, and color. Since it is a broad, focused, indirect source, it emits soft illumination which seems to flow around the subject, tapering off ever so gradually.

One or more umbrella reflectors can be used at different distances from the subject depending upon the results desired, as described below. The lighting source can be either a flash unit or a continuously burning lamp. Typically, the lighting source is attached to the long rod which corresponds to the handle of the umbrella so that the center of the lighting beam points toward the center of the reflector. The distance between the light and the umbrella is determined by experiment with the view toward illuminating the entire inside spread of the umbrella, thereby making maximum use of the light output.

The lamp-and-umbrella assembly is usually attached to a lighting stand although it might also be clamped to the back of a chair or a ceiling-to-floor pole. Through test exposures, maintaining a fixed distance between the inner surface of the umbrella and the lamp, you can arrive at a guide number for that lighting source. Thereafter, you can use this dependably, subject only to adjustment if you should be working with lighter or darker subjects than average.

Umbrellas for photographic use are available in different sizes and fabrics. Some are rectangular—a departure from conventional umbrella design. Some fold down for maximum portability. Some will also lock in a variety of positions to achieve different angles of reflection and diffusion. You can also use umbrellas so that the rounded exterior is pointed toward the subject with the light source driving through the fabric acting as a diffuser. In this case, there is a substantial loss of light output. Umbrella fabrics are available in white, silver, and gold. When using a hot lamp source, such as a tungsten-halogen lamp, you

must have a fabric which will withstand heat without scorching and discoloring the reflector fabric.

The positioning of umbrella-reflector units will vary with the subject and the intended effect. A typical portrait set up for a Rembrandt-type lighting effect is to place the umbrella unit off to the side at approximately 45 degrees to the subject-camera axis and also above that axis at an angle of 45 degrees. Using this as a single light source, a supplementary reflector can be positioned to throw some of the light from the unit back into the shadow areas.

With a single umbrella flash using this Rembrandt-type of lighting and a single flat reflector for fill, a grey shadowless background will be achieved if the subject is midway between the umbrella and a white background. For a darker background, the lighting source and subject would need to be moved further away from the background. For a lighter background, an independent light would have to be thrown onto the background. Variations in lighting effects can be achieved by placing the umbrella light in different positions. Instead of a flat secondary reflector, another umbrella without a lamp in it can also be used to concentrate the secondary reflection.

In making exposure tests for loss of light through use of an umbrella reflector a point of departure would be the assumption that you will lose about one f/stop. To express this in a lower guide number you would divide by 1.4. Thus, if your guide number ordinarily would be 112, it would be reduced to 80 after division by 1.4.

Bare-Bulb Techniques

The use of bare-bulb lighting equipment was described earlier. The single, unreflected bare bulb is used to greatest advantage as a fill-in light source held not too far from the subject. The distance-covering utility of the bare bulb is

increased by positioning it close to the ceiling or to the conjunction of the ceiling and a wall, as discussed above. As next described, bare-bulb flash can be used effectively in conjunction with other high-output source of flash illumination.

Dean Conger, assistant director of photography of the *National Geographic Magazine,* used a combination bare bulb and conventional-unit multiple-flash setup to photograph inside a tent-like structure called a Pendoppo in the City of Jogjakarta, Java. The scene consisted of musicians playing the Royal Gamelan, a brass-pot percussion instrument. The main light is a bare bulb at the end of a stick that, in most cases, is held out of the range of view of the taking lens. The bare tube was held high and left of center. It was fastened to a 14-foot light stand and extended out over the players. A Graflex 4 with a regular reflector was held high and to the right of center, and bounced off the pyramid-like ceiling. A trigger light bounced from the camera position was an old Heiland 7. This light provided weak fill, although its main function was to set off the other flash units, which were connected to remote slave sensors.

Another picture captured a trance dance or "Rejog," a wild, hectic dance usually performed until the people are exhausted. The dance reenacts the legend of a king who loses his betrothed to another but wins her back by using a disguise and a hobbyhorse army to frighten away his foe. A bare flash tube was held high and to the left. A Graflex 4 with regular reflector was held high and to the right. Two assistants carried the power packs on their shoulders while the lights were positioned at the end of 10- or 11-foot stands. Conger positioned them to either side and to the back; as the action moved he and his assistants moved with it while attempting to keep the same relationship to the principals.

Outdoor Fill-In Flash

Outdoor fill-in flash is used to reduce contrast ratios and to soften hard shadows made by the brilliant directional lighting of the sun. One of the more dramatic applications is to fill in the dark side of a back-lit portrait subject. The hair comes out luminescent, even fiery, depending upon the brilliance and angle of the sun and the color of the hair. News photographers make a great deal of use of flash outdoors since they cannot control the direction of the lighting or whether or not a subject may be wearing a wide-brimmed hat which throws a deep shadow over the face. Fill-in flash is also used outdoors to give punch and depth to subjects which are illuminated by flat, shadowless light. Blue flashbulbs should be used with color film, while blue or clear flashbulbs can be used with black-and-white film.

The daylight exposure for the sunlit area is determined first. Then, divide the f/stop into the exposure guide number to find the middle distance at which you should work. If you want the fill-in flash to be brighter (and the background darker) move forward; if you want the fill-in flash to be darker, move backward. Under this system, if you want to maintain control over image size, use interchangeable lenses. Or, tentatively, you can cover the flashbulb with one thickness of handkerchief, which is the equivalent of moving back about one-third of the distance.

Shutter speed and f/stop combinations, with FP-type flashbulbs, can also be changed for lighting control. While these will not affect the daylight-exposure component if you make normal compensating changes, faster shutter speeds cut down on the amount of flash illumination and slower shutter speeds allow more flash illumination to be recorded.

Fill-in flash should tend to be on the side of slight underexposure to protect

the overall effect. With black-and-white film, when the negative is printed, an overexposure of an important foreground subject would cause the rest of the outdoor scene to seem dark and underexposed. With color slide film the overall outdoor scene would tend to be properly exposed while the particular object which was "painted" with fill-in flash would, if overexposed, look excessively thin and washed-out.

Multiple Flash Exposures

Through making successive exposures on the same image frame you can achieve interesting effects such as overlapping or repeat images of one or more objects that do not overlap. You can also walk around an object making successive "open-flash" exposures in order to fill in shadow areas or to place highlights where desired.

In all cases you must have the camera supported on a solid base such as a tripod. When you make overlapping exposures you may need to reduce each exposure by as much as one half. If you take successive pictures of the same object, such as a head against a dark background, you must keep in mind the pre-cise positioning of each exposure. In this case, full exposure is given each time you make the picture since there is no overlapping.

In painting with light in order to place highlights selectively or to fill in shadows, you make your principal exposure—ordinarily that which is closest to the object to give it its directional source of lighting—and then, while the shutter is held open with a locking cable release, you make successive exposures from different angles to fill in shadow areas. These should either be at a greater distance than that of the main modeling light or you should use a flash of lesser powered output. An exception would be if you were to expose from behind the subject in order to outline it with a rim of brightness. In that case, you would have to be sure that the light is not within range of the camera lens. Another variation is to use flash behind a translucent object, but you must avoid creating hot spots. This technique of painting with light can be used also with a continuous tungsten illumination. In this case, the room should be dimly lighted in order to minimize the exposure effect of the ordinary room lighting.

CONTINUOUS LIGHTING SOURCES

Continuous lighting sources offer a steady level of illumination within which exposures of any duration can be made without need for shutter synchronization as in flash. Photoflood lamps and other continuous light sources are referred to, for exposure-planning purposes, as "tungsten" illumination. They usually have color temperatures of 3200 K or 3400 K; when high-fidelity color is needed it is essential that precise color temperatures be known for basic film matching and for more precise light balancing.

Continuous sources enable you to pre-visualize results as observed through the viewfinder and as measured in terms of contrast ratios through the use of an exposure meter. You can control highlights and shadows more effectively in this manner. You can do this also with flash units which incorporate continuous modeling lamps as described below. Ordinary photo lamps emit a great deal of heat, proportionate to their brilliance. With some subjects heat can literally be withering. When the subject is conscious of the heat it is much more difficult to obtain spontaneous actions or expressions. The low light output of modeling lamps cuts out the heat until brilliance is actually needed.

Power drain on the existing service (or mains) facilities must be considered, particularly when working in a home. You must know the amperage of the particular circuit in use. Typically a 15 ampere (amp) line can take from 1500 to 1800 watts in lighting output. Wiring of sufficiently heavy gauge, currently installed in contemporary homes, can usually support a 20 amp circuit on a wattage load of from 2200 to 2400 watts. You cannot increase the load capacity of a 15 amp circuit by substituting a 20 amp fuse. Sometimes light receptacles in the same room are wired into different circuits.

Use of heavy-duty extension cords leading from other circuits will enable you to distribute lighting loads. Other substantial power drains on the same circuitry should be cut off. When appliance motors cut on automatically they have initial surges of power usage which could overload the circuit if other heavy demands are being made upon it.

Fluorescent Lamps

Although fluorescents seem to give a daylight effect, color pictures will appear greenish unless properly filtered. As there is little standardization among fluorescents (which may be cool or warm) what will work as good filtering for one fluorescent source might not for another. This is a lighting source which is best for black-and-white films. Some special-purpose fluorescents are available which match the color of daylight, but they must be specifically designated as such.

Ordinary Light Bulbs

Ordinary domestic light bulbs are most suitable for black-and-white films because they have a color temperature of about 2600 K leading to excessively reddish results if not properly compensated with filters in the cooling or bluish series. They can also be used as modeling lamps. They are necessarily used as sources in existing-light photography without seeming to be objectionable due to the reality factor.

Photofloods and Reflector Lamps

Ordinary photofloods have the same shape as ordinary light bulbs. When new, they emit light with a color temperature of 3400 K, but with continued usage this declines. You must then either discard the bulbs when taking color pic-

tures or make suitable filter compensations. If you have a reserve of fresh bulbs, it is far better to substitute them. The wattage of these bulbs ranges from 250 to 500 to 1000 watts.

Reflector floods, sometimes called "mushroom" floods, combine both a lighting source and a reflector within the same glass envelope. They are available in different combinations of characteristics, including a choice of color temperatures of 3200 K and 3400 K, wattages which range from 200 through 500 watts, and narrow and wide angles.

Studio Flood and Tungsten-Halogen Lamps

Long-life lamps—up to 100 hours—rated at 3200 K for use with type B color films, are more economical than the ordinary photofloods referred to above. Used by professional photographers, they are called studio floods.

Tungsten-halogen lamps are more compact, have longer life, and more consistent color temperature. Most commonly they are available with color temperatures of 3200 K and 3400 K, but they may be obtained with color temperatures as low as 3000 K and as high as 4000 K. The 3000 K lamps have exceptionally long lives—up to 2000 hours. These lights come closest to being point sources since they have smaller filaments emitting more concentrated light. They emit a great deal of heat and therefore should be used no closer than 6 to 8 feet from the subject. They can be used for direct illumination or in bounce lighting. Quite commonly, they are included as components of location lighting kits.

Projection Lamps

Projection lamps are small light sources used in all types of projection equipment. You can use your slide pro-

jector as a spotlight, but you will need to have a suitable support for it at the right height. (Incidentally, the slide projector, in combination with an area reflector, can be used in close-up photography where you want to drive light into small areas for which a narrow beam is desirable.) Projection lamps are available with a color temperature of 3200 K. When used in spotlights, the combination of a reflector and a Fresnel lens, with adjustment of distance between the two, controls the angle of the beam.

Lighting Kits

At the very minimum, a portrait studio, even in the home, must have some background materials, supports for the background, reflector surfaces, lights of different wattage output and angles of coverage, and stands to support the lights and reflectors. A more elaborate setup will include at least one *boom*—a long pole reaching over the head of the subject or over the object in order to drive a light downward; the boom is usually counterbalanced on its short end with a weight. Then, there are the assorted snoots, barndoors, scrims, and other accessories mentioned above.

For maximum flexibility in portraiture, you need at least four basic lights, including a main light (sometimes called a key light), a fill light, a kicker light, and a background light. These can be supplemented as necessary or desired by reflector devices, background materials, and special filtering and diffusing materials to go over the light sources.

Background materials are made either of fabric or paper with the latter most popularly used. Their purpose is to simplify the background through the use of a material of uniform tonal characteristics. When draped from ceiling to floor, continuing under the subject, they eliminate the line of intersection between the wall and floor which otherwise

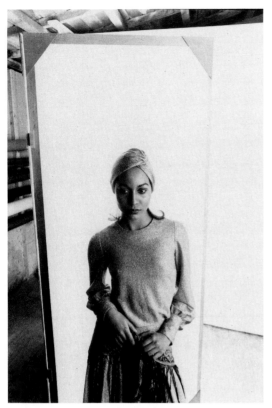

Graham Finlayson

Two perspectives on London model Hylette Mauritius. Background panels are white paper stretched over light wooden frames. Electronic flash behind creates backlight and burned-out area against which to isolate model. Soft modeling light provided by bouncing another flash off second white panel at right in picture. 35mm lens f/5.6, Ilford FP4.

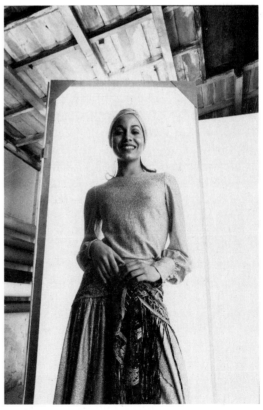

Low angle makes Hylette tall, elegant and dominant. High angle makes her more vulnerable.

149

would appear as a distraction in the picture. Background paper is usually about 9 feet wide (sometimes wider) and may be anywhere from 36 feet to 150 feet long. In the black-and-white series the available tones range from pure white to jet black with progressive shades of darkness or lightness in between. There are also different shades of other colors affording the photographer maximum flexibility for use with either color or monochromatic film. Background paper holders are available from professional photographic stock houses. They are sold also by companies which make up portable lighting-equipment kits.

In place of lighting stands, whose bases take up floor area, you can use ceiling-to-floor spring-loaded tension poles such as are used to support lighting fixtures for the home. These can support one or more lights at different heights through use of an attachment bracket. They can also support a crossbar to hold a roll of seamless background paper.

Lighting kits and fixtures are available from many different sources in different price ranges depending upon how much usage, amateur or professional, the equipment is to receive. Among the more well-known American names are Smith-Victor Corporation, Acme-Light, Lowel-Light Photo Engineering, and Bardwell and McAlister, Inc. Many other lighting-fixture sources are advertised in the pages of the photographic fan magazines. Elaborate kits for professionals are also available, usually including tungsten-halogen lamps, barndoors, lighting stands, and other accessories. These are called location lighting kits and enable one to set up a wide variety of lighting arrangements.

Reflectance properties of the background are significant for exposure purposes only when the subject is fairly close to the background. In a large room or when artificial lighting is used outdoors, the background will, for all practical purposes, be nonexistent. One problem in color photography is that the colors of the floors, walls, drapes, ceiling, and any other large surfaces will be reflected back onto the subject, thereby altering the color properties of the total light reaching the subject. If the walls are painted blue or pink, for example, the subject is likely to have a corresponding tint overriding the normally expected color balance.

You can detect undesirable highlights or other background (and foreground) reflections and distractions through depressing the depth-of-field preview button. Correction in most cases is achieved simply by moving distracting elements out of the picture area—if possible or convenient, by changing light-source positions, by shifting the camera, by raising or lowering it, or by combining any of these corrective actions.

Typical Lighting Setups

Lights and reflectors are placed to achieve pleasing lighting ratios appropriate to the subject. Lighting contrast ratios were discussed in the preceding chapter. You are likely to favor a 1:2 or 1:3 lighting ratio for babies, young women, floral arrangements, delicate objects, and others which you might consider on the light or gentle side. More contrasty lighting ratios are appropriate to men, industrial objects, and those in which dynamic qualities are to be achieved.

You can start with the fill or splash light whose purpose is to provide general illumination for the main subject at a light level about three times less than that of the main-source illumination. A base is created which, together with a main light, would provide open shadows with clear details. The fill or splash light is usually placed fairly close to the camera position when you have a

three- or four-light arrangement. It is placed off to the side when you have a two-light arrangement.

The key light or main light is most important in creating the pictorial effect best suited to the particular subject. It is highly directional. It creates the dominant pattern of light and shade. The shadows cast by this light accentuate or moderate facial or other characteristics depending on the position of the light. This light source is usually higher than the camera and off to a side. Typically, it is the Rembrandt-type of arrangement of 45 degrees to the side of and 45 degrees above the camera-to-subject axis. Naturally, you can vary this according to the subject—lowering the light position and moving it further away or closer to the camera.

The background light is important when you have anything other than a dead black background. It controls background intensity and tone and eliminates shadows cast by the key or fill lights. With a white background, the positioning of the background light (out of view of the lens, near the floor, pointing to the area immediately behind the subject) will provide a white-to-dark grey, depending upon distance. Background tone is important, for it provides suitable separation or contrast for the main subject, depending upon its light-or-dark properties.

An effect or kicker light provides a highlight or special effect as desired. You might want a light behind the subject's head to illuminate the hair or you might want a light suspended from a boom directly above the subject's head to put a splash of lighting there. Kicker lights can be used to achieve desired effects which cannot be accomplished through use of one main source.

You can control the output of any source and, hence, its contribution to the lighting ratio through use of a diffusing material in front of the source.

This makes it unnecessary to be moving the light to and from the subject for the control of lighting ratios. The diffusing material should be heat resistant.

Although each of the four basic light sources must be used creatively, appropriate to the subject, the main, fill, and background lights generally serve to light-model the subject as a whole. The kicker or effect light (or lights if necessary) adds creative touches. In addition to the placement of lights, you must also consider the use of reflectors as fill sources and, as discussed above in the section on continuous sources of light, you can manipulate light through use of a variety of attachments to the lamp reflector. You may want to reflect light and you may want to block it from reaching the subject. Study the effects of various light combinations and positions on the camera viewing screen.

Background Problems

Each lighting source throws its own shadow, discernible to the extent that the source is either of point or broad-surface origin. Sometimes the shadow contributes pictorially; usually it does not and must be eliminated or modified. Typically, when you use lamps, flashbulbs, or electronic-flash units indoors, each causes a shadow pattern to fall beyond objects in its directional path. The shape and quality or density of the shadow can actually tell you something about the light source such as whether it is a point or broad-surface source, how high it is relative to the subject, and whether it is clear or diffused illumination. In portrait or figure photography, the treatment of shadows is relatively simple as compared to industrial, office, or other situations in which objects are at different distances from the camera and must be separately illuminated.

Whether the background is light or dark could have some influence on expo-

Portrait Lighting Schemes with Flood, Flash, Window Light, and Reflectors:
Illustrative Examples

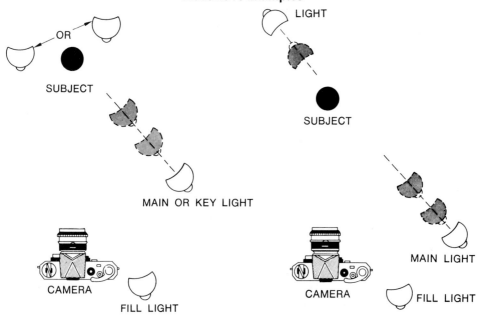

SUBJECT

OR

MAIN OR KEY LIGHT

CAMERA

FILL LIGHT

Three-light plan.

LIGHT

SUBJECT

MAIN LIGHT

CAMERA

FILL LIGHT

An alternate three-light plan.

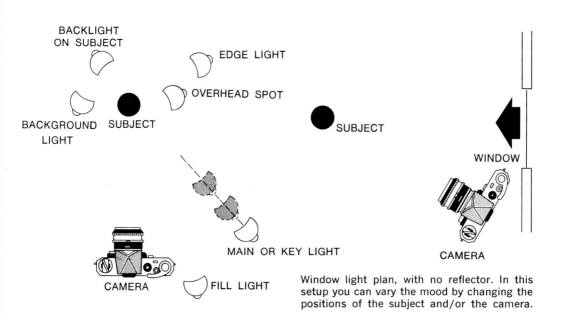

BACKLIGHT ON SUBJECT

EDGE LIGHT

OVERHEAD SPOT

BACKGROUND LIGHT

SUBJECT

MAIN OR KEY LIGHT

CAMERA

FILL LIGHT

Plan for four or more lights.

SUBJECT

WINDOW

CAMERA

Window light plan, with no reflector. In this setup you can vary the mood by changing the positions of the subject and/or the camera.

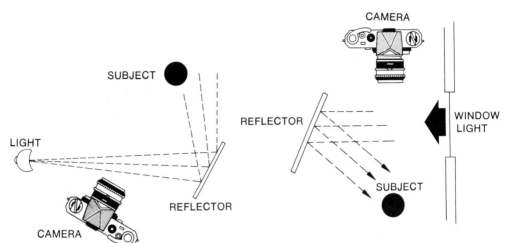

SUBJECT

LIGHT

REFLECTOR

CAMERA

Plan for one light and reflector.

CAMERA

REFLECTOR

WINDOW LIGHT

SUBJECT

Plan for window light and reflector. In this setup you can vary the light by changing the positions of the subject, camera, and reflector.

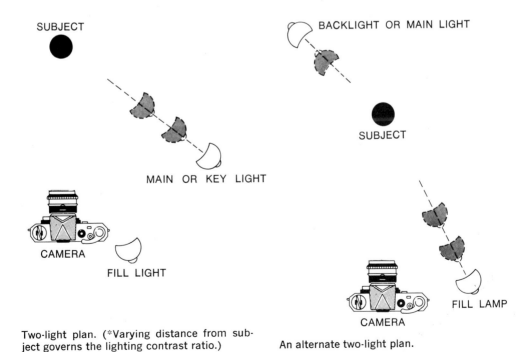

SUBJECT

MAIN OR KEY LIGHT

CAMERA

FILL LIGHT

Two-light plan. (*Varying distance from subject governs the lighting contrast ratio.)

BACKLIGHT OR MAIN LIGHT

SUBJECT

CAMERA

FILL LAMP

An alternate two-light plan.

153

sure and pictorial effects, depending upon the closeness of the main subject and whether or not light is reflected back onto the subject from the background. Otherwise, the main pictorial problem is to assure that the background sets off the subject through good contrast. This is usually accomplished either through using a dark background to set off a light-haired subject or a light background for a dark-haired subject. Lighting directed specifically toward the background will also influence tonal and pictorial contrast. In color photography, background control or modification can be achieved additionally through use of colored papers hung in place as seamless backgrounds or through placement of colored gels over background lighting sources.

In a large room or when artificial lighting is used outdoors, the background will be practically nonexistent unless there is some extraneous object reflecting light back toward the camera. Reflection interferences from background objects constitute a greater problem indoors, especially when working fairly close to a background.

The depth-of-field preview button, when depressed, can be used to detect background and foreground hot-spot reflections and highlights. These reflect so much light in comparison with the rest of the scene that when the total image area is dimmed through stopping down they become relatively more conspicuous. Highlight distractions can be corrected usually by moving them out of the picture area, by changing the camera position, by changing lighting positions, or by a combination of the last two.

LOW-LIGHT CONDITIONS
(EXISTING-LIGHT PHOTOGRAPHY)

Photography under existing-light conditions (also called available-light photography) is that body of technique through which satisfactory pictures are obtained using ordinary indoor lighting sources in homes, offices, public entertainment places, factories, and the like. Daylight coming through the window, store-front lighting, and street lighting are also customarily considered as coming under the general term existing-light photography. In common, all of these situations present low levels of lighting as compared to outdoor daylight, flash, and the various brilliant continuous lighting sources designed for photographic use. An understanding of the photographic potentialities when working with existing-light sources is essential. This has a bearing not only on pictorial outcomes but on exposure and development as will be discussed below.

The traditional existing-light picture is recognizable as such because it has a natural look readily associated with the particular light source. Although the effects will vary accordingly, a certain amount of dramatic effect is achieved because we don't ordinarily associate successful pictorial outcomes with ordinary existing-light sources. In comparison with pictures made under balanced lighting setups where subjects are illuminated so that harsh shadows are filled in nicely and backgrounds are controlled for both tone and light level, existing-light pictures are usually characterized by a downward lighting thrust. The latter will yield shadows in many respects comparable to the different forms of daylight.

Low-Light Problems

A room in a private home typically has an irregular distribution of lighting. The sources might be from the center of a ceiling area, table lamps, and floor lamps. Occasionally, strip or incandescent light sources are mounted along the edge of the ceiling. Each of these light

sources is the center of a sphere of illuminating influence. Because of eye accommodation and a tendency to look at objects of principal interest rather than at light sources, you might not ordinarily detect this irregularity of distribution. It can be observed to some extent through use of a wide-angle lens set at its smallest aperture with the depth-of-field preview button depressed; under these conditions the centers of the spheres of lighting influence will be most readily discernible while areas furthest from the lighting sources will taper off into darkness. When lighting sources are widely separated they may create independent pools of illumination that may or may not touch or overlap depending upon brilliance of the light sources, distance between light sources, and brightness of reflective surfaces within the room.

Office, factory, and institutional settings usually employ numerous fluorescent lighting fixtures mounted to the ceiling. These tend to create a diffuse, shadowless lighting effect comparable to hazy-to-bright daylight or to open shade with a bright sky overhead casting a generalized reflectance downward.

Shadows are most typically discerned in sharp outlines and in harsh character when created by point sources. When light sources are widely separated they will create multiple shadow effects like spokes radiating from the same object.

Overhead illumination causes shadows to be cast in the eye sockets and under other protruding features. These may in themselves be sufficiently disconcerting, but if push-processing techniques are utilized, the contrast between highlight and shadow will be magnified. In either case, facial textures will be more sharply rendered—possibly an advantage in the portrayal of characterful subjects but hardly desirable with women who wish their wrinkles and facial blemishes to be dissolved away.

Auxiliary lighting sources and reflectors can be used to fill in shadow areas, but oftentimes this is not feasible, particularly in spontaneous or candid photography. Moreover, unless done carefully, the use of fill-in lighting may take away from the inherent existing-light impression. If this does not matter, however, you can soften or eliminate most objectionable facial shadows through use of a simple reflector board or sheet held outside of the picture angle of the lens.

Characteristic of ceiling illumination of any type is the fall off of light intensity from ceiling to floor. The effect with standing subjects is that their heads are illuminated most brightly while lower portions of the body darken progressively downward in accordance with the principles of the inverse square law. Hence, the contrast range for a standing subject from head to foot is much greater than for the same subject seated.

Comparable effects are observed when taking pictures outdoors with the illumination from store windows and street lamps. The lighting from a single store window is highly directional and presents problems similar to those encountered when taking pictures near windows and porch enclosures. Subjects closest to the window will be most brightly illuminated while subjects further away from it will be less brightly illuminated. In an open street where light strikes a subject from many different sources and angles, shadow details should be filled in well enough to eliminate harsh contrasts. When the streets are wet or when snow is on the ground the additional fill-in reflector lighting from below will amplify existing-light sources perhaps as much as one light value.

The color-temperature problem is not easily managed due to the mixtures of lighting sources, reflecting surfaces, and lamp reflectors. Imagine the mixtures of color temperatures to be encountered in any typical brilliantly illuminated shopping district where every conceivable type of lighting source may be operating

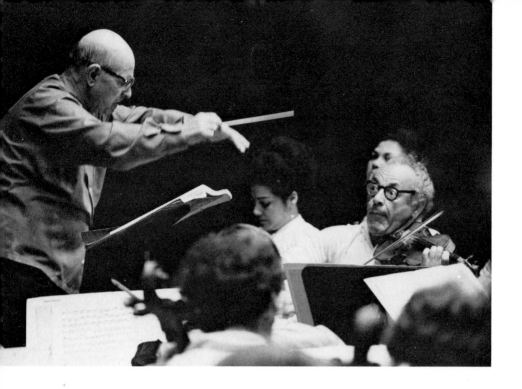

Bernd Silver

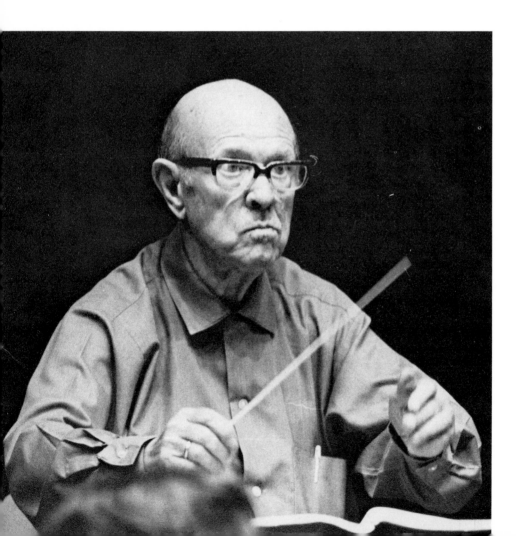

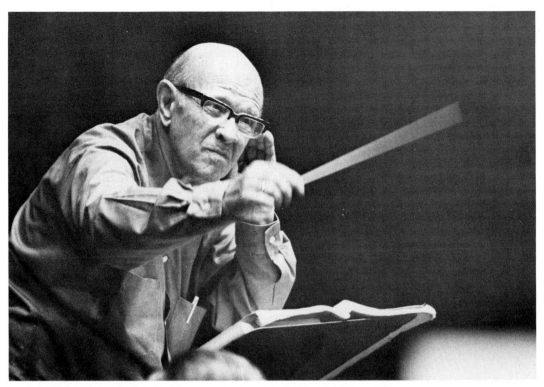

Pablo Casals at rehearsal—an ideal time for picture taking . . . at a distance, for conductors, musicians, and clicking cameras do not mix well, especially at formal concerts. 200mm distance lens used to bring in Casals and Alexander Schneider, while 300mm (held in hand!) recorded Casals alone. Kodak Tri-X and Acufine.

at the same time! On balance, one is best advised to use a tungsten-balanced color film without filtering under these circumstances. Indoors, however, subjects illuminated with fluorescent lamps will come out ghastly green; a warming filter such as CC30R will provide suitable compensation in most cases while, with a daylight film, an FLD filter is suggested.

Lenses, Camera Supports, and Shutter Speeds

The appropriateness of a lens in terms of maximum aperture for existing-light photography is governed primarily by light levels, whether the picture taking is to be with camera in hand or on a solid support, the sensitivity of the film to be used, the extent of depth-of-field required, and the movement of the subject in relation to shutter speed, among other factors. These are modifying considerations to the general rule that greatest flexibility under low-light conditions is obtained through use of lenses with apertures ranging from $f/1.2$ to $f/1.8$. In the Nikkor lens range, the available-light group—adequate for the widest array of conditions to be encountered—includes the 35mm $f/1.4$, 55mm $f/1.2$, and 85mm $f/1.8$. Wider-angle and longer lenses can also be used, but they have smaller maximum apertures. For general purposes, the standard 50mm $f/1.4$ lens may be regarded as a dependable workhorse with optimal qualitative results.

Maximum apertures should be regarded as reserve power resources. Best optical performance is usually obtained when the lens is stopped down at least two $f/$stops from maximum.

Shutter speeds will tend to be on the slow side subject to the particular combination of film speed, lens aperture, and light level for the given circumstance. In the most critical sense, there are no absolutely safe hand-held shutter speeds. When at least ordinary care is used a speed of 1/125 sec. may be considered safe for the avoidance of camera movement during exposure with most lenses up to a focal length of 135mm. With the latter, a safer shutter speed is 1/250 sec. because of the magnification of defect achieved with the longer focal length. Assuming that most hand-held existing-light photography would be done with lenses up through 85 or 105mm, reasonably safe shutter speeds with these are 1/60 sec. and 1/30 sec., but the latter must be regarded as a relatively slow exposure during which the camera must be held comfortably and steadily while the shutter-release action must be brought off with a soft squeezing pressure of the finger on the release button to avoid jarring. From 1/15 sec. on down the likelihood of getting a jar-free exposure becomes less and less. Some photographers are able to achieve excellent results with long exposures such as 1 second, but they must be able to exercise practiced control over their bodies, their camera-holding, and their shutter-release actions. Examples of slow hand-held exposures will be found in the illustrative materials in this book, in particular, examples of the work of Francisco Hidalgo.

A motorized camera should be excellent for slow-speed picture taking. The added weight lends greater inertial stability thereby making the camera more resistant to physical pressure by the photographer. Also, the soft touch on the electrical contact-release button requires less hand and finger pressure.

Briefly, for most purposes tripods are not likely to be very helpful—at least where you have to move around considerably and interact with people spontaneously. Also, you will find yourself in many situations where you do not have any room for a tripod. You will, however, be able to make use of assorted small supports, such as a table-top tripod.

Index